An American Sculptor on the Grand Tour

An
American
Sculptor
on the
Grand Tour

The Life and Works of
William Couper
(1853-1942)

Greta Elena Couper

TreCavalli Press

TreCavalli Press
Post Office Box 49-1271
Los Angeles, California 90049

Library of Congress Cataloging-in-Publication Data

Couper, Greta Elena.
 An American sculptor on the grand tour.

 Bibliography: p.
 Includes index.
 1. Couper, William, 1853-1942. 2. Sculptors—United States—Biography.
3. Artists colonies—Italy—Florence. I. Title.
NB237.C64C68 1988 730'.92'4 [B] 88-50666
ISBN 0-9620635-4-1

The acid-free paper used in this publication meets the American National Standards for Information Sciences, Permanence of Paper for Printed Library Materials ANSI Z39.48-1984.

Design by Words & Deeds, Inc., Los Angeles

Typeset in Garamond and Böcklin

Printed by McNaughton & Gunn

Printed in the United States of America

Preface

From the early eighteenth century until the first decade of the twentieth century it was customary for artists, musicians, and literary figures to go to Europe to obtain a formal polish in the finishing school of the arts. The tradition began in England where aristocratic gentry sent the oldest son abroad for an extended educational tour after completion of studies in the university. These "Grand Tours" lasted a minimum of two years, and were usually centered in France, Italy, or Germany. Excursions were taken to all the art centers of the Continent.

Painters tended to migrate to Paris, London, Rome, Munich, and Dresden; sculptors to Paris, Florence, and Rome; musicians to Paris, Rome, and Munich; and writers to Paris and cities in Italy and Greece. During their training at the École des Beaux-Arts many architects and painters went to Capri and the Amalfi Coast of Italy, from Naples to Salerno, to sketch the ruins of Pompeii and paint the beautiful landscapes of the region.

This book relates the true story of a young American from Norfolk, Virginia, who left for Europe in 1874, at the age of twenty, intent upon establishing himself in a career as a sculptor. The traveling experiences he had, the training in the concepts of art, and the people he met along the way, are narrated in chronological order, after a brief overview of the artist presented in the first chapter. His was a Grand Tour that began as a brief sojourn to Europe but became an odyssey that was to last much of a lifetime.

Note: The writing style of the Victorian era was very flowery and sentimental, but it has been retained in the excerpts cited in order to provide some perspective on the personality of the period.

Acknowledgments

The author is extremely indebted to Monroe Couper, without whose help this book could never have been written. He provided an extensive file of family history—original photographs, letters, theatre programs, newspaper clippings, geneology charts, and related items. His constant enthusiasm, generosity, editing, and assistance insured the completion of the project.

In addition, many persons in American institutions have provided invaluable assistance: The Boston Athenaeum; Boston Public Library; Chrysler Museum, Norfolk; Cincinnati Historical Society; Daniel Chester French Papers Collection, American University, Washington, D.C.; J. Paul Getty Center, California; Metropolitan Museum of Art, New York City; Minnesota Historical Society; Montclair Art Museum, New Jersey; National Military Park, Vicksburg; National Trust for Historic Preservation; New York Historical Society; New York Public Library; Norfolk Public Library; Providence Department of Parks, Rhode Island; Richmond Public Library, Virginia; Smithsonian Institution—National Museum of American Art and Archives of American Art; Stanford University, California; University of Delaware, Newark; University of Washington, Seattle; Valentine Museum, Richmond, Virginia; and the Virginia Historical Society.

In Florence, Italy, special thanks go to the staff of the following institutions: Accademia di Belle Arti; Archivio del Stato; Biblioteca Berenson, Villa i Tatti, Harvard University; Biblioteca Marucelliana; Biblioteca Nazionale Centrale; Kunsthistorisches Institut; Gabinetto Scientifico Letterario G. P. Vieusseux, Palazzo Strozzi; Conservatoria dei Registri Immobiliari; Galleria d'Arte Moderna, Palazzo Pitti; Uffici di Richerche e Documentazioni, Galleria degli Uffizi. La Vostra collaborazione è stata estremamente preziosa.

Grazie tanto.

Contents

1

Introduction
The Artist in Perspective

*I have been inspired from my earliest years with the desire to
leave something of beauty behind, something which was
not in the world when I entered it.*[1]

So expressed American sculptor William Couper, native of Virginia,
while summarizing his philosophy and lifework. He established a wide
reputation in both Italy and America for the broad scope of his work,
which included bas-reliefs, portrait busts, allegorical figures, and heroic stat-
ues. He was also known for his serious and sympathetic study of winged
figures. Loredo Taft stated there were few American sculptors who modeled
angels so generally acceptable.[2]

The first professional training that William Couper received was in 1872 at
the Cooper Art Institute in New York City. Then, in 1874, he went to Munich,
Germany, to attend both the Academy of Fine Arts and the Royal College of
Surgery. Seeking a warmer climate he left for Italy the following year. There he
became the pupil, and son-in-law, of noted Boston sculptor Thomas Ball
(1819–1911), and specialized in portraiture and works of an ideal nature, both
statues and reliefs. The Ball-Couper studios were a meeting place for local
artists and musicians, and the American and English residents of Florence.
During his Italian sojourn of twenty-two years Couper executed many marble
groups which often seem similar in style to the works of Antonio Canova,
neoclassic in spirit and technique. Yet they differ by Couper's introduction of
more finely detailed carving.

In 1897 Couper returned with his family to America, opening a studio with Thomas Ball in New York City. Before his retirement in 1913 he had executed more than a hundred and fifty works which include the heroic statue *Moses* atop the Appellate Court House in New York, a series of monuments for the National Military Park in Vicksburg, Mississippi, and fourteen heroic marble busts of scientists for the American Museum of Natural History in New York. In a period when American art moved toward sentiment and realism, Couper's works reflected a dignified restraint. Idealization was a strong element in his sculpture. [3]

One of his most important allegorical works is the seated female figure entitled *A Crown for the Victor*. This sculpture depicts a crown being woven for the Olympic winner. It is chiseled in pure white Carrara marble and shows the classical style and detail that were the artist's trademark. William Couper is best remembered in the South for his heroic statue *Confederate Soldier* which stands defiantly atop the Confederate Monument in downtown Norfolk, Virginia. "Johnny Reb," who proudly holds the unfurled Stars and Bars at his left side and a sword ready at his right, stares with eyes fixed northward. This symbol of the lost cause of the Civil War, measuring 15 feet in bronze, is mounted on a 50-foot white carved granite shaft. In the early days the statue was located on busy Commercial Place, at the gateway for the ferries that ran between Norfolk and Portsmouth. In 1965 it was moved to a more central spot when the downtown area underwent renovation. Other heroic works by the artist in the Norfolk area include a swashbuckling bronze statue *Captain John Smith* at Jamestown, and *Recording Angel* at the Couper family plot in Elmwood Cemetery.

William Couper's career began at a significant turning point in the development of American fine arts—a time of sensitivity to European guidance, of yearning for the fine arts, for good music—a period in which the École des Beaux-Arts in Paris rose to international fame with its formal training and annual juried exhibitions. Neoclassicism of the day reflected a longing for the glory of the past. The style was characterized by staunch traditionalism, centering on themes from antiquity and of morality. Sculpture was public art designed to educate and elevate the viewer. A brief overview of the development of American sculpture will provide a basis on which to analyze Couper's style.

The study of art was slow to be accepted in this country because of the lingering Puritan belief that visual arts, especially sculpture, were a form of idolatry. Public inhibition to the nude and to the study of anatomy using live models persisted, and in addition marble was inaccessible. The first attempts at stone and wood carving were for utilitarian purposes such as tombstones, figureheads for ships, shop signs, cabinetmaking, and architectural decoration. After the Revolution of 1776, however, there was a demand for statues and memorials to commemorate the heroes and founders of the United States. But the young country lacked local artists, so many commissions were sent abroad, especially to Italy and France. Soon these examples attracted native sons to the profession and after 1825 American sculpture began to emerge as a vocation. But casting in bronze was still done in Europe, and it was not until 1847 that the first work was cast in this country.

American sculptors of the nineteenth-century were of two groups. Those who went to Italy studied neoclassicism and included Horatio Greenough, Hiram Powers, and Thomas Crawford. Those who decided to work in the United States chose realism, or naturalism, to depict American life—pioneers, Indians, and historical events—and included Henry Kirke Brown, Erastus Dow Palmer, and Clark Mills.[4]

In the 1880s American sculpture entered its "bronze age" and local foundries were established. Artists who worked in this medium included Thomas Ball (Couper's father-in-law), Martin Milmore (Ball's pupil), and John Quincy Adams Ward. After the Centennial Exposition of 1876 a new pictorial and natural style emerged, probably influenced by the development of photography, and France became the country to which artists turned for training. By the end of the nineteenth-century naturalism, romanticism, and the complex compositions in bronze from the French school predominated, as seen in the works of Augustus Saint-Gaudens and Auguste Rodin. And symbolism began to emerge, inspired by primitive art found in archeological discoveries.

William Couper's art remained essentially Italian in style, a contrast to the Parisian school of realism. The pseudoclassic style of Florence was combined with a cleverness and attention to detail that sometimes took precedence over more powerful lines and planes. But Couper had a refinement and sound knowledge of human anatomy to balance this Florentine trend. In later years

his style gently turned toward realism, which was evident in his treatment of dress and in the reflective personality characterized in his portrait works.

Couper began each work with a definite idea of what he wanted to portray, and enjoyed the challenges in the process of execution. As he stated, "In art we have to know exactly what we are going to do, then do it. It is not easy, but if one is sufficiently inspired one can do it." [5]

2

Growing Up in Norfolk

J ust five years before William Couper's birth his father founded the Couper Marble Works behind the family home on the corner of Main and Granby Streets in Norfolk, Virginia. This firm specialized in the import and carving of stone used in construction and monuments. The business was run by succeeding generations of the family for 133 years (from 1848 to 1981), and in later years was called Couper Memorials. It was here in the marble works that William often played as a boy, watching the artisans create and carve works for sculptural display. This experience was to have a profound impact on his life.

The Couper family of Norfolk began in 1801 when William's paternal grandfather, also William Couper, sailed aboard the ship *Jean* from Dundee (Longforgan), Scotland, to Virginia, a voyage of seventy-three days. Upon his arrival on July 29th he found the climate very hot and humid compared to that of his homeland, and shortly after the landing half of his shipmates had succumbed to the "Seasoning fever" (yellow fever). Although a weaver by trade, William began work for a baker who provided seabiscuits to ships, and later he became a successful merchant in this important seaport. He was never to return to the country of his birth but he kept in touch with relatives through written accounts of life in America. One of his children was John Diedrich Couper.

William Couper the sculptor (fig. 1), was the son of Euphania Ann Monroe Cowling (fig. 2) and John Diedrich Couper (fig. 3). He lived within sight of Norfolk's teeming harbor, which attracted ships from many nations, and he attended private schools, including Professor Nathan B. Webster's Institute. His family was active in civic affairs and supported charities and the

arts. In addition to their Norfolk home they owned a large farm, Clifford, near Sewell's Point in Norfolk County. During the Civil War, while the family was living at Clifford, William, at the age of eight, witnessed the naval battle of the *Monitor* and the *Merrimac*, from the bank of the Elizabeth River where it joins Hampton Roads. [1]

While in his teens he carved his first work, which gained much attention, and led to his decision to pursue a career as a sculptor. One evening at the dinner table his father told the story of a local sculptor, Alexander Galt, who had made a cameo carving of a Bacchante, on a conch shell. He explained how the artist had used the layers of pink tone in the shell to obtain a remarkably realistic blush to the cheeks and face. William was intrigued by the story and, remembering that his brother had a conch shell, decided to try such a carving himself. He set to work but the shell was too hard and slick and his tools were inadequate. He obtained some fine steel cutting instruments from the local blacksmith and finally with much patience and determination was able to complete the cameo. His father took it to the town jeweler to have it set as a brooch, and the jeweler asked if he could display it in his shop window. Soon townspeople who saw the cameo were urging young Couper to pursue the study of art, and the following newspaper article appeared in the *Virginian*:

> NATIVE GENIUS: Our friend, Mr. Freeman, has exhibited to us a beautiful cameo, cut by Mr. William Couper, of this city, who is about eighteen years of age. The work is a Bacchante, and as far as we can judge, is exquisitely cut.... Such genius and industry combined should not be neglected, and we trust to hear of Couper the sculptor. [2]

In October 1872, William received a letter from Edward Valentine, noted Richmond sculptor, who offered to advance him in the field of sculpture. But plans had already been made for William to attend the Cooper Art Institute (now called Cooper Union) in New York, where he won a scholarship, taking fourth place in a class of thirty students.

A second exhibition of William's works took place in Norfolk at the annual Agricultural Fair of 1873. The sculpture included a miniature fountain in the shape of a shell; a clay model *Don Quixote*; and a study of a hand. The

Norfolk Landmark printed a special edition for the fair which included an article on the Couper works:

> Our young and gifted townsman, William Couper, Esq., has on exhibition at the Fair a number of exquisite works of art.... But the greatest thing after all is an anatomical study. It is a hand.... He went through this work with patience and accuracy, and the model... shows that he promises to become master of his beautiful art. Norfolk gave Galt to the State, and we trust that Couper will succeed him. Let him be sent to Rome and Florence.[3]

William's father gave a great deal of thought and consideration to the best means by which William could continue his education in art. On January 22, 1874, he wrote to Edward Valentine:

Mr. Valentine, Dear Sir

> In the morning my son Willy expects to leave here for Richmond and his special purpose is to see you. His mind seems set upon improving himself in modelling, etc., and desires to take hold of systematic methods by which to accomplish it. His friends here are persistent in advising him to go to Italy or to some place where development might be assisted. I understand that you rather recommend Germany—and not familiar with the advantages whether in point of economy or in the study of art, which the one possesses over the other, I thought I would ask favor of your advice.... Will you, Mr. Valentine, oblige with such information as you may think would help him? How should he proceed? Will it not be better first to write to someone to secure him place.... There is none that I know of who can tell me anything definite other than yourself....

> I am yours very respectfully & truly,
> John D. Couper [4]

Six months later William left for Europe, carrying letters of introduction from Governor Kemper and Edward Valentine. Valentine had studied in Germany and knew a Professor Holtzendorff whom he asked to provide Couper with advice and direction, so that he would "receive the proper instructions and return with fond memories of his experiences and the kind people of Germany." [5]

3

On the Grand Tour

Williiam Couper set sail from New York on June 27, 1874, aboard the steamship *Nürnberg*. He enjoyed a very elegant twelve-day trip, socializing and feasting on sumptuous meals. A brief episode from the cruise is presented below to show the kinds of experiences a Victorian voyager might encounter on the lengthly shipboard sojourn. Many of the passengers became close friends and often played jokes on one another to pass the time. William relates some of these activities in a letter he wrote to his family on July 7:

> Dear father and mother, sisters and brothers,
>
> I have certainly enjoyed my trip so much I would find it hard to select words to express it. We have *only* four meals a day and at dinner just eight different courses, and everything gotten up in the best way possible. On Sunday 28th we gathered in a jolly crowd on deck: everything so bright and beautiful, it made the whole party agreeable especially a gentleman from Washington by the name of Simpkins. He is the life of the ship, and whereever he may be there is almost a constant war of laughter; He was entertaining us when someone called our attention to a whale off a little distance which was a great curiousity to me, and the only trouble he would not show himself enough though I should be satisfied as he *squirted once for the benefit of the crew.*
>
> About Tuesday . . . I was sitting by the cabin door when a young lady asked me if I had seen a book . . . we struck up a conversation and . . . through her I became acquainted with every lady on board. So now if it is pretty weather we are constantly on deck walking or up in the bow of the ship having a pleasant time, etc.

As I have said, the gentleman on the ship is always in for fun. On the July 3 Mr. Stein and other gentlemen were sitting in the smoking room when somehow Mr. S understood from them there was a tremendous sandbar, which was in a very dangerous place, directly in mid ocean which we would have to pass; the gentlemen did permit him to believe it, and encouraged his misunderstanding by making up wonderful *tales* and *such* relating to the bar; one said at *low tide* the bar was twenty feet out of water, and at high tide there was a certain place that the ship could just sail through, all of which was so pressed upon that he believed it and at night he wrote a petition to the captain in this way—

July 3rd, 1874
To Captain Yeager,

At a meeting of this day the passengers on board of your noble ship have resolved to request you to avoid the sand-bank and buoy south. This request is made in consideration of the large proportion of ladies and children on board. Hoping that you will grant this favor I am yours respectfully,

Daniel Stein

The gentlemen all marched in the captains room giving him the wink. After they had arranged themselves Mr. S walks up to the captain as *big as life* and read the above. It was all the gentlemen could do to keep from laughing.—After Mr. S finished the Captain told him he could not give him an immediate answer but would let him know in the morning. So the next day the captain told him it would delay the ship two days to run *around a sand bank* but as it was so earnestly requested he would grant it. So Mr. S treated the *passengers* and *crew* to Champagne that day at dinner. *We have not gotten to the sand bank yet!*[1]

On the evening of July 8th the ship's passengers caught sight of land, seeing the lighthouses along the coast of England. They had been twelve days at sea and everyone was in a merry mood at the prospect of stopping at Southampton. The ship then continued on its way to Bremerhaven, Germany, and from there Couper took the train to Bremen, staying at the Hotel

L'Europe. There he wrote a note expressing his feelings about the trip from America to Europe, and the generosity among the passengers who now were assisting each other to settle in Europe, and promising to stay in touch.

Because the schools in Dresden did not open until late fall William decided to stay in Bremen with another art student, Ephraim Keyser, where he could have assistance with the German language on hand "at every request." He described his first experience with "culture shock," and even said that he would consider coming home if such were proposed.

> I tell you it is a dazed position to be placed in not being able to speak, not knowing how to count your money, and the whole amount in not knowing nothing. Now today I bought me a pair of shoes and if Mr. Keyser had not been with me what would I have done. They were shoes, I never saw such things broader, or as broad at the toe as the widest part of the foot it reminds me of their fantail pigeons. I put them on consoling myself I would have to do as the Germans do,... the nicest material and strangest looking I EVER had.... Before I got on shore my shoes from the salt air cracked almost across, I think I should advise those who come to bring a supply within that line with them. [2]

He found the customs in Germany very formal compared to those in Norfolk. It was always necessary to tip or raise the hat when seeing someone whom one knew, or who lived at the same hotel, or, when asking someone a question. If anyone was caught disturbing the city gardens or lakes he was subject to an eight-day prison term; consequently everything was "in the best order." It was rare for a young unmarried woman and man to walk together and whenever Couper went out with a lady the people stared as if he had "horns on his head."

After a few weeks in Bremen Couper went to Dresden, where he planned to enter the Academy of Art. While waiting for an opening he began to study German and see the countryside. He took a boarding room with an English student, R. G. Fletcher, and another student, a Mr. Roseigh, from France. They often toured the city together enjoying the local customs and holidays. On August 30, 1874, there was a special celebration:

There are grand doings here today everyone most has a flag out of the window as this is the annual celebration of the battle of Sadan [sic], where the German troops captured Napoleon with about 120,000 of his men. All of the business houses close and the people flock to beer gardens, and in the neighboring cities.

...I wanted to see a little of the celebration and let you know how I spent the day. Our landlady got up a nice dinner and then Fletcher and I went to the Kings Groves where there are numbers of deer and wild hogs. The woods are very extensive, and look beautiful. All the undergrowth is cleared out for the purpose of hunting the animals with dogs, and all the riders have spears.... On the northeast part of the grounds is a very large castle or Schloss the King spends his summers in, and quite near are two large lakes filled with swan and ducks. Near the borders of these were very large trees here and there, and at the edges of the water clumps of plants with very large leaves which hang gracefully over. It was near sunset when we rode along there. The soft light that shown on the ripples made by the fowl and the deep shadow of the trees and plants, with the castle that is of a light brown in the background gave additional beauty to the scene. I pulled a flower there for Sis.

This is the first horseback ride I have had since I have been in Germany.... As we rode along through the crowded streets we had a fine view of the illumination, every hotel, beer garden, and public house was as bright as possible. In the river there were boats filled with lights very prettily arranged. I have seen no celebration in America to equal this.[3]

On another excursion Couper related that one knew at once when he had entered Bohemia because of the large crucifixes along the road, which were about 8 feet in height. The crosses were made of wood with figures of painted tin. Many homes had holy figures over the doors in glass-covered boxes.

The Academy of Art in Dresden had a long waiting list of applicants, and when Couper received a letter from Ephraim Keyser in Munich he decided to go there, where the schools were not so crowded. Before leaving Dresden he bought some meerschaum and carved a pipe in the shape of a man's head for Fletcher, to thank him for all the help he had provided. (Keyser eventually settled in Baltimore, Maryland, and became an accomplished sculptor.)

When Couper arrived in Munich at the beginning of October he entered the Academy of Fine Arts, and took a room in a student boarding house. More than forty Americans were studying in Munich at the time so he had an opportunity to make many new friends. One was "a very jolly and splendid young man," John C. McKowen, who had been studying medicine in Munich for two years. McKowen was one of the few Southerners studying in Europe, as most American students were from the northern states, and he and Couper established a lasting friendship.

Couper found sculpting figures from life models difficult, because their posture altered when they grew tired. After weeks of struggling with the problem he decided to study anatomy so thoroughly that each change would be completely understood and the problems of modeling would be overcome. With McKowen's help he was able to enter the Royal Academy of Surgery and spend two hours a day in the dissecting rooms, studying anatomy firsthand under Professor Rudica. The remaining time he studied drawing at the academy, and worked on a sculpture bust to send home to his family.

Toward the middle of the school year he wrote a note to his mentor, the sculptor Edward Valentine, as follows:

Munich, Jan 27, 1875

I am late in saying my voyage was a safe and pleasant one.... The letter you so kindly gave me has been delivered to Professor Holtzendorff. He was very glad to hear from you and desired that I should send his kindest regards with many thanks for the photographs.... My attention is strictly devoted to drawing from the Antique under Professor Strahuber. The old man is very discouraging at times when he comes in the humor to criticize and tears my work *all to pieces.* You can well imagine it gives me a fine appetite for dinner. And, oh! don't I wish sometimes I had never thought of studying art (you know how it is). The facilities here for sculpture are of no great consequence but drawing fine, therefore, I will not remain in the city any great length of time. Have not decided exactly where I will go.[4]

Valentine responded with friendly advice from home.

April 22, 1875
Dear Mr. Couper,

So you are hard at it in one of the best art schools in Europe. You will there have fine advantages and you must keep a strong heart and work steadily and earnestly. Do not allow the criticisms of your instructors to give you the dyspepsia, but the more they tear your work to pieces the more you strive to conquer. The time which you can spare from your art studies, visit the museums and historical collections. Read art history, and keep a notebook of what you see and hear. Do not depend too much on your memory, but write down what will be useful to you in connection with your profession. Keep a notebook...

In regard to the "Bilderboque" if there are any nice studies of antique or modern drapery I should like to have them. Anything else that you think would be useful to use you can tell me of in your next letter. My marble figure of General Lee is safely stored away in Lexington until the mausoleum is ready to receive it. A gentleman who has returned from Lexington tells me that the students of Richmond College who accompanied the figure as an escort were highly pleased with the visit. A procession was formed from my studio to the Danville depot where the statue was shipped. I will send you accounts of it when on exhibition.[5]

An incident that occurred during Couper's student days always reminded him of the place of art in life. He and a group of friends, which probably included artist Frank Duveneck, were on a holiday tour of the countryside when they turned back and saw a lovely sunset. As they were gazing at the horizon an old peasant stopped to ask what they were watching so intently. One student described in perfect German what they were doing and the man responded:

Gentlemen, I thank you. I suppose these things have happened before, but in my sixty-five years of life, the sun's rising has meant that I started work, and its setting has meant that I rested, nothing more. You have made me see something which I never saw before, and I thank you.[6]

On July 31, 1875, Couper received a diploma from the Academy of Fine Arts. This school emphasized the study of painting and had few courses in sculpture. Because Couper was not able to study sculpture as much as he wished, and he did not want to spend another cold winter in Germany, he decided to go elsewhere. Both Germany and Italy had national sculpture studios subsidized financially by the government, which attracted students from all over the world. France had established a formal training program in Paris at the École des Beaux-Arts, where bronze sculpture began to take precedence. Italy offered individual training under expatriate artists and had an abundance of the world's finest marble. Examples of antique sculpture, both Greek and Roman, that the artist might wish to emulate were best seen in Italy; and the materials and supporting craftsmen were available there at inexpensive prices. Couper hoped to find a benefactor among the sculptors of the American colony. On September 9th he boarded a train bound for Florence.

4

The American Colony in Florence

he Italy toward which William Couper traveled was at the threshold of great change. For decades it had been, to foreigners, a mecca of art and picturesque charms; of colorful peasants, vineyards, and little villages with crumbling walls; of idealistic romance in the eyes of those who could overlook its turbulent history. Political unification of Italy, however, had occurred just five years earlier. There was a shockingly low standard of living, and the people were highly superstitious, with strong beliefs in fatalism. The young nation was struggling toward identity and strength from a late start. The expatriate community, on the other hand, distanced itself from political developments. Its members identified with the intelligentsia and made the most of Tuscany's rustic charm, enjoying the elegant and magnetic art heritage of Florence. Italy, beautiful, artistic, dreamy Italy, continued to exercise a strong influence on her foreign guests.

When Couper arrived in the city by the Arno in 1875 his first reactions were mixed. By day the colorful piazzas were filled with sunshine and excitement, with the lovely Tuscan hills and Florentine architecture as a backdrop; but at night, in the dim glow of few gaslights, the streets seemed dingy, narrow, and circuitous. He took a room in the Hotel Suisse until he could get permanently settled. He chose this hotel because he could now speak a little German but had no knowledge of Italian. He wrote a note home describing the trip from Germany:

> My trip through the Tyrol was splendid and most interesting espe-
> cially in Austria. I stopped at Innsbrook overnight so that I could see
> the beautiful country on my route. Next morning... we followed up
> the river through tunnels, over bridges, and skirted hillsides, afford-

ing beautiful views of peasant huts... at the bottoms of large moun-
tains towering five and six thousand feet above them. At one of
these places I bought the Edleweiss which only grows where the
snow lies the whole year round.

We reached Verona about ten oclock at night.... Next morning
took a walk through the city. Saw the old ampitheatre [*sic*] (some
two thousand five hundred years old).... My attention was called
particularly to the little jackasses no taller than up to a man's waist,
lugging along with a load and a big fellow sitting on top who could
with all ease put the little animal over his shoulder if necessary. Left
Verona... and in the afternoon when we arrived at Sortita there I
had to give up my third class ticket and pay the difference on a
second. When the train came it had two engines attached and lamps
burning. I knew then we would have a rough country to pass
through which was the case. The mountains were tremendous and
at least two thirds of the distance between the last place mentioned
and Florence the tracks are under ground, at times it would take
some fifteen or twenty minutes to get through. It became very
disagreeable because of the smoke sulphuric odor that comes from
the engines. Arrived in Florence at ten oclock at night.[1]

The next morning Couper went to the American Consul to ask where the
other American students were staying, and was surprised to learn that none
was there at the moment. So he went to visit the sculptor Joel T. Hart, for
whom he had been given an introductory card by one of his Munich friends.
He asked about finding permanent lodgings and Hart suggested he see
Daniel French, a young American sculptor studying in Florence under Tho-
mas Ball. On the way Couper stopped by the studio of the late sculptor
Hiram Powers and saw many works in progress by his sons Longworth and
Preston. He then continued on his way to see French, but French was not at
home so Couper visited the city and later wrote to his family, "Florence is a
stately looking old place. In the old part of the city the streets crook in every
direction and are very narrow. The stores are all small and cramped up, and
know how to put on one half as much again for an article, and the cheekiest
fellow you ever saw. If you hand him or her minus one quarter they will
always take it. This is a miserable way of doing business."[2] On the other
hand, he was much happier with the climate of Florence, which was similar
to the weather in Norfolk.

Joel Hart let Couper share his studio. This sculptor from Kentucky had worked in Florence since 1849 and had assisted other artists upon their arrival, including Thomas Ball. He was well known for his sculpture, his invention of a pointing machine, and his generosity. One day Couper wanted some clay to work with but it had all had been used for a bust in progress. Hart suggested taking some clay out of the base of the bust and putting in a brick to fill the space. "I appreciated his kindness and was very much amused at the idea of stuffing in bricks to fill in a work of art. I of course withdrew my request at once saving the old man from working on a brick foundation." [3]

Later in the week Couper was invited to dinner at the home of the Powers brothers, whose studio he had visited earlier. "Little did I ever think this time two years ago, no not so long as that, that I would ever take a meal at the table of the family of so great and distinguished a man as Hyram [*sic*] Powers." [4]

Florence at this time was the home of many American families who had constructed an artistic colony of beautiful villas, set in high-walled gardens, on a hillside outside of the Roman Gate (Porta Romana). This area was on the south side of the river Arno, near the Pitti Palace, and was accessible from the city by walking across the Ponte Vecchio. Some of the houses were backed up on a great avenue, the viale Poggio Imperiale (fig. 5). An old palace stood at the top, the Porta Romana at the bottom, and all along the way were huge cypress trees said to have been planted by the Medici family. The patriarchal Powers family lived in half a dozen villas. The family included Preston, a portrait sculptor; Longworth, both a photographer and sculptor; Ned Powers; and Mrs. Ibbotson, the former Louisa Powers, who had married an Englishman. Thomas Ball, a sculptor from Boston, had also built his villa in this area. His home was a large brown two story structure in the middle of Italian gardens, a spot where the artists, musicians, and literati from America, England, and Florence congregated.

Thomas and Ellen Ball, and their daughter Eliza Chickering Ball, were known for their gracious hospitality and dedication to music and the arts (fig. 4). Ball was aesthetically versatile and had once earned a living as a singer in operatic and religious oratorios. Eliza, or Lizzie as she was sometimes called, was an accomplished pianist. She studied in Florence under the Hungarian pianist and composer Henry Ketten. Her middle name of Chickering was

from relatives of her mother's family, members of the Boston piano manufacturers of the same name. The Balls kept in close touch with their friends in America, to whom they often showed generosity. During the year 1874-75 they hosted Susie Jewell in their home, daughter of noted Boston attorney and statesman Harvey Jewell. Between 1875-76 the sculptor Daniel Chester French lived at Villa Ball. Another time, Eliza's cousin Annie Chickering stayed with them for five years. Their kindness would later be extended to William Couper.

Couper met another sculptor, John A. Jackson, a resident of Florence for twenty years, who advised him that the sculpture academy was open only in the mornings and suggested that he take a small studio in which to work in the afternoons. Couper wrote, "I think I am far enough advanced to work some alone and with the criticisms of my friends I am sure I will be able to turn out something tolerable. Galt did it, *I can.*"[5] Shortly thereafter he began to share the studio of Preston Powers, located near the room he had rented from Mr. Grecchi at No. 4 Viale Petrarca, in the Porta Romana area. Here he modeled a copy of a bust of Mrs. Preston Powers, and began a 2-foot-high statue of a young boy.

Couper became a close friend of the Powers family and when they were out of town they asked him to stay at Villa Powers to watch over the estate. He often helped Mrs. Powers and Mrs. Ball at their afternoon receptions. He found these delightful as there was always "a string of carriages at the gate." Nellie Powers was active in the young people's get-togethers, and she painted Couper a picture of a rose and a butterfly. Later this was preserved in the guest book for Villa Ball.

Another American, Harwood Kretchman of St. Louis, was studying sculpture in Rome and paid a visit to Couper and the Powers family. Couper's Grand Tour was gaining momentum, and he then went to visit Kretchman's studio in Rome. He saw the ruins, temples, and antique buildings; visited with American government officials; and bought a number of stereoscopic slides to send home. He made special mention of the bronze statue of St. John in St. Peter's church which the people had "kissed the toes off of."

Couper had gone to Florence both to advance himself in sculpture and to assist in his father's business, the Couper Marble Works. He visited the mines and quarries of Carrara to arrange for marble and monuments to be shipped

back to Norfolk. He also went with Preston Powers to the quarry at Seravezza, known for its superior white marble. Couper was astounded to observe that here the stone was pulled out of the mountain by large engines and over to a precipice, where it was let go to tumble to the bottom. Powers helped with the arrangements to have marble cut by an Italian craftsman in a design following a sketch sent by Couper's father, of a vase and two snakes. In return, Mr. Couper arranged to send some mockingbirds from America for the aviary at Villa Powers. Apparently it was popular to keep exotic birds, especially Japanese varieties, in glass conservatories at the Florence villas. In the wintertime these structures also housed flowering plants.

Thomas Ball's villa and studio were located adjacent to Hiram Powers' villa. This area was once part of a monastery and vineyard, and was on a hill overlooking the city of Florence (figs. 7, 8). Villa Ball was just as Daniel French had found it two years earlier, large and handsome, but not built for the cold Florentine winters. The rooms were very large, with high ceilings. Numerous studios were on the ground floor. One contained large figures in progress, including the *Webster,* and the figure *Eve* standing before a crimson curtain. Another was full of small statuettes and busts. Two studios were used for marble cutting, and a showroom had large marbles on display. The image was that of a Renaissance workshop, with studio boys, marble cutters, and plaster casters working around the master.

But as winter approached a chill settled in the villa. Outside the locals carried pots (*scaldini*) filled with coals to keep warm. These were also used to heat the houses, and often caused a layer of soot to darken the walls and furniture. In the studios straw mats were placed on the floors where the sculpture was being modeled and carved. Overhead, a cold breeze drifted through the lofty spaces, which French affectionately called the "gentle zephyrs." [7]

Almost from the time of his arrival in Florence, Couper participated in the exciting cultural activities of the artistic colony. He quickly took an active role in this social set of creative intellectuals in residence from abroad and attended the many musicals, studio exhibitions, teas, and theatrical productions. Longworth Powers had set up a permanent stage in his home Villino Powers (fig. 27), and Dr. Van Marter frequently had entertainment evenings at Palazzo Arese. The cast for the theatre events consisted of artists, sculptors,

and family members. One program was called the Snolly Gostor Chorus, and William dressed himself as a black singer. Other performers were McNamee, Powers, Austin, Smith, Sweet, Newman, Van Marter, and Hall. (see figs. 30, 31.) On another evening "Lizzie got up a swell musical... All seemed to enjoy the music very much for certainly it was of a very high order which was not only mentioned in the Florentine papers, but also in the 'Galignani', published in Paris." [8]

Daniel French wrote of these events and included a first impression of Couper, with an amusing note on his new rival.

> I am to lead a "German" a week from Monday at Mrs. Ball's, with Miss Lizzie!! It is to be a very fine party with all the available, which means dancing, young ladies & gentlemen (Americans) of Florence. I must say I should prefer not to lead, but Mrs. Ball seems to want me to so I shall.... There have been no special festivities this week, theatricals taking the spare evenings for rehearsals. I find myself strongly drawn to take part in the acting, but discretion holds me back. Tuesday evening, Mr. Couper and I went, with the Ball's, to the opera "Norma."... Mr. Couper is a young man of 21 or 22 who is here for the purpose of studying sculpture. He is from Virginia and of Southern tendencies, I think, though he has too much good sense to say much about it. I give this sketch of him because, as he enters into all the gaiety of this neighborhood, you will be likely to hear of him again. Don't you think he is rather a dangerous personage to leave behind, when I go home next summer? [9]

On another day:

> To return to... the play side of life, last Thursday, the younger portion of the family Powers including Couper, Mr. Hatten & myself dined, spent the afternoon & tea'd with Mrs. Ibbotson. It is needless to say that we enjoyed ourselves. Tell mother that Miss Nellie rather went beyond herself in making herself agreeable to me. [drawing of tree & lady here] That's a weeping willow if you must know and those [are] the relative positions of the pair who, crowned and decked with flowers and leaves, enjoyed each others society on an ivied bank in Mrs. Ibbotsons garden. "Faint heart ne'er won fair lady."...There has been a gentleman lecturing here on the subject of

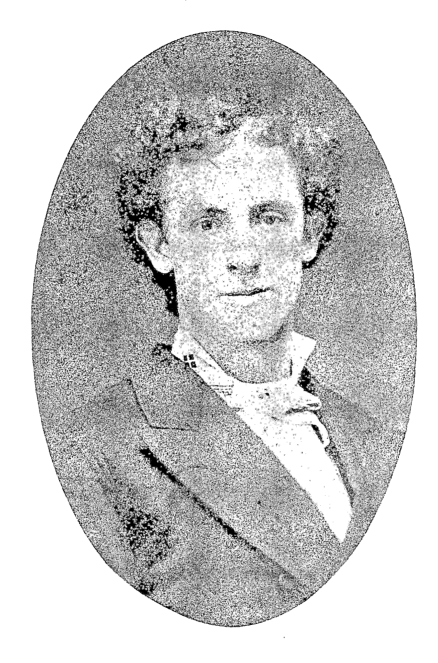

1
William Couper *c.*1878

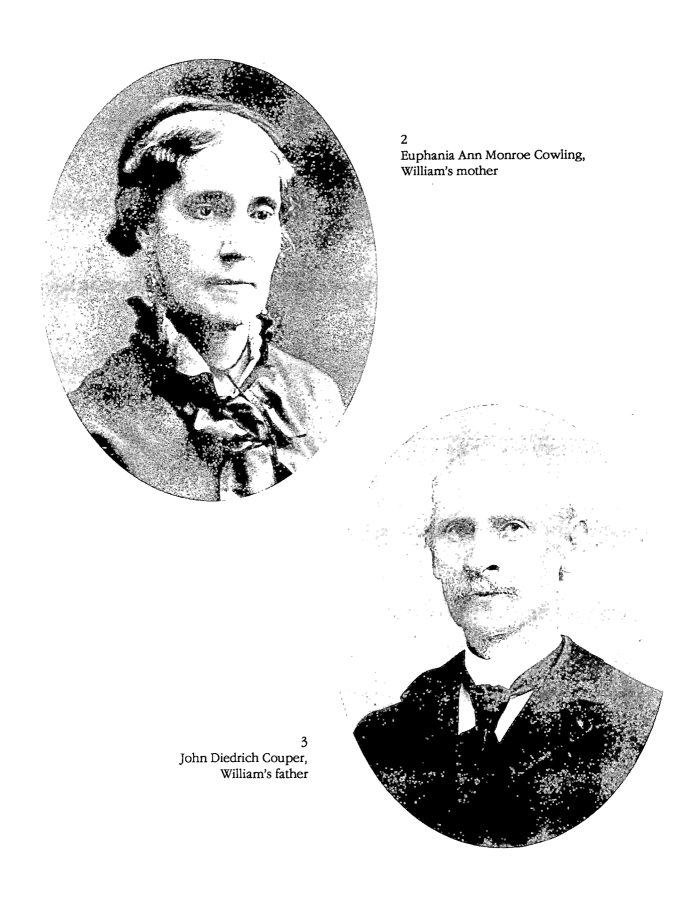

2
Euphania Ann Monroe Cowling,
William's mother

3
John Diedrich Couper,
William's father

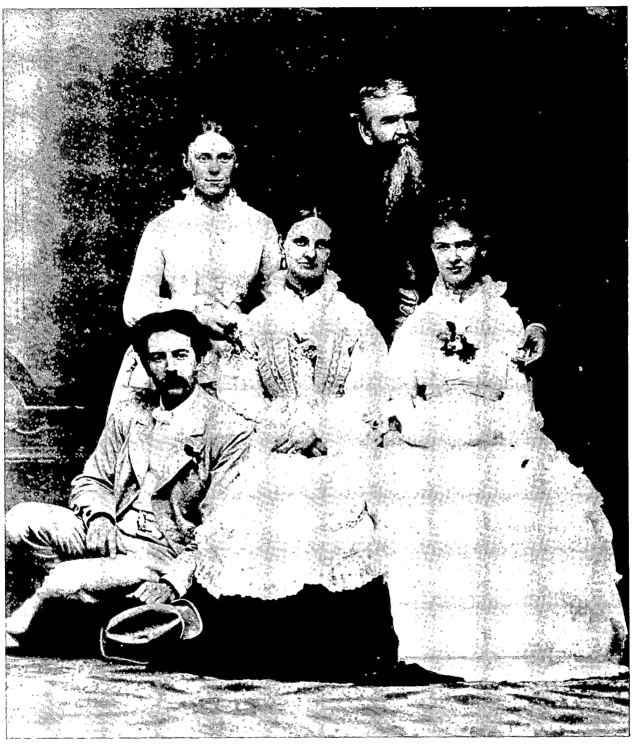

4 The Ball Family with Guests, 1875
 From left: Daniel Chester French, Susie Jewell, Ellen Ball, Thomas Ball, Eliza Ball.
 Courtesy of the Chesterwood Museum Archives, Chesterwood, Stockbridge,
 Massachusetts, a Property of The National Trust for Historic Preservation

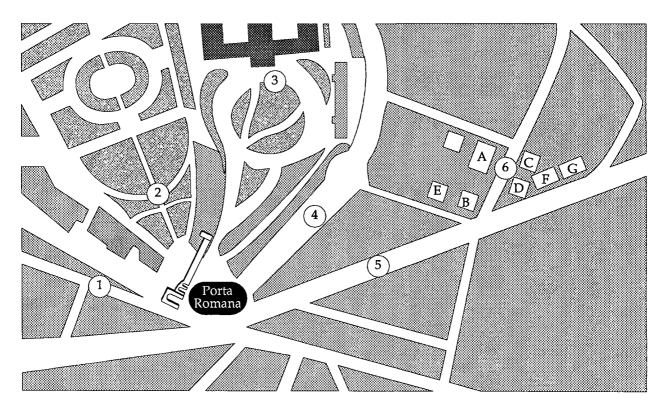

5 Map of American Colony near Porta Romana
 A= Villa Ball, B = Villa Powers, C = Ibbotson's villa, D = Villino Powers,
 E,F,G = Powers family villas
 1 = via dei Serragli, 2 = Boboli Gardens, 3 = Institute of Art, 4 = via Machiavelli,
 5 = via Poggio Imperiale, 6 = via Dante da Castiglione

6
Villa Ball Lot Plan

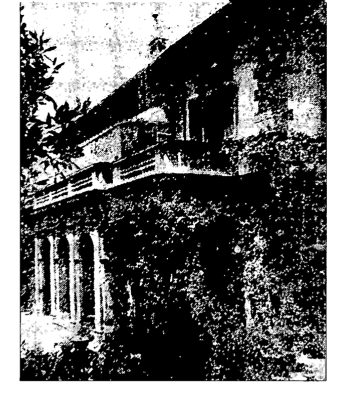

7
Villa Ball, 1890

8 *below*
Villa Ball, from the back, *c.*1880
(Villino Powers in distance on right.) Courtesy of
the Chesterwood Museum Archives, Chesterwood,
Stockbridge, Massachusetts, a Property of The
National Trust for Historic Preservation
(NT73.45.5274)

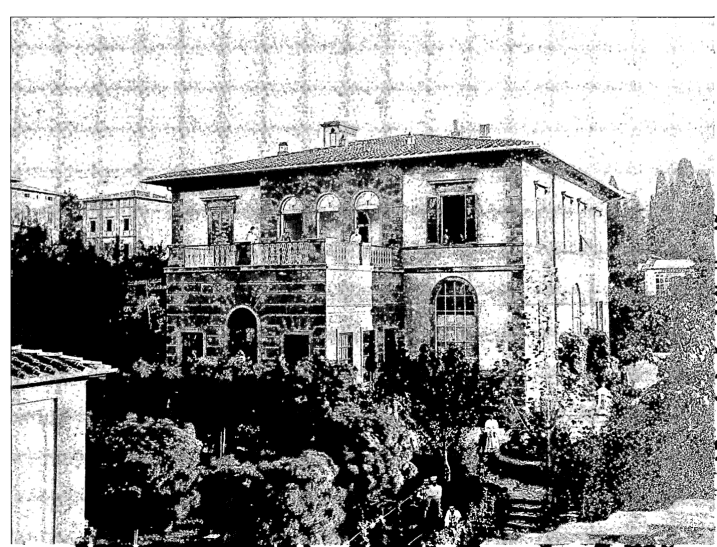

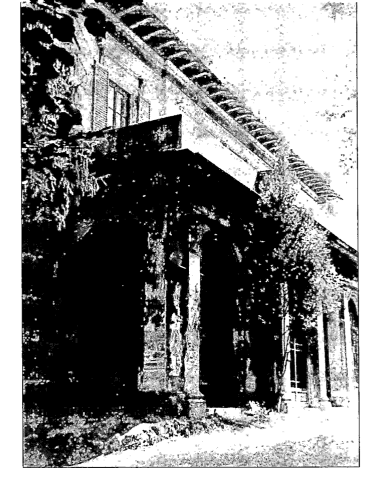

9
Villa Ball exterior, 1986

10
Villa Ball exterior, 1986

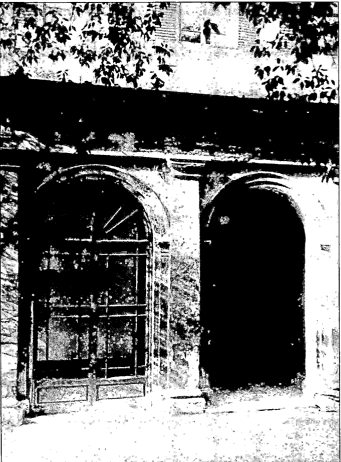

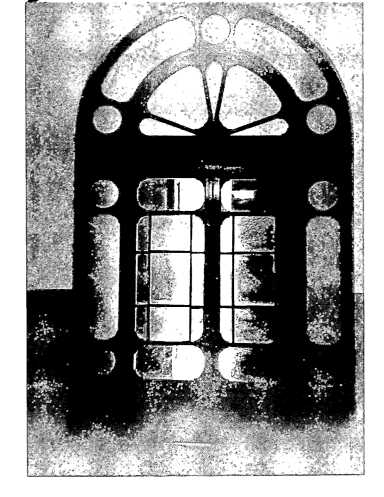

11
Villa Ball interior, front door

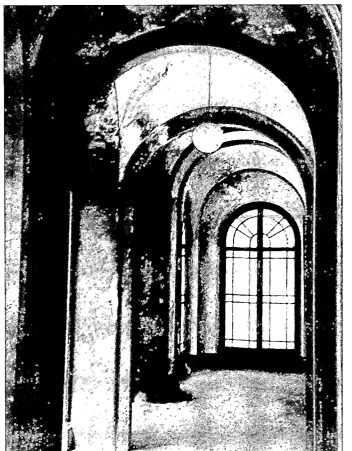

12
Villa Ball interior, front arcade

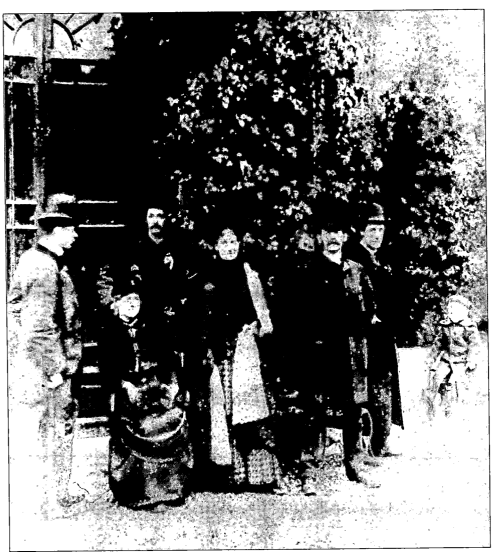

13
Friends at Villa Ball, *c.*1888
William Couper standing on right

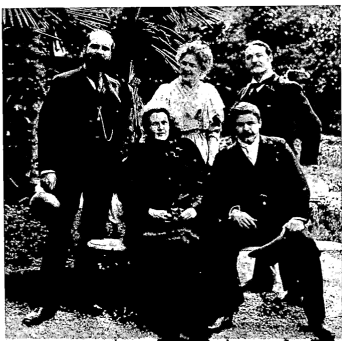

14
Friends at Villa Ball, *c.*1895
Eliza Couper in center

15 and 16
Villa Ball interior, wall motif

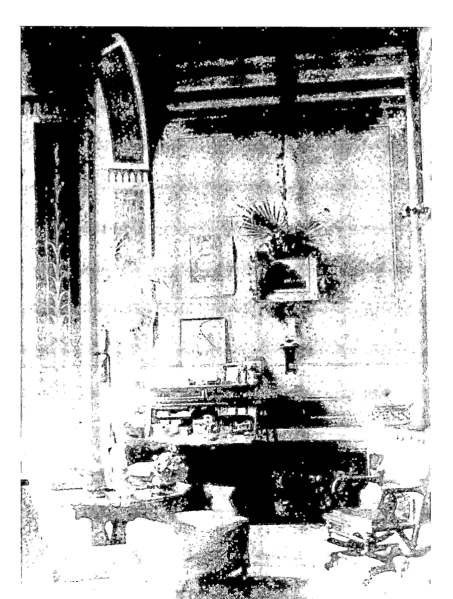

17
Villa Ball interior, front room,
c.1890

18
Villa Ball interior, arcade ceiling

19
Villa Ball interior, music room, *c.*1890

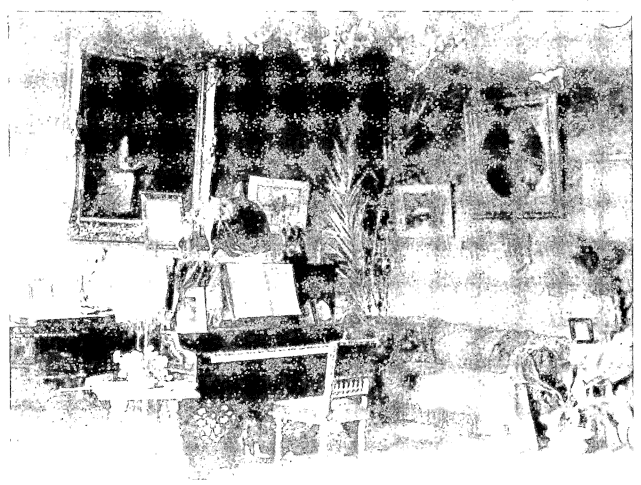

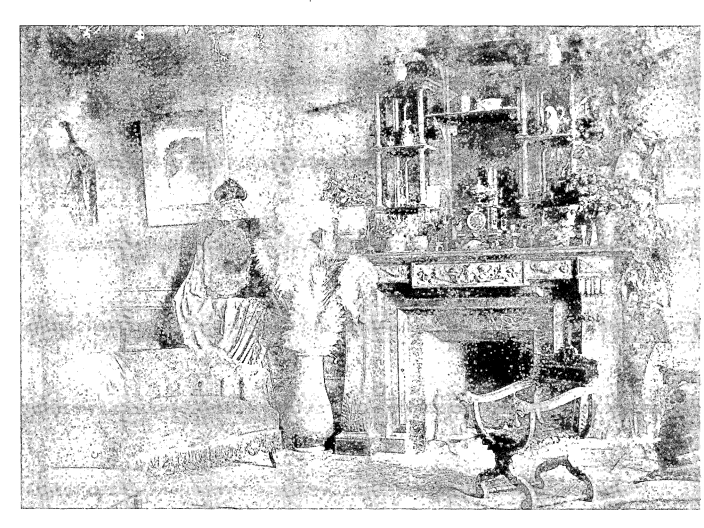

20
Villa Ball interior, living room, *c*.1890

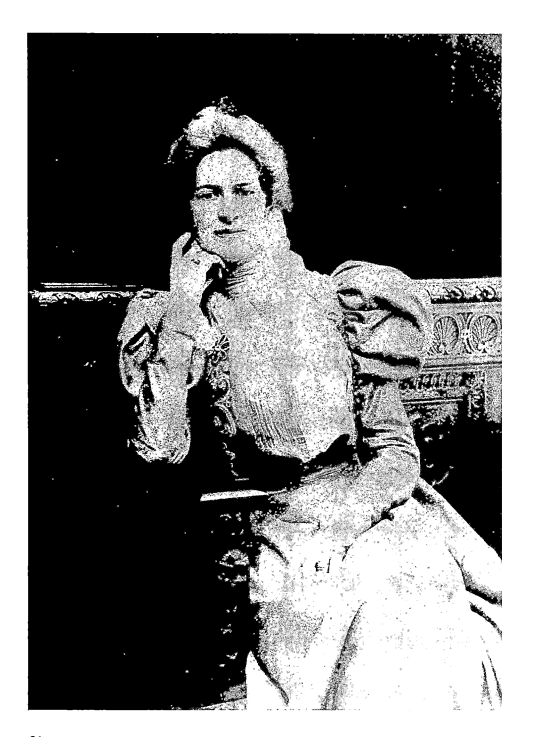

21
Eliza Chickering (Ball) Couper, 1890
Courtesy of Lisa Merryman

22 *opposite*
William Couper with sons Richard and Tom, 1890

27
Villino Powers, *c*.1890
Courtesy of R.O. Bechi

28 *opposite, top* Viareggio, *c*.1890
Adults from left: Preston Powers, Lizzie Ball Couper, Mary Powers
Ibbotson (with parasol), Ellen Powers Lemmi.
Children from left: Tom Couper, Josie Lemmi,
Charlie Lemmi, Dick Couper. Courtesy of L. Michahelles

29 *opposite, bottom* Viareggio, *c*.1890
Adults from left: Lizzie Couper, nursemaid, Mary Ibbotson, Thomas Ball,
unknown man, Alice Ibbotson, Jessie and Minnie Roberts (seated), Preston
Powers, Eddie Roberts. (Buried man is Campbell). Courtesy of L. Michahelles

Florence, **VILLINO POWERS**, February 17th 1876.

Prompter, M.r **Daniel C. French.**

Programme.

MY SON'S A DAUGHTER

A Comedy in two acts by J. PARSELLE, Esq.re

CHARACTERS.

HECTOR BLOWHARD (Trumpeter) M.r **J. E. Austin.**
SERGEANT O'BLARNEY. M.r **W. Couper.**
MOULDYWORT (A village Fiddler) M.r **E. E. Powers.**
TIMMINS (a waiter) Master **Frank Rose.**
BRIDGET GOOSEQUILL (a widow) Miss **E. E. Powers.**
FAN (an orphan). Miss **C. C. Rose.**
POLLY SWEETBREAD (a bride) Miss **E. C. Ball.**

Interlude by M.r **W. Couper.**

A KISS IN THE DARK

A farce in one act by J. B. BUCKSTONE, Esq.re

CHARACTERS.

M.r SELIM PETTIBONE.. M.r **L. Powers.**
M.r FRANK FATHOM.. M.r **E. E. Powers.**
M.rs PETTIBONE. Miss **C. C. Rose.**
MARY Miss **E. C. Ball.**
UNKNOWN LADY. M.rs **P. Powers.**

Printed by G. BARBÈRA

Florence, VILLINO POWERS, January, 25th 1877.

————∘⦚∘——

Prompter, M.r John Altrocchi.

Programme.

DEAREST MAMMA

A comedietta in one act by WALTER GORDON, Esq.re

CHARACTERS.

HARRY CLINTON.. ..	D.r J. G. Van Marter.
NETTLE CROKER ..	M.r Edward E. Powers.
BROWSER.. ..	M.r Longworth Powers.
JONES. ..	M.r Randle Lemmi.
M.rs BREEZELY FUSSELL. ..	Miss Annie Barnette.
EDITH CLINTON ..	Miss E. C. Ball.
M.rs HONEYWOOD. ..	Miss C. C. Rose.

AN UGLY CUSTOMER

A farce in one act by THOMAS J. WILLIAMS, Esq.re

CHARACTERS.

M.r SIMON COOBIDDY (a retired Grocer).	M.r Thomas Ball.
Captain CORIOLANUS SNAPDRAGON..	M.r George Lemmi.
ALBERT WESTON. ..	M.r William Couper.
SOPHIA (Coobiddy's daughter)	Miss E. C. Ball.
MARY (a servant Maid). ..	Miss Kate Adams.

THE BOOTS AT THE SWAN

An original farce in one act by CHARLES SELBY, Comedian.

CHARACTERS.

M.r HENRY HIGGINS	A gentleman with an unfortunate name, and fervent attachment to Emily Trevor.	M.r George Lemmi.
M.r FRANK FRISKLY	A cavalry Captain, with a genius for invention, a propensity for progression and an attachment for everything but his regiment.	M.r E. E. Powers.
PETER PIPPIN	A promising young Gentleman in livery, with an enquiring mind and an unfortunate attachment.	M.r W. Couper.
JACOB EARWIG..	"The Boots at the Swan," a free and easy youth, with a talent for Pantomime, a refined taste and a strong attachment for refreshment.	M.r Longworth Powers.
Miss CECILIA MOONSHINE	A romantic lady, a victim to sentiment and light reading, with a fond attachment to extraordinary novelties.	Miss Beatrice Ley.
EMILY TREVOR..	A young lady, with a fortune in prospective and a confessed attachment to M.r Henry Higgins.	Miss E. C. Ball.
SALLY SMITH..	A genteel Housemaid, with a good character from her last place, and a slight attachment to a fancy Baker.	Miss C. C. Rose.
BETTY JENKINS.	A plain cook without any attachment.	Miss Kate Adams.

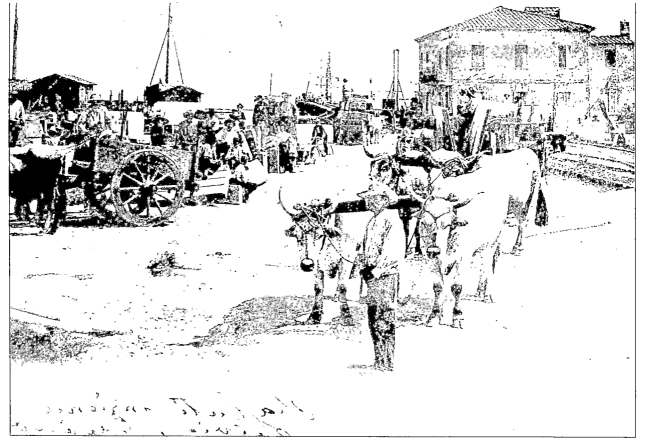

32 *above*
Oxen hauling marble, *c.*1880
Courtesy of Studio Fotografico Fabbroni,
Forte Dei Marmi, Italia

33 *below*
Marble port at Forte Dei Marmi, *c.*1880
Courtesy of Studio Fotografico Fabbroni,
Forte Dei Marmi, Italia

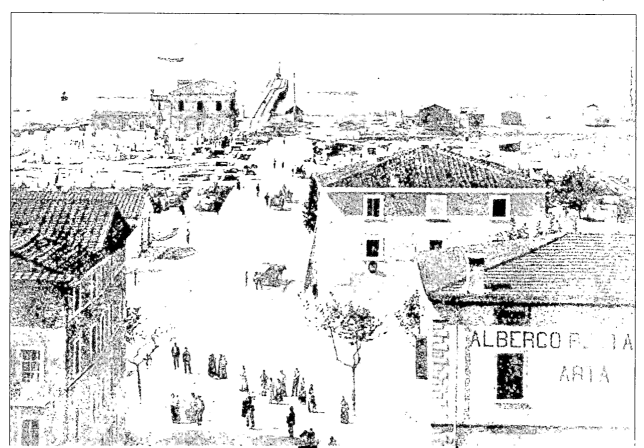

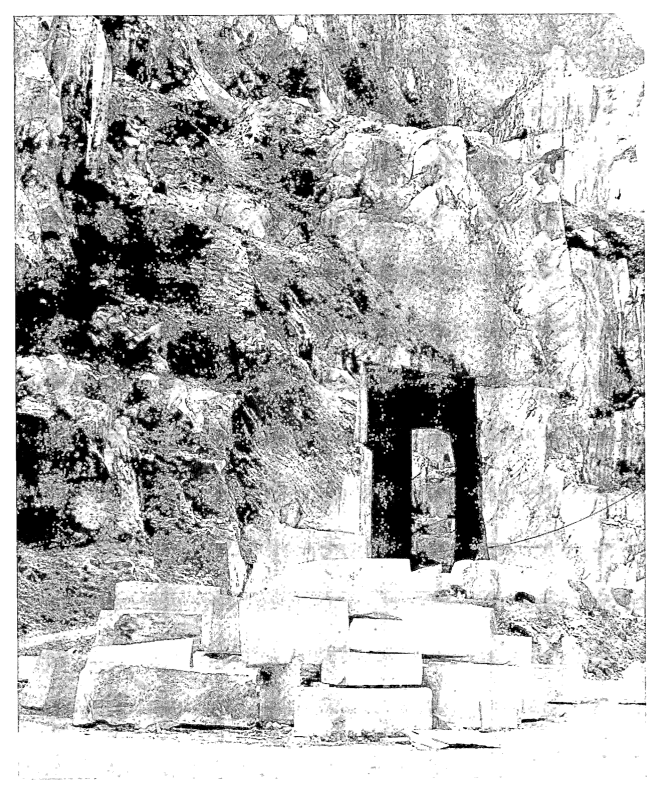

34 Marble mine, Carrara, Italy

35
Enlarging triangle with calipers

36 *below*
Simple pointing machine

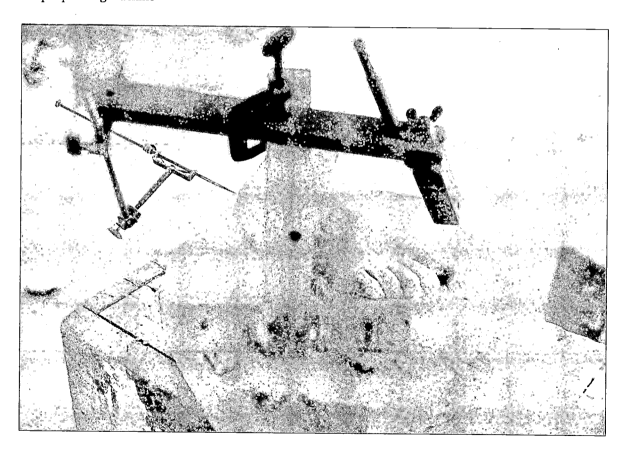

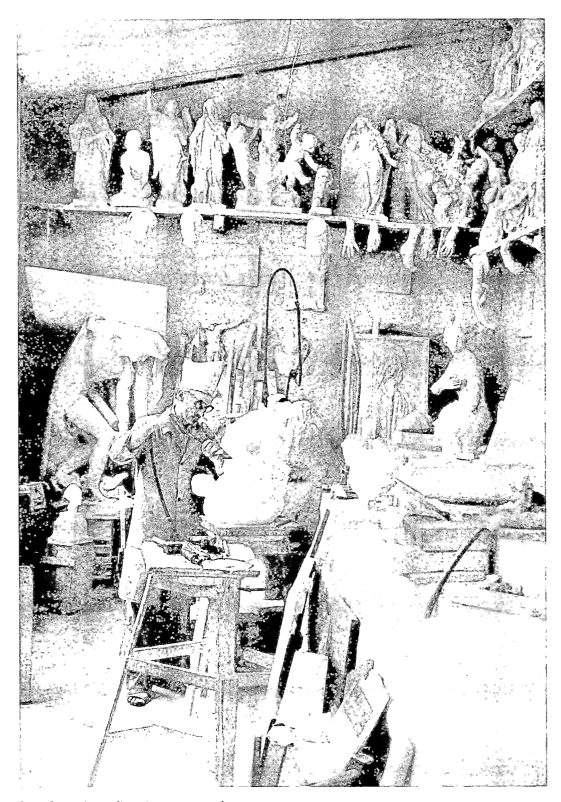

37 Carver's studio, Pietrasanta, Italy

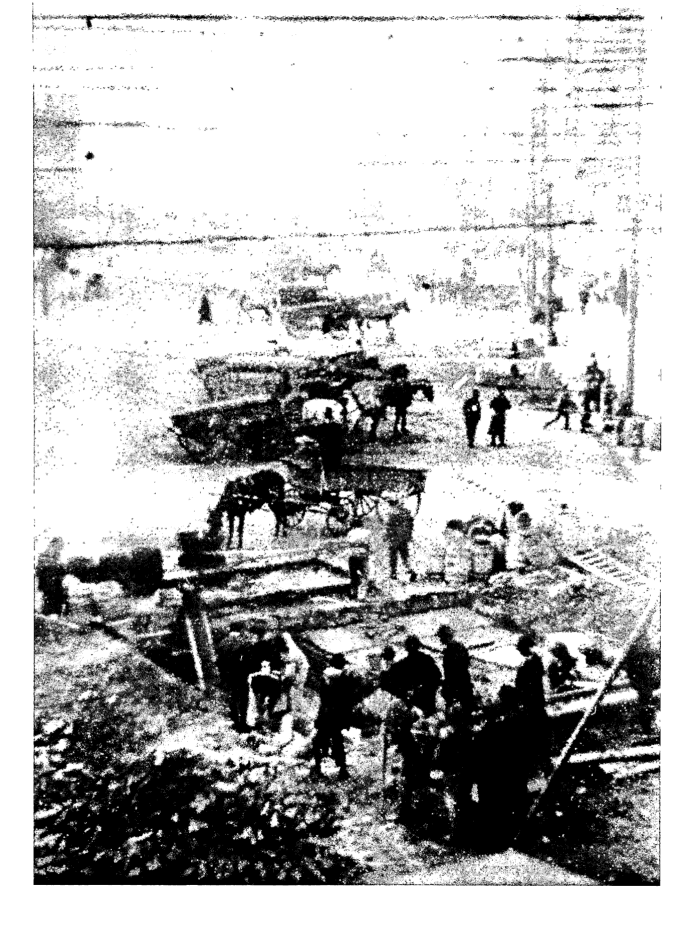

38 *opposite* and 39
Installation of the Confederate Monument
Courtesy of John Lee Couper

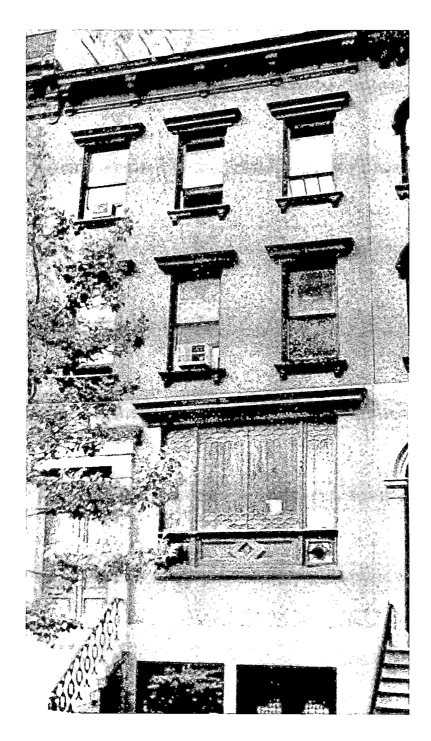

40
Studio on East 17th Street,
New York City

41
Poggioridente, Montclair, New Jersey

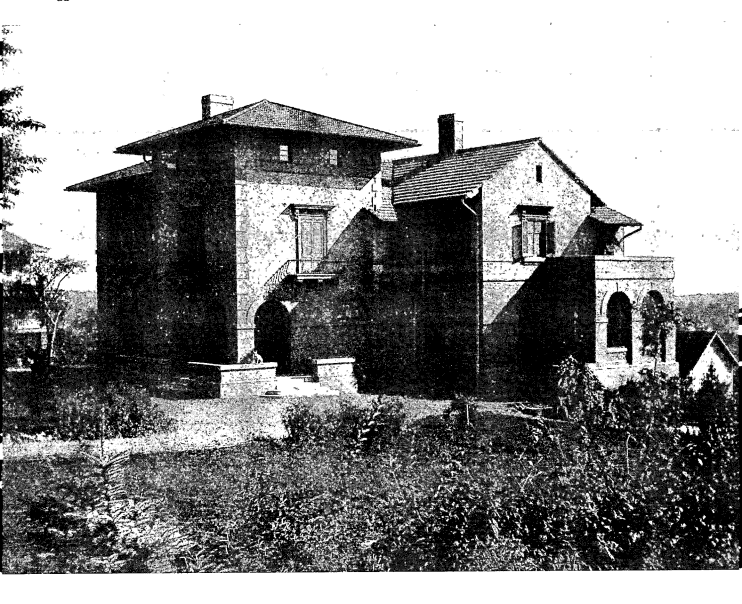

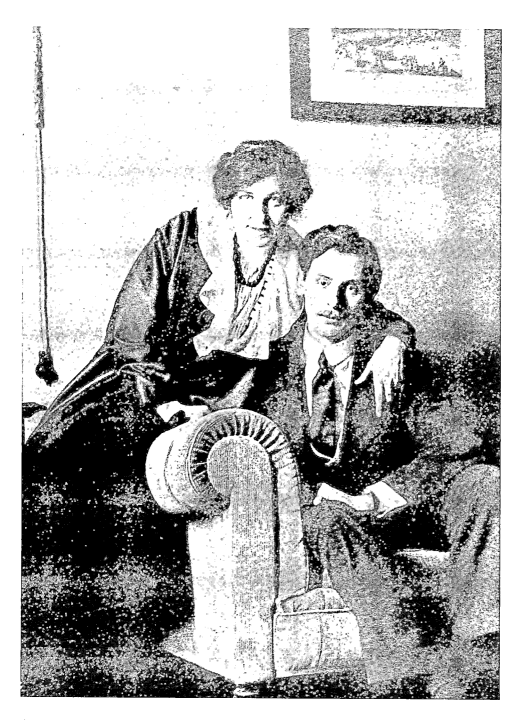

42
Mildred and Richard Couper, 1910

43 *opposite*
On the steps at Poggioridente
From left: Eliza, Mildred, William

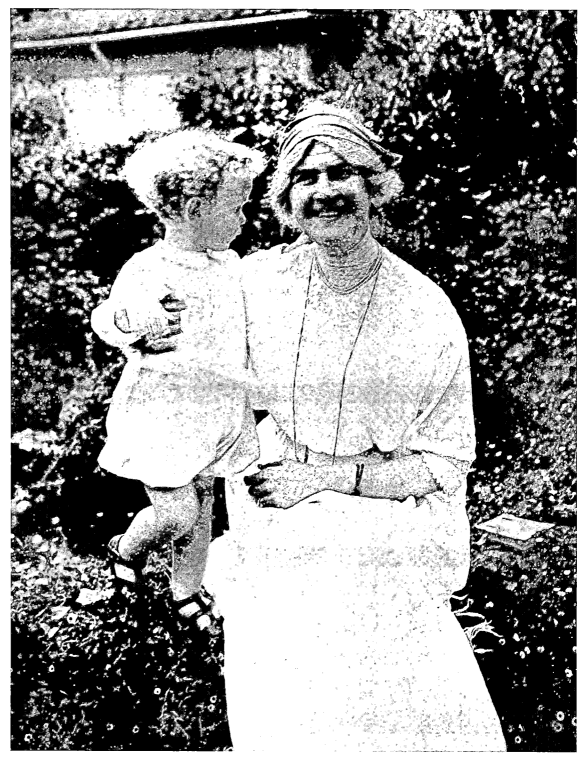

44
Eliza Couper with grandson Clive

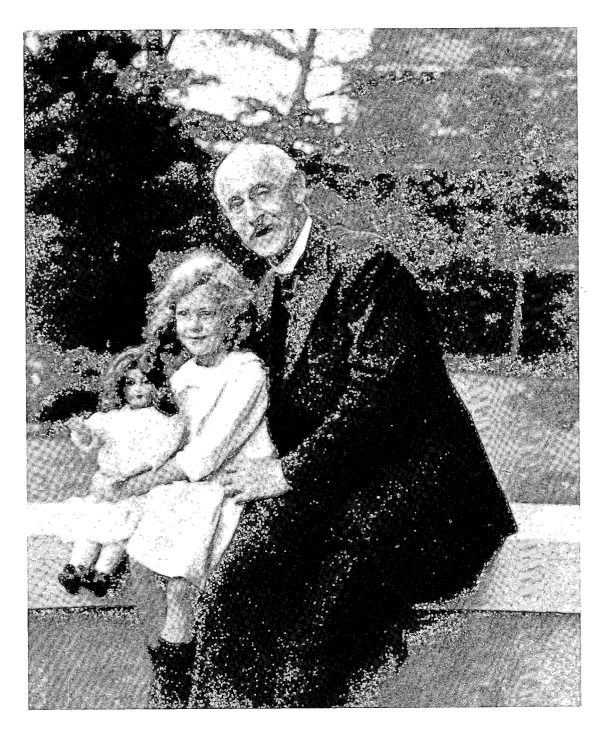

45
William Couper with granddaughter Rosalind

America in the last century or since the U.S. *were...* Six lectures free, attended by more of the young ladies & gentlemen of this community, and quite interesting and instructive.[10]

These lectures presented the grounds and motives of the American Revolution and ended with "The Perils, Duties, and Hopes of the Opening Century."

The Florentine "season" for visiting artists and studio exhibitions went from November to May. An article in the *Boston Transcript* described the events:

As usual, this winter Florence is the rendezvous of many American and English artists, who come here to work, as studios are plenty, not expensive, and living can be made very cheap as well as good. The models here are plenty.... A few hours' ride into the campagna brings the artist to picturesque towns and picturesque people, subjects rich in originality and out of the commonplace.[11]

The King of Italy kept a villa near Florence which was visited by tourists, and Couper wrote of this:

Sunday before last I went in company with a young Italian friend to visit the palace of the king which is a short way out of the city.... This most beautiful palace is furnished in the daintiest manner and its walls hang with pictures of the Medici family which are of enormous value because of their quality—Connected to this building is a private theatre which is a little gem.... As for comfort of the house it would seem nothing is wanting. The park that surrounds this gorgeous palace is none the less beautiful—fountains busy playing—large groves with winding pathes—statuary in fact everything that would tend to make a park beautiful.[12]

In addition to attending social events and going to colorful Italian circuses, the Americans often went on shopping tours for friends and relatives at home. Mrs. Ball was often asked to send "Italian sashes" for the children,

and she and Daniel French went in pursuit of chairs for his mother. These were to be for a front entry room of limited dimension. French wrote:

> We found some splendid structures about as big externally as our house and internally like the Irishman's turkey (exception to the rule, Fannie & Wheeler) carved in a most elaborate manner, and arranged so as to combine a woodbox or chest and a chair. These entirely took the wind out of the sails of some mere modest ones... I will contine the search as opportunity offers.[13]

In 1876 the sale of sculpture was at a lull. French wrote of this in a letter to his sister, described a visit to the studio of Joel Hart, and gave his comments about coming home.

> I am sorry to hear that the *stone business* is not better, but everybody, here as well as home, seems to say the same thing—"business dull." My business looks much brighter... I am sure that Concord will pay me handsomely for my statue when the time comes.... The bust progresses gradually and I hope will be finished next week.... I view my statue of Endymion occasionally and think how I will pitch him when I finish the bust.
> ...I called at Mr. Hart's studio the other day, and though I did not see him, I saw his statue of "The Triumph of Chastity"... Mr. Hart has worked on the figure a dozen years or so, and has lately had it cast. He has been quite seriously ill lately, but is much better and will get well in time they say.
> ...My thoughts turn homeward more than ever now, as the season that I have set for my departure draws near.... Mr. Ball thinks strongly of going to America next summer... and if so I should like to go with him—and the rest of his lovely family.[14]

Joel Tanner Hart passed away when his figure was only half put into marble. His friends arranged for its completion and sale, with the proceeds used to carry out his last request, that of publishing a book of his poetry with his biography. Hart's statue, a standing figure holding Cupid's last arrow out of reach, illustrated that the virtue of a woman can resist the temptation of love. On the base were broken arrows to show that this was the only one

remaining from the quiver. Three statues were made: one for a Florence gallery, one for America, and one for a site in England. The marble statue erected in Lexington, Kentucky, was destroyed by fire in 1897.

John McKowen, Couper's former fellow student, was now practicing medicine in Rome, the physican to many Americans living in that city. In September 1876, he came to Florence for a visit. He took a special interest in Couper, with whom he shared a Southern heritage. This visit was pivotal to Couper's professional and personal life, because it came at a time when his circumstances were about to change in a profound manner that would affect his career prospects and future. Couper had hoped to study with either Signor Rossi or Thomas Ball, but Ball was currently on vacation in America, and Rossi was not ready to begin instruction. McKowen was surprised to learn that Couper, perhaps discouraged, was planning to return to America, and emphatically convinced him to stay longer. He arranged to buy a copy of Couper's relief *Evening* (fig. 58), giving the young sculptor a needed financial assist and allowing him to postpone the departure for home.

One day after his return, Thomas Ball stopped to pay Couper a visit. He was impressed with his progress and models, especially the medallion called *Evening*, and invited him to share his studio and occupy a room recently vacated by Ball's former pupil, Daniel Chester French. Couper accepted, and in December 1876, he found himself in the midst of many social, dramatic, and musical events that were popular entertainment among the Americans living in Florence.

After Daniel French returned to Concord, Massachusetts, he wrote often to Mrs. Ball, asking for news of Florence, and sustaining a strong friendship that had developed while French studied with Thomas Ball. He felt like a permanent member of the family and sometimes closed his letters with, "Affectionately your eldest!" He continued to be curious about Couper, and wrote,

> Your last letter made *me quite* jealous. I am afraid there will be no place for me if I come back.... You brag of your weather; a Florentine might live twenty years without seeing such bright, warm invigorating days as we have had... just the weather that I longed for when I was in the city that I think of & long for now.... I wonder why I like to write to you more than to anyone else in the world, now that I am home.[15]

Soon his fears were realized, as he described in a note to his sister.

> Well! What do you think has happened now? "I never loved a tree
> or flower"—O'dear, O'dear! News has come from Florence that
> "Lizzie the fair, Lizzie the lovable, Lizzie lily maid of Florence" has
> been & gone & got engaged to the perfidious Couper & such is the
> end of volume first of my Florentine romance. I suppose its all right,
> but how unkind of him.[16]

Two years after Couper had arrived in Florence he asked for permission
to marry Thomas Ball's daughter Eliza. Ball immediately wrote a joking note
to French.

> To think of that Couper: to say nothing of our Kitty. You'll know
> one of these days what it is to have the wool pulled over your eyes.
> Well, my dear boy, knowing now 'how the cat has jumpt', your
> welcome will be warmer than ever when you return to us. You shall
> have your old room again, if I have to turn him out—into a better
> one, or you and he shall odd and even for a better which I will
> manage to prepare.[17]

The future father-in-law later reflected:

> As I could not possibly find any fault with him, and as my
> daughter's happiness was the leading thought of my life, I surren-
> dered gracefully,—and if I had known him then as well as I do now,
> it would have been gratefully,—for he is not only a kind and affec-
> tionate husband, son, brother, and father, but is one of the most
> talented and refined sculptors that I know. And he has his match in
> his wife, who possesses all his domestic qualities and is an exquisite
> musician.[18]

During the summer months it was customary for Americans to leave
Florence on trips. There were few visitors at this time, and commissions were
usually received during the winter. Sculpture was covered to protect it from
the intense heat, and remained covered until the colder weather returned.

In July 1877, the Ball family took a trip to Venice and Couper went along. They stayed in a hotel right off San Marco square, next to a villa where Princess Margaret was visiting with her young son. Couper wrote that Venice was built upon seventy-two islands and that he and Eliza took gondola rides on the canals that were fed by clear sea water. The canals reminded him of the inland waterways in his hometown of Norfolk. In the mornings they would take the gondola to the Lido, a ride of fifteen minutes, and swim in the Adriatic sea, then have lunch in the salon before returning to Venice for dinner. One day they visited a church and saw the painting *Titan's Ascension*. He stated that it was the finest painting he had ever seen, the color magnificent, and that it could make an artist feel "down in the mouth" for three years, by comparison. Then they went to the church which contained the tomb of the sculptor Canova, "our great artist *uncle*."[19]

Many concerts were held in the evening at the Piazza. Once there was a special festival to honor Princess Margaret. A large craft with glass lanterns was decorated to represent a bower of plants and flowers. The lamps were connected by colored gauze, and musicians sang and played instruments on the float. The entire canal was full of gondolas illuminated by glass Bengal lamps. The lights reflected in every direction, giving the surrealistic effect of a large mass of live matter on the water. In the sky above a large fireworks show added to the glow and the dreamy atmosphere of the evening.

William and Eliza visited all the major sights in the city including the Murano glass works, and sent many photographs and stereoscopic slides home to Norfolk. There were no horses in Venice, and the fire engines were small boats run by steam, with the machinery for throwing water connected to them. Two columns at the north end of the Grand Canal, where it entered the city, were decorated with the symbols of Venice: a Lion with Wings and an Alligator being Killed by a Man.

After the trip to Venice the family took a months holiday in Viareggio (figs. 28, 29), on the Mediterranean coast, where Thomas Ball was building a seaside vacation home in the pine groves. There Couper worked on portrait reliefs of Ball (fig. 48) and the American Consul to Italy, Col. J. Crosby. The family took daily sea baths. Couper wrote an amusing description of the bathing attire:

I think I never saw women and men so reckless anywhere as in this place. Though they represent Italy, Germany, France, and England, numbers of Americans can be seen also. Some Italian women go in the water with a long white shirt on like a night gown, and I have seen them even with low necks; others with thin cotton pants and shirts, many with woolen clothes, etc. Though if one with extreme modesty were to walk down the beach they would be considerably shocked. The men most all wear little drawers with the legs a whole four inches long from the seat, and no other covering. This though in either case is not objectionable to an artist for he always enjoys human form, let it be seen as it may.[20]

On return from Viareggio, Couper had his bust of Navy Engineer Brooks cast in plaster. He then assisted Thomas Ball with the colossal figure of Quincy, for Boston, an experience he was very grateful to have. "This you know is splendid practice for me because it is a branch of my profession that is immensely valuable, and one can only get a practical idea of doing such a work in a great sculptor's studio, for it is only they that have such heavy work to do. O, father, you can little imagine how fortunate I am, some great Providence led me here."[21]

The preparation for the wedding was full of complications caused by Italian customs. Couper stated the actual day of the wedding would not only be a relief to him, but also to Ball. Ball had to go to town more than a dozen times, and Couper appeared with up to twenty witnesses for different purposes. They finished the procedure with a pile of papers "sufficient to compose a book," which were cosigned by Preston Powers and Molton Forrest. Lizzie wrote that she would be twenty-one years old two weeks after the wedding "even according to Italian laws."

After their marriage William and Eliza Couper left for a honeymoon in Paris and Switzerland. They wrote of seeing the Statue of Liberty under construction in Paris:

My own dear Father & Mother,

You see I am now in Paris, the leading city of the world, & well it may be called so, for every turn of the streets shows attention to refinement and the root of all is unmistakeably Art...Today we were at the salon where there is a yearly exhibition of pictures & sculp-

ture. The building is one of the grandest I ever saw. Why the place that is devoted to sculpture alone resembles the arcade at the grand depot in N. York, and every bit as large. All overhead is glass throwing such soft lights down that plaster looks quite as well as marble. The pictures are equally as well placed. Now to show you what these people do for art—Whenever a statue is originated, or made worthy of note, the city gives the artist an order for the work and places it in the museum. Besides this, you see to encourage them to work on, they have this magnificent building in which they can exhibit their works to the best advantages.... It is solely because the French people are lovers of art that makes them what they are, and makes their home a Paradise.... The art galleries at the exhibition contain the finest collection of modern art.... The head of that large bronze figure that will be presented to America by France is exhibited on the grounds. I tell you it will be a tremendous thing when finished.[22]

About Switzerland:

The following morning we left for Berne which is noted for its den of bears.... The other object of interest connected with the place is a large clock that seems to create quite an attraction when it strikes.... There are figures in motion such as a personage resembling a king, or lord, with a wand in his hand who makes a motion just before each stroke of the bell, a rooster also crows.... From Berne we went to Interlaken.... The great attraction here are the lofty mountains on each side and two beautiful lakes hemming the little village in, in a most picturesque manner. Its free access to the pass that leads up among the ever snow-clad mountains makes it attractive to those who are of a *high turn of mind*.... Lizzie enjoyed her Interlaken trip very much as most all of the people there were fond of music, particularly three young ladies (American) who have [been] cultivating that talent in Stuttgart, Germany. One of them was the daughter of Mr. Hamlin of Boston, who is a noted organ manufacturer.... Afterwards we went to Geneva where... there are many sights... such as museums, statues, etc. Here, for the first time since I left home I got a glass of *regular American Cream Soda* water.... On yesterday morning... we found the gates at Villa Ball open to receive us. To wind up I must say I am certainly one of the most fortunate of fellows.[23]

In the fall of 1879 William and Eliza Couper traveled to Norfolk, Virginia, to visit the Couper relatives. At the end of the trip they were met by Thomas and Ellen Ball in Boston, who proclaimed that they had missed them and so came over to "fetch them back." Before departing they attended a large reception at the home of the Honorable Moses Kimball, who had recently presented Ball's work, *Lincoln Emancipation Group*, to the city of Boston.

Many Americans traveling in Europe visited the art studios of Florence, Italy. In fact, the sculpture studios were listed in the guidebooks, along with churches, galleries, and Italian monuments. This provided a steady flow of visitors through which the expatriate sculptors could maintain a strong link to their countrymen. The working areas were arranged to include exhibition sections to display finished pieces. The walls or background drapery for showing marble were usually a dark maroon or cinnamon, to reflect a flesh-like blush to the stone's surface. A flickering gaslight, soft and diffuse to avoid harsh shadows, seemed to animate the works.[24]

A Norfolk newspaper reported on the life enjoyed at Villa Ball:

> In the American colony at Florence, Italy, there is a house of all others noted for its social distinction and for generous lavish hospitality.... Americans who have visited that lovely and fascinating city and who have been favored with an introduction, will never forget the associations that cluster there.[25]

Another correspondent wrote about his tour of Florence:

> We have been most kindly and hospitably entertained by our former townsman, Mr. William Couper.... We found him at Villa Ball and surrounded by marbles and models.... We were most politely received by Mr. Ball and were shown through his studio, which contains some of his most recent as well as reproductions of his older works.
>
> Mr. Couper has just completed a life-size bust of his accomplished wife, and several other busts executed by order of several prominent Americans, among them Chief Engineer King, of the USN. A medallion—Evening—is a charming work, and a pretty bust called "Forget-Me-Not" is a work of great merit. Mr. Couper is very

enthusiastic in his profession, and a hard student, and is considered a rising man, and with the unusual talent he has developed and the excellent opportunities presented him, he will carve a name for himself high on the arch of fame.

We have been through the studios of most of the American sculptors and painters resident in Florence, among them that of the late Hiram Powers. Here we saw his famous statue of the "Greek Slave," his first great work, and also his last work—and by some considered his best, is—"Eve Before the Fall." Mr. Hiram Powers has left a large number of statues and busts, which are held as a rich legacy by his two sons, who have succeeded their illustrious sire, not only inheriting these very valuable works of art, but also the genius which inspired the father. They are both practical sculptors and full of orders. Mr. Preston Powers we found in his studio engaged in modelling the bust of Sweedenborg, ordered by the Sweedenborgian Society of Boston. He has just finished a fine bust of the late Professor Agassiz, ordered by his family.

In Mr. Longworth Powers' studio we found a large number of busts, finished and in progress of modeling, most of whom we recognized as Americans of fame, among them Longfellow, Charles Sumner, and others. Both these gentlemen are very cordial, gave us a most kindly greeting, and courteously entertained us during the short stay we made.

We then visited the studio of Mr. J.A. Jackson, the oldest working artist now in Florence. He has been working for the past year on a group —Eve and Abel—and it promises to be a very fine production. We called in at the studio of J.R. Brevoorst, painter. His walls are hung with fine paintings of Italian lakes and forest scenery, which are his specialties. His most recent picture is sunset on the bay of Naples.... S.A.S.[26]

The American colony in Florence attracted many leading painters of the period, including Frank Duveneck and Julius Rolshoven, Couper's associates from the Academy of Fine Arts in Munich. In 1884 a newspaper article described their arrival:

Frank Duveneck has returned to Florence, and, with his assistant Julius Rolshoven of Detroit, has reopened his school. They have taken the Gould villa on the Viale Imperiale, outside of the Porta

31

Romana, and have already a large class working from life. Mr. Duveneck gives it out as his intention to remain here for two or three years. He has taken the studio of Miss Nevins, the sculptress, who is soon to return to her home in Lancaster, Pa.[27]

While in Florence, Rolshoven restored the thirteenth-century Talani palace, sometimes called the Devil's Castle (Castello del Diavolo). This was located along the viale Dei Colli, just past the Piazza Michelangelo. He and his wife continued to make their summer home there as late as 1930.

Three sons were born to William and Eliza: Thomas Ball Couper, who became an accomplished violinist; Richard Hamilton Couper, who became a landscape painter; and William Alan Couper, who became a businessman. The Coupers enjoyed their children and took them throughout Europe on holiday travels. All three sons spoke Italian, French, and English, one nearly as well as the other, but "there are many combinations they get off now and then in either of the languages that are very funny."[28]

The art influence in Florence touched every family that lived there. The Reverend Pierce Connelly was minister of the Episcopal church for many years, and his son Pierce Francis Connelly became a sculptor, known for portrait busts and a few large study models. The artists often made portraits of each other and their families. Couper wrote:

> We are particularly in luck regarding the generosity of my painter friends. Mr. Frank Duveneck, a painter of great distinction, is now making a life size portrait of our little Willie. He is sitting in a rich chair with a cushion of plush behind him, delicate green background, and is dressed in a pretty little baby frock made of raw silk. Now we have portraits in color of each of our boys, and all of them *works of art.*... Dick's portrait (by Rolshoven) is a perfect dream. He is standing in the garden with the sunlight dancing among the flowers and he looks like an angel boy, with a lily in his hand, listening to a sound that comes from above.[29] (figs. 24-26)

Business was slow during the spring and summer of 1884. There was an outbreak of cholera in Italy, and although this was confined to the poorer sections of the cities, many foreign visitors avoided travel in the country.

During this time Gov. and Mrs. Leland Stanford, in California, learned of Couper through their mutual friend Edward F. Searles, who owned neighboring property in San Francisco. The Stanfords planned to build a country home on their estate in Palo Alto, but after the death of their son they decided to erect a mausoleum on the site. A portrait bust of Leland Stanford, Jr. and a marble hand were commissioned to be a part of this memorial in 1888. Two feminine sphinxes by another artist were installed at the entrance to the tomb, but the family decided they would prefer more traditional Egyptian sphinxes, and in 1891 Couper was commissioned to complete these (fig. 65). The other sphinxes were moved to the back. Mrs. Stanford was interested in purchasing other statues for the university, one of which was to be of Prof. Heinrich Schliemann, the German archeologist who uncovered Mycenae, Greece. Mrs. Stanford, Couper, and Mrs. Schliemann, of Athens, were in correspondence regarding photographs of the professor and the design of the statue. This was to be a seated figure of heroic size, installed on one side of a large stairway 312 feet in width. Couper wrote regarding this work, and the route used to ship sculpture to California:

> Sept. 9th 1891
> My dear Mrs. Stanford,
>
> ...It would give me a great deal of pleasure to make the portrait statue in marble of Prof. Schliemann for you,... which would be an eight foot statue, were it standing.
> ...The sphinxes are both ready to be packed, and will start off in a few days for Leghorn where they will be shipped to New York, and from thence on land to San Francisco where they will be cleared from the custom house and then sent on to Palo Alto. This is the manner in which I have sent all of my shipments to California, excepting one case, which I have not heard from that went by sea....
>
> Yours very truly,
> William Couper [30]

Discussions continued between Couper and the Stanfords regarding a full-size group sculpture of the family which would be constructed for the mausoleum. The design presented Gov. and Mrs. Stanford seated in two

handsome chairs with their son standing in an attitude as if he had just stepped from between them. The molds and models of the son's portrait bust had been preserved in Florence for this new task. The group would take three years to complete, but with the Stanfords anxious to get on with the construction of the university campus it appears the only work to come out of this was a portrait bust of Governor Stanford (fig. 67).

In October 1885 Couper went to Paris and London to exhibit his works. He took along *Psyche, Before the Scenes, Evangeline, Vision, Coming Spring* model, and *Princess*. Copies were sold, and he arranged to have an art dealer in London (probably Bellman & Ivey) keep two medallions and a bust for display. The works were presented in England at the art gallery of the *London Graphic Magazine,* through the help of the editor, Mr. Thomas. They were also on exhibit at the Royal Academy of Art. While in England William and Eliza Couper attended a reception for English war correspondents, on the event of their return from Egypt. Included in the group was Sir Henry Morton Stanley, the African explorer. "He is certainly a most fascinating man, though he carries a front of steel; determination is marked not only in his words but every look and action." [31]

Couper sailed with his family from Liverpool to America on March 16, 1886, to attend the unveiling of his statue *Coming of Spring* at Tiffany and Company, New York. They took the steamship *City of Richmond* of the Inman Line. Eliza was five months pregnant so they decided to stay the summer in Norfolk until the baby was strong enough to travel back to Europe.

In 1892 Couper was appointed to the advisory committee for the Columbian Exposition at Chicago, to select representative works of American artists resident in Europe. He held this position for many later exhibitions. These national events introduced the most interesting artists of the time to the American public. They fostered a collaboration among architects, painters, sculptors, and landscape gardeners. "Between 1876 and 1893 were packed most of the essential lessons our sculpture has learned, either at home or abroad. No subsequent exposition has disclosed so great an advance as that noted in 1893." [32]

As a direct result of the World's Fair of 1893, the American Academy in Rome was founded to promote promising citizens in the fields of art, music, and literature. The artists who had worked together on the exposition, in-

cluding Augustus Saint-Gaudens, Charles McKim, William Mead, and Christopher La Farge, vowed that young Americans should have the same experiences of working together in Rome for a three-year period—thus the academy motto, "Not merely fellowships, but fellowship." [33] Couper's son Richard would later attend this academy in pursuit of a career in landscape painting. Daniel Chester French was on the board of trustees. This opportunity for a Grand Tour of study abroad had two important aspects: The student was immersed in continental European culture and was exposed to the styles of the international contemporary leaders of the time.

Couper shipped many of his statues to the United States; they were sold on exclusive rights through Tiffany & Company, New York. He sent his earnings back home to his brother John in Norfolk, to be used for real estate investment. This pattern was interrupted in 1892 and 1893, which were troubled times financially for the American colony. The villas around the Porta Romana were victims of a burglar who seemed to know exactly where valuables were being stored. Then, four local banks went out of business (the du Fresne Bank, Fenzi Bank, Wagnière Bank, and Maquay Hooker and Company). After the Fenzi Bank failure Thomas Ball took 5,000 francs (one year's income) out of another account and put the money in his villa. Two days later he was robbed. Couper saw the event and got into a scuffle with the intruder. A man was later arrested because he had scratches on his face, but was released for lack of evidence.[34]

William Couper and Thomas Ball exhibited their works together. The receptions were often attended by visiting Americans on their Grand Tours of European countries (figs. 13, 14). Florence and Rome were important cities of those tours. Art patrons would visit exhibitions, and sculptors, in turn, would offer their wares. Guidebooks were printed with locations of the artists' studios. Many traveling newspaper reporters visited the studios and sent articles back to the American public, who were extremely interested in the exploits of their expatriate artists. One correspondent wrote of his visit to the American colony:

> Outside the Porta Romana are the studios of four American sculptors. The first one reaches as one comes up from the Poggio is that of Mr. Ball, universally acknowledged as one of America's greatest sculptors. His studio is full of beautiful works, many of them copies

of those by which he made his fame. He is engaged upon a colossal figure, to be placed on the Washington Monument in the small town of Methuen, in Massachusetts. The design for this monument consists of a statue of Washington, which is finished, and is being cast at Müllers foundary at Münich, and of four allegorical figures to be placed at the four corners, and four busts of generals to be introduced into the pedestal of the statue.

The figure of Washington will probably be sent to the Columbian Exposition at Chicago. The statue upon which Mr. Ball is now at work is one of those for the four corners and represents Revolution. It is a sitting figure of a man wearing a Phrygian cap, and a loose cloak. In his right hand he holds a Roman sword, his left is placed on his heart. The upraised head has a grand expression of resolve and determination; the whole figure is full of life, animation and power. Like all Mr. Ball's work the modelling is spirited. The entire group, of which this masterly figure forms a part, is the gift of a munificent townsman of Methuen. Mr. Ball has also a figure of David to show, the most recent of his completed works. It is fine, full of action and strength, as well as beauty. A small bronze copy of "Paul Revere's Ride" is also, we believe, to go to Chicago.

...Mr. Couper's last work is a pretty little bas-relief of a young mother carrying her little child pick-a-back. The baby is the sweetest, softest mite of humanity imaginable. The sculptor calls this "A Labour of Love." Mr. Couper is not at present in Florence, having left his family and his charming home to go and study in Paris.[35]

After Couper's return there was another studio exhibition to display Ball's heroic statue *George Washington,* and Couper's *A Crown for the Victor.* Lizzie wrote home about this event:

> We had a studio exhibition on the 17th of November to exhibit father's colossal statue and this figure of Will's. Over two hundred people came.... The studio did look so beautiful. I worked hard all the day before to arrange it—and as it was fortunately just in the height of the crisanthemum [sic] season, we had about a hundred large pots of them in groups about the studio, and the effect of color was very beautiful. In father's studios with their dark red walls I put deep richly tinted crisanthemums with several large palms nine or ten feet high. The effect of color was gorgeous—In Will's modelling room which is all white I put some white and delicately tinted

crisanthemums against a large curtain of pale silvery green plush and it did look lovely.[36]

There were occasional earthquakes in Italy, and on May 18, 1895, a particularly bad one made the Villa Ball temporarily uninhabitable. During the repair work the family stayed next door with Mr. Reynolds, a lawyer from New York, whose family lived in half of the Villa Powers estate.

In 1896 Couper's father John came to Italy for a visit. He wrote about the trip from Norfolk to Florence:

> Our stay at Gibraltar was short,—not more than a couple of hours.... It would be a great pleasure could I as vividly picture to your mental vision Gibraltar as it appeared to me,—its beautiful harbour and surroundings, the novel construction of its town and very narrow streets, the varied costumes and appearance of its singularly mixed population,—markets near the landing.... About 7 o'clock p.m. our good ship was on the way to Naples where she arrived Thursday, May 7th, 2:30 p.m. More than half the passengers stopped there among them all of my table-companions and room-mate. I went with them upon the steam-tender to the landing; thence through the city to "Parker's Hotel" situated upon a high slope overlooking in every direction city, bay and other objects of interest including Vesuvius.... Took tea with my newly made friends and about nine o'clock was accompanied by them to the steam-launch where we parted.
>
> ...Very early Saturday morning, May 9th, our fine Craft, having reached her destination, was resting quietly at her Genoa wharf. 'Will' was there and finding his way to my stateroom lost no time in making his presence felt. Am sorry the ham and potatoes did not pass; the officials say the laws prohibit their coming.... Will & I had a ride through parts of the city,... also a visit to one of the most attractive cemeteries I ever saw. At about 1 o'clock p.m. we left Genoa for Florence.... Lizzie, Dick & little Willie were at the station to meet us; Tom has not been home since last October. Our reception was unrestrained, hearty, affectionate. Even our neighbor Reynolds three little sons were on the lookout and finding we were in the carriage ran ahead of it shouting Grandpa's come! Grandpa's come![37]

During his stay John Couper went with William to visit one of the marble quarries in Carrara owned by Mr. and Mrs. Torrey. The most immediate mountain range was ascended halfway up by a train system of semicircular routes, the uppermost one entering a long tunnel which ran through the mine to an immense opening. At this point there were a store, huts for the quarrymen, and blocks of marble piled up for deportation. Farther up the hillside many men were cutting the marble, some of the men so distant they could be seen only through binoculars. John Couper purchased five finished marble pieces and two large vases to be sent to Norfolk, via the Old Dominion S.S. Company of New York. These were packed into cases and put aboard the *Italia* at Leghorn, a ship of the Anchor Line. At this time Carrara had a population of 27,000, almost all of whom were employed in the marble business. (For more details on the Carrara quarries see Chapter 6.)

On the way home they stopped to visit the cathedral in Pisa. Suspended from the ceiling in the center of the nave was the oscillating chandelier that had suggested to Michelangelo the scientific principles of the pendulum. They then visited the Baptistry, a magnificent marble building of considerable height and excellent acoustics. And, of course, they climbed the Leaning Tower to enjoy the view of the countryside.

Although Couper and Ball spent many years in Italy they were always conscious of their American heritage. The *Detroit Free Press* documented Couper's comments on this subject during his visit to Michigan:

> I, like most other loyal Americans would rather live in this country than anywhere else on earth. But it is simply impossible. In the first place, the absolutely pure white marble which is required in fine sculpture cannot be obtained in America. Then, in Italy, we employ native talent to chisel the work up to a point which leaves nothing to be desired except the absolute finish. These men are almost artists—not quite—but they are wonderfully ingenious and skillful as marble cutters. This advantage we could not enjoy in our own country. [38]

Couper stated that

> America is my home, and God being willing I want my family to become a part of the country and my bones [to] rest there. If I knew,

or was assured of even a fair living were I to return home, it would not take me long to start. But unfortunately I would miss the assistance in marble cutting—so the next best thing I can do, is to try if possible to make an income that will provide for us when that joyous moment can be realized "Home Again" to stay.[39]

During the year of 1896 new taxes on art exports were levied by the Italian government, and the thought of returning to America became more plausible. A reporter mentioned this possibility after a studio visit:

> Mr. William Couper, the well known American sculptor resident so many years in Florence, gave a studio-reception at the Villa Ball, outside the Roman gate, on Thursday the 19th. The magnificent suite of studios was beautifully decorated with flowers, and everywhere amid these gleamed the brilliant marble of the artist's own creations, shapes of ideal beauty and portraits of realistic interest. Such is the now completed bust of Dr. Baldwin, admirably executed in bronze, and the fine portrait bust in marble of a subject more suave in line and no less interesting as a portrait subject, Mr. Reynolds. Of the ideal there is the beautiful Eve [by Ball], an exquisitely chaste and refined nude in marble, Eve awakening to life at the moment of creation, an expression of mingled awe and naive joy rendered with much sympathy....
>
> The handsome and hospitable villa is known to all visitors to Florence, set in the midst of its beautiful garden, it is a fit home for the artists, father and son. All who know it and its gifted owners will regret to think that next year it may be in other hands, for the family contemplate going back to America to live. Some hundreds of guests visited the studios on Thursday, including most of the American and English colony and many passing visitors.[40]

And from another correspondent at the same exhibition:

> Thursday, Nov. 19th,... the American sculptor, Mr. William Couper, gave to his many friends and admirers here an exhibition of some of his latest creations.
>
> ...We are no strangers... to this wellknown studio nor to its annual exhibitions which all American Florence remembers and

again looks forward to with each recurring year, and yet, on this occasion, an added interest is lent to the event by the knowledge that it is the last of these never-to-be-forgotten reunions. It is hard for us American Florentines to realize the fact, but Mr. Ball and Mr. Couper have announced their intention, (alas, for American Art in Florence), to remove their studio, with the coming year, to New York City. As patriotic and practical Americans we cannot shut our eyes to the fact that the greatest city of the great New World offers a wider and worthier field to their creative genius, and yet, as Florentines we can only say that we shall miss them, and art will miss them here.

...In various parts of the studio we greet again with pleasure some of our former favorites, past works of Mr. Couper's versatile genius,—heroes or heroines of past exhibitions. We note especially his "Psyche," his "Flora" (allegorical statue of Spring), his "Evangeline."... Besides the foregoing there are, on the walls and resting on easels around, a number of "Low Reliefs," some of them portraits and others representing imaginary subjects. These "Low Reliefs" have long been a specialty of Mr. Couper's and have been much, and justly, admired.

...Thus far we have spoken mainly of Mr. Couper, not of Mr. Ball, for the veteran, with that delicate thoughtfulness peculiarly his own, has peremptorily decreed that this last Exhibition at the Florentine Studio shall be, not his and Mr. Couper's as in former years, but Mr. Couper's alone. Evidently Mr. Ball does not believe in the maxim "Age Before Beauty," but insists, like a true gentleman of the old school, in stepping aside.... He can now rest from his labors, but, instead of his works following him, in the prescribed and usual way, he will insist, in spite of all we can do or say, upon following his works all the way to America.

All art-lovers in Florence will bid Messrs Ball and Couper Godspeed on their journey, if leave us they must, and will unite in the hope and belief that, in the course of the next year,... and the opening of the Ball-Couper trans-Atlantic Studio,—America cannot fail to recognize that she welcomes back to her warm bosom two illustrious sons.[41]

In 1897 Couper and Ball began plans to return permanently to America. Their neighbor John Reynolds had already moved to Montclair, New Jersey, and members of the Powers family were considering selling some of their

villas. Art commissions were now more available in America, and supporting craftsmen could be found.

Couper's last piece of work, *Falconer*, was completed life-size in clay, and would be cast in plaster before he left. It was "being modelled with the idea of putting it in bronze. I sometimes think I will never have anything more to do with marble. It is such treacherous stuff I have lost hundreds of dollars by its going bad, whereas bronze work is cheaper and the sculptor has no risk to run except the selling of his work after it is done, which is enough." [42]

Thomas Ball was then traveling in America and Couper expressed his appreciation for the man. "Now that Mr. Ball is away we all know how much we miss him for certainly he is a man that acts in such a soothing way he can only be compared to the oil that is put upon troubled water. I have sadly needed his quiet, thoughtful counsel of late, for the winding up of everything." [43]

Shortly before his return to America, Couper was watching his sons play. He turned to his wife and said, "Our sons speak Italian, dress like Italians, and now they even walk like Italians. It's time we returned to the United States."

5

The Expatriate Returns

Preparation for the trip from Florence to America was a great undertaking. The Ball family had been in their villa since 1869, so there was a span of twenty-eight years of art works and collections by the two sculptors. Many plaster casts of completed works had to be destroyed because the cost to ship them to America was too great, and it was unsafe to leave them behind where they might be commercially copied. Couper described the task of packing and dealing with the sculpture:

> Yesterday our second batch of cases left containing the studio things, casts, some marbles, modelling stands etc., and this second shipment raises the number of boxes up to 165. Probably in all they will come up to 180. Just think what it means for a sculptor to pull up—and what a pretty little sum it will take to move and settle all of these things. Then the amount of work connected with keeping everything straightened out so we select things when they are wanted without having to open everything, it is enormous....
>
> July 13th. Today has been rather a sad day for me in carrying out one of the duties that had to be executed and one that I have put off as long as I could. It consisted of breaking up numbers of casts—some of life size figures of noble statues made by Mr. Ball, busts, medallions etc. all of which make two great piles in the garden. It *does* seem too bad, but it cannot be helped, it is impossible to carry them. Tomorrow my two large Sphinx will go under the hammer with many other things. I don't blame father Ball for getting out and not seeing this wholesale destruction. Regarding Lizzie... were it not for her and her methodical way of working one half of the things which seemed without number would have been sacrificed.... She is the main spring of everything and I have often

felt like the fellow in the circus with a swallow tail coat and white gloves on.... Give my dearest love to Father and tell him with God's permission we will all see him soon again.[1]

Couper's sons had known no other country but Italy as their home but were very excited from all the discussions about how life in America was to be. Tom returned to Florence from his music studies in Switzerland, to help with the packing. The second son had a special way of measuring the time before departure.

> I was passing through Dick's room just now and I saw hanging on the point of his looking glass a calendar which he had made consisting of a block hung by a silvered cord, with a number of little pieces of paper tacked on it, and on each paper is a number that tells him exactly how many days there will be before he is to start off to see his cousins in America. He says every night before I go to bed I tear off one.... He is... filled with all sorts of notions. [2]

William Couper and his family moved to Montclair, New Jersey, a city which attracted many artists of the day. Here they built an Italian-style villa, Poggioridente (fig. 41), which was patterned after a neighbor's home in Florence, located on via Da Foiano.

The task of finding a New York City studio was not easy, but despite high prices there was a real estate slump and it was a buyer's market. Ball and Couper found a townhouse on East 17th Street (fig. 40) which was ill adapted for use as a home, but was just about what they wanted for a studio. It was located on the north side of the street, four doors from Stuyvesant Square. Couper wrote:

> The street cars run right in front of the door down to the ferry I have to take to get home, and the elevated railroad running up Third Ave. has a station right around the corner.... I will be obliged to sell what I have there in Norfolk and make up with what I hope to get to do here in the way of work.... Today the contract was signed and as soon as the deeds & C can be examined things will be brought to a close and the masons will commence.[3]

The front parlor was converted to a studio 22 by 42 feet, with a ceiling 21 feet high. Couper's exhibition room and offices were on the ground floor. Upstairs was a balcony overlooking the studio, which had a high pitched roof. On the upper level was Ball's exhibition room. The studio was designed with leaded glass windows probably brought over from Italy. The opening reception was held on May 17, 1898.

The expense of moving was made even more acute because it was not possible to accept any commissions during the period of establishing a new studio. Couper's first work in America was an allegorical bas-relief called *Repose,* done for Capt. William H. White, and Couper wanted to be sure it was well received. "I am getting along with my first order after arriving on this side, and which will go to Norfolk.... Mr. White will get more for his money, certainly as far as time and care goes, than he ever got before. It is my great desire to have him proud of it."[4]

Friends and relatives from Norfolk were always welcome in Montclair, and Couper kept in touch with the news of his hometown. He often expressed a desire to do something for his birthplace, and when the 50-foot white granite column for a Confederate monument was carved and erected by the Couper Marble Works, Col. W. H. Taylor wrote Couper asking that he model a statue for the top. The initial design was of a statue of Peace holding an olive branch, with two sheathed swords below representing the North and the South. Couper thought this subject timely because of the war currently going on with Spain. There were four additional statues at the base, representing branches of the military services: the navy, infantry, cavalry, and artillery. This elaborate design was preferred but, with restricted funds during wartime, the city decided on a single statue, the *Confederate Soldier.* Thus, the entire monument was constructed by members of the Couper family (figs. 38, 39, 109). Later William Couper outlined a plan for a "City Beautiful" campaign for Norfolk, which was seriously considered but never implemented.

Architect James Brown Lord then asked Couper to do a statue for the new courthouse in New York. The result was a heroic-size statue, *Moses,* one of a number of large figures decorating the roof of the structure. For *Moses,* Couper mentioned the process of execution: "Very soon now I shall have... my Moses cast in plaster, buying the marble and having it cut."[5] He was not

always able to obtain the same quality craftsmen to assist him with the execution that had been available in Italy. The relief *Protection of Our Country* (fig. 77) for the Dewey Arch gave him some problems:

> When I got back to NY I went around to Madison Sq. Garden to see what was being done with the relief that was to be enlarged. When I saw the attempt my heart almost failed me for the thing that was to represent me was... so bad.... That was the fifth of this month. So I took my working model to my studio promising to have the large relief (12'0" x 11'6" requiring two tons of clay) finished in ten days. The result is I had to work both day and night—always commencing at 7 am, and working up to eleven at night.... I went home only one evening and that was for clean clothes. I am happy to say I got through in time and the moulders will take the forms away from my studio this afternoon.[6]

The Dewey Arch was a collaborative temporary monument built in 1899 by members of the National Sculpture Society to celebrate the return of Admiral Dewey. It was erected at Fifth Avenue and 24th Street in New York City. The construction was of plaster and wood, and Couper's contribution was a large relief panel, *Protection of Our Country,* which depicted a woman standing at the prow of a ship, with a man sitting on each side, scanning the horizon. Twenty-five of the most prominent sculptors, including Daniel Chester French, worked together on the arch. The Madison Square Garden Company offered their basement for the enlargement of the works, but finishing touches were done outdoors in the park. It was a stirring sight for the public to see busy sculptors and assistants in this great open-air studio, performing tasks in their studio clothes. Large throngs gathered to watch. The design consisted of an arch (based on the Arch of Titus in Rome), with a colonnade of double columns on each side, which formed a court of honor. Only two months were allotted to complete the works. At their finish, a large parade marched along Fifth Avenue and commemorative speeches were given at the arch.

At about this time Eliza Couper planned receptions in the New York studio every second and fourth Tuesday of the month, which included tea and musical presentations. These receptions were used to display new

works. In 1900, for example, the *Art Exchange* reported the showing of Couper's full-scale model *Angel of the Resurrection*. Couper enjoyed modeling angel figures because "it is a beautiful kind of work, for one lives no longer in this world when his thoughts are above things human."[7] This subject became one of his specialties, probably influenced by his childhood days of watching the artisans carve angelic figures for his father's monument business (See figs. 73, 76, 80, 111, 112, 113).

This same year the city of Syracuse, New York, desired a monument in memory of firefighter Hamilton Salisbury White. The design was to be chosen by competition, and Couper submitted the model of a fireman's memorial (fig. 79).

In 1901 Couper was represented at the Pan-American Exposition at Buffalo, New York, by his work *A Crown for the Victor* (fig. 72), which won a bronze medal. He also submitted a design of a fountain for the Government Building, and the plaster model of *Recording Angel*. This exhibition took as its theme the great waters, the earth, and the wonders of nature. The presence of Niagara Falls provided a colossal, imposing, and unparalleled effect on the works. "Unlike the architectural dream come to be known as 'White City' at Chicago, with its antique intervention of spirit, the Pan-American is a rainbow of colour, besides offering more practical and material resources in its make-up."[8] Most of the five hundred sculptural models were submitted in a scale of 2 feet. These were then enlarged to heroic proportions using a recently developed pointing machine. Although the merit of the sculpture suffered somewhat from this commercial reproduction, the overall effect of a spectacular decorative display was the main object. Works were exhibited in a garden setting, with colonnades, loggias, and arcades, and in a building of Spanish Renaissance style, which provided an airy picturesque background.

Between the years 1889 and 1905 Couper and Ball worked on a full-size model for an equestrian *Abraham Lincoln*, which was to be placed in a prominent American city (possibly Detroit), but this work was never completed. When Couper executed a statue of former New York mayor Abram S. Hewitt, he went to Florence to accompany the work home after its completion in Carrara marble, returning from Genoa on the North German Lloyd steamer *Prinzessin Irene*. Hewitt was depicted standing on a platform with a document in his right hand, as if addressing an audience (fig. 93). The statue

was installed in one of the spaces adjoining the grand marble stairway at the
Chamber of Commerce, New York City.

Couper was granted a commission to produce busts of ten eminent
scientists for the foyer of the American Museum of Natural History. These
busts included *Prof. J. Louis Agassiz, John James Audubon, Alexander von
Humboldt, Benjamin Franklin, Joseph Leidy, Edward Drinker Cope, James
Dwight Dana, Joseph Henry, Spencer Fullerton Baird,* and *John Torrey.* After
the unveiling, Morris K. Jesup, president of the museum, sent this message: "I
want you to know that I feel that the success of the commemorative exercises
held at the American Museum on Saturday afternoon was largely due to the
masterly way in which you had executed the commission given to you two
years ago.... I have been strongly impressed with the character of the men as
you have expressed it in these portraits."[9] And from Edwin Blashfield: "It
makes a really impressive display and the Museum takes one back to Europe
and the respect paid there to such great collections. *We congratulate you
heartily.* What beautiful men you had to do—thinkers—"[10]

On April 26, 1907, the Jamestown Exposition was opened with the theme
of educating the public along the lines of national history. The opening date
was chosen because exactly 300 years earlier, in 1607, the colony of
Jamestown had been founded. The architecture of the buildings was colonial.
The exposition parkway was named the Warpath, in sacred memory of the
native Indians who took to war paint to alarm the colonists. In Chicago this
main promenade had been called Midway Plaisance, at Buffalo the Midway,
at St. Louis the Pike, and at Portland the Trail. Couper submitted a life-size
statue of Captain John Smith (fig. 106). The statue was well received and a
bronze copy was permanently installed on Jamestown Island overlooking the
river.

Couper placed strong emphasis on client relationships and thoroughly
researched each subject. He was influenced by advice from Phineas T.
Barnum, of the Barnum and Bailey Circus: "Trust those whom you know, and
do your best for them. They make your best drummers." He resolved never
to complete a work until those who had commissioned it were pleased with
the model, or models, as many as were necessary. This close relationship
between artist and buyer was illustrated during work on the heroic bronze
statue of Dr. John Witherspoon, the only clergyman to sign the Declaration of

Independence. Before the commission was granted, John deWitt of the Theological Seminary, New Jersey, wrote a note of reference about William Couper:

> I am sure that he will seek his inspiration in a thorough study of the subject.... What I have seen of his work makes me confident also that in executing the commission, he will seize the trails of Witherspoon that yield themselves best to statuesque treatment, and will nobly synthesize them.[11]

Four senators were on the government committee that had authorized the commission. Couper made four clay models in varied poses. Each of the senators preferred a different model. When they met to discuss the statue, each wanted different features. The final work incorporated something from each of the senator's suggestions, and everyone was pleased with the result. (See figs. 104, 105)

When the family of John A. Roebling was seeking a sculptor to design a memorial they chose Couper to do the work (fig. 103). In learning that the city of Bridgeport, Connecticut, was planning to erect a statue of the late Mrs. Beardsley, Roebling's son Washington wrote the following letter:

> August 16, 1907
>
> Mr. Couper recently executed the model of a portrait statue of the late Mr. John A. Roebling, the famous civil engineer.... The choice of a sitting statue was very fortunate. A civilian in modern clothes is an unhappy object, when deprived of the aid of military accoutrements or medieval costume.... Of all the looks the portrayal of a plain·civilian in bronze is the most difficult. The opportunities of lifting it above the commonplace type are almost nil.... This quality Mr. Couper possesses in a high degree.[12]

Couper continued to keep in touch with the artists he knew in Europe and the United States and attended exhibitions of their works. In 1899 he took his sister-in-law to a showing of the paintings of Julius Rolshoven in New York, which she commented on: "They are perfectly wonderful—One

an interior you feel must be real sunshine; it really dazzles—I realize the difference as I never thought I should in the man who mixes paints with brains & the other man." [13]

The "Duveneck Boys," artists who studied under Frank Duveneck in Munich, became quite famous and had a strong influence on the direction of art in this country. Julius Rolshoven wrote to Duveneck from London in later years:

> My Dear Duveneck,
>
> I was at once happy & surprised to receive your letter a few days ago at the club—You *did* give me a lot of news about the old friends & also about yourself—Thank Heaven that you have had enough of teaching.... Let others do the teaching—you do the work—... My days too for teaching are running to an end—I do not know when I shall take it up again after next month—... Things have gone extremely well here—a very large class & besides I am very busy painting portraits—Only I shall not spend another winter here if it can be avoided—... The time to reach London is March & remain until July or even until September & hereafter this will be my plan—... Even now in my present work I can see who has been my master—You have taught me so much & of late Sargent has continued to point out qualities quite in your own vein—It is a great joy to me to know that *our* school—*your* ideas, are foremost in the acknowledged standard of painting—The longer I work, the more I praise our master—God bless you & inspire you to do the most beautiful work of your life.
>
> As ever
> Giulio [14]

In October 1908, Couper lent his New York studio to Daniel C. French for a presentation of models to the city. French arrived early in the morning to prepare, only to find that the sculpture had already been set up, in "an ideal manner." The models were accepted.

Couper had a strong influence on his family and friends, and encouraged them to excel in their chosen fields. His first son, Thomas Ball Couper, attended school for music and violin in Lausanne, Switzerland, participating

in family musicals when at home. He later studied under Prof. Otakar Sevcik in Prague, Bohemia, and was an accomplished professional violinist.

Richard Hamilton Couper, the sculptor's second son, followed a life pattern much like his father's. He studied art in Paris and Rome, and worked as a landscape painter in Italy. Richard married musician Mildred Cooper of Buenos Aires, Argentina, and they organized musicals in Rome in conjunction with exhibitions of art, which were attended by fellow expatriates including painter Julius Rolshoven and sculptor Chester Beach. After Richard's early death, Mildred continued her career as a pianist and composer of quarter-tone music, eventually settling in Santa Barbara, California, where she was president of the Music Society.

The third son, William Alan Couper, graduated from Pratt Institute, Brooklyn, New York. He owned and operated a successful leather tanning business, and after his retirement enjoyed painting landscapes. He wrote fondly of his parents and the social events at their home:

> My father was an aesthetic yet powerfully willed person. A patriarch of the Household but always warmhearted, gracious and considerate. He was a very genial Host at many dinners and Musicals held at the Studios in Florence, Italy, and at the Montclair, New Jersey, home.
>
> Many of the important guests at these gatherings included such names as: Franz Liszt, Dennis O'Sullivan (famed Tenor of the Era), Thomas Edison and family, Edwin Blashfield, Daniel Chester French, Wm. Gedney Bunce, Julius Rolshoven, Frank Duveneck, and many others.
>
> All through these years of his prominence my Father was inspired and helped by my Mother who was not only a talented pianist but a most gracious and beautiful Lady.[15]

Thomas Ball wrote an ode to his son-in-law on the twenty-fifth anniversary of his daughter's marriage.

> Let us drink to the Artist of world-wide renown,
> Who dwells in this beautiful, spotless town.
> And his wife who has lived with him twenty five years
> WIthout shedding much more than a cup full of tears

For any harsh treatment she may have received
At his hands, which today can be hardly believed.
But it's true; they have seemed to live happy as lambs
Or proverbially speaking as happy as clambs [*sic*]

When the water is high and no diggers are nigh
To yank them up bodily, out high and dry.
Don't imagine, because of scant hair on his head
That his wife is to blame; for quite oft he has said

He was Balled when he married her; but ever since
He has found his male friends very hard to convince
That his wife had no hand in it; but I declair [*sic*]
That as far as I know, not an inocent [*sic*] hair

Has been plucked from his head by her fingers, so deft;
For she tenderly cherishes all that is left,
And consoles him by telling him early and late,
That she sees more and more of his precious old pate.

And the fact—so consoling—is often recalled,
That the greatest of men are the earliest bald.
So now—to put hair-splitting questions to rest,
With the joy of the past, may their future be blest.

 Thomas Ball
 May 9, 1905 [16]

William Couper retired from sculpture in 1913. His New York studio was purchased by sculptor and coin designer Chester Beach. Beach had been sharing a studio on MacDougal Street with Daniel Chester French but needed a larger space for his growing family. The president of the American Museum of Natural History in New York wrote a note upon hearing of Couper's retirement:

> I am indeed surprised to learn that you are retiring from your studio and I regret more than ever that I was unable last year to give you the opportunity for studies…. I think you have richly earned your retirement. Your contributions to the Memorial Hall of the American Museum and your historical contributions to marble portraiture in many parts of the country will constitute an enduring monument

and will always give you the greatest pleasure to reflect upon. I am quite familiar with the work of Chester Beach and admire it very much. I must make an appointment with him at the studio to talk over another relief portrait which we have in mind for the museum.... With very cordial regards and best wishes,... Henry Fairfield Osborn.[17]

After retirement Couper began to concentrate on painting seascapes in oil and watercolors, working from his home in Montclair, New Jersey. He achieved some interesting lighting effects in studies of the sea under differing degrees of illumination. Beside his easel hung two abalone shells, to which he turned whenever he found himself regarding his canvas with too great an appreciation. In respect for the brilliant play of colors given these shells by nature he stated: "If I can achieve on canvas an approximation of the beauty of these colors I shall feel I have done something worthwhile." [18]

Because the city of Montclair was the home of many leading artists, sculptors, and prominent citizens of the day, an art museum was established to house large private collections and to promote an interest in the arts. The museum was opened in January 1914. Two years later a special exhibit included Couper's paintings.

Much interest is being manifested in the present loan exhibition of paintings by Julius Rolshoven, William Couper, and Richard Hamilton Couper, at the Montclair Art Museum.... Julius Rolshoven, of Detroit, is an artist of wide reputation both in this country and abroad.... Two of his Salon pictures, "Entrance Hall of Castello del Diavolo," and "The Dance" are in the present exhibition....

William Couper, of Montclair, has a world wide reputation as a sculptor, whose ideal and portrait works are to be found abroad and in many of our large cities, one of the most important ones being owned by our Montclair Art Museum,—"The Crown for the Victor." Mr. Couper's present exhibition of water colors is a great surprise to his many friends, who knew he had retired as a sculptor.... But while visiting his son in Rome a few months since, he took up the water colors as a pastime, and became fascinated with the work, in which he could give free play to his imagination.... All the subjects are marines, of rich quality and coloring....

> Richard Hamilton Couper, son of William Couper,... has only recently returned from Rome. He is interested in various methods of painting, his favorite medium being tempera, as may be seen in his brilliantly colored Italian scenes. He is also represented by oils, monotypes and colored etchings. Excellent compositions, imaginative and poetic charm, and rich coloring are characteristic features of all his work.[19]

William Couper was a member of the National Sculpture Society and the Architectural League. He was a founding member and trustee of the Montclair Art Museum, located near his home. In 1925 he sold this home, Poggioridente, and moved to a more modest house on Berkeley Place. He often gave his neighbors seascape paintings as gifts of appreciation and friendship. (Note: A photo album of Poggioridente, dating from 1925, is now in the Montclair Art Museum.)

Daniel Chester French corresponded with the Couper family from his home in Glendale, Massachusetts. In 1928 he stated that his wife was writing a book of reminiscences called *Memories of a Sculptor's Wife*. He recalled with gratitude the kindnesses at Villa Ball, his sojourn in Italy, and the "merry, merry days when we were young."[20]

William Couper seemed to sense from early childhood what his lifetime vocation would be. After becoming a sculptor he once made an amusing comment about his profession to his father:

> I am quite busy now working in the mud. I remember once when I was a little boy you saw me playing in the mud in the gutter—You said to me, my boy keep out of the gutter and the mud as long as you can. The first part of your advice I have succeeded pretty well with, but as to keeping out of the mud—well I can't do that to save me.[21]

6

Sculptural Techniques and Materials

William Couper worked at a time when many new art techniques were being explored and developed. His contemporaries shared results of their experiments through treatises, letters, notebooks, and newspaper articles. Reporters frequently visited the studios in Europe and sent information back to America. This chapter departs from the chronological events of the Grand Tour and provides an overview of the sculptural materials and processes as they were actually perceived by the artists of the last quarter of the nineteenth century.

Sculptural techniques were influenced both by the study of ancient methods and by advancements in the fields of science and art. A set of principles and laws was proposed to underlie the practice and theory of art and sculpture across all eras. These were formulated by the German sculptor Adolph von Hildebrand, and set forth in his book *The Problem of Form in Painting and Sculpture* 1893. In France, the École des Beaux-Arts established a formal system of sculptural rules governing postures, gestures, and proper proportions. These were documented by Charles Blanc in the *Grammaire des Arts du Dessin* 1883.

Artists strove to work in the manner of various periods. As the nineteenth century progressed those who looked to the future attempted to create an entirely new style. This was influenced by the science of optics, and some artists became very interested in light and luminosity. Sculptors such as the Frenchman Rodin and the Italian Rossi tried to obtain an emotive style not only by depressions, projections, and the use of ornament, but also by modeling to both reveal and obscure the actual form. Hollows were deepened to obtain strong dark effects, or made shallow to increase reflected

light. Details were accentuated or suppressed to produce greater luminosity.

Another sculptor used the translucence of marble in a way very different from that of his contemporaries:

> A new departure has been made in sculpture hitherto considered as the most stationary of all the arts. The departure is due to a young Amreican Mr. Frederick A. Shaw who calls his method of working translucent sculpture. The idea is to use marble in the wall of a building like a window and to story it like glass. By means of different thicknesses high lights and shadows are produced. The effect is marvellously and astonishingly beautiful, the whole mass of marble being suffused with a rich golden colour produced by the rays of light penetrating through it and bringing out the design with exquisite life-likeness.
>
> The soft delicate shadings produced by the refracted light gives a perspective and atmospheric effect never before achieved in anything but painting. In fact Mr. Shaw's work might be defined as painting in marble with a chisel, without the use of colour. At present Mr. Shaw has only finished one of these translucent sculptures, of which the design is Christ walking on the waters. He is now busy on a triple gothic window, which is to be sent for exhibition to Chicago. It represents Ascension; the centre window is to be 18 ft. high by 3½ wide and the two side windows will be each 15 ft. high and 2 ft. wide. The original thickness of the marble is about 1½ inches, the deepest cutting is an inch. Mr. Shaw works by means of a pneumatic tool of American invention, which strikes 3000 blows per minute, and which can be regulated to act with the most exquisite precision. Mr. Shaw is also making a window representing the wood-nymph Sylvia standing by a pool of water in which her shadow is reflected. By causing this water to be represented on polished marble a really wonderful shimmering effect is ensured. This latter work will be exhibited at the Paris Salon of 1893.[1]

The process of sculptural execution is briefly described in the following categories: choice of subject, planning, modeling, carving, polishing, and materials. Excerpts from newspapers and sculptors' personal notes are included where they illustrate how the artists evolved and compared new techniques.

Choice of Subject

Influence for the selection of a subject came from the artist's training, personality, and the popular themes of the time. Sculptors tended to specialize so they could master the particular problems of execution, style, and the adaptation of a theme appropriate to the physical setting in which the work was to be placed. An artist usually chose a subject that he both understood and loved. Sculptural themes were often drawn from Greco-Roman culture. Subjects taken from mythology, ancient history, the Bible, or literature sometimes required that the artist accompany his work with a descriptive pamphlet that would elaborate on the subtleties being conveyed in the marble.

Statues and portrait busts continued to be the "bread and butter" for the sculptor, as they were in demand by public institutions, civic organizations, and private families, for use as memorials of war heroes, of prominent citizens, and of relatives. In addition, during the last quarter of the nineteenth century many sculptors chose to do works of an ideal or allegorical nature. It was in these figures that the neoclassic style was expressed most fully. They were often serious and sublime attempts at expressing nobility, beauty, or pathos. Nearly nude female figures were justified in the Victorian era by their traditional or virtuous titles, as well as by the positioning of the sculpture, and the use of white virginal marble, which gave an abstract feeling to the form and made the nudity more acceptable. Some male figures were executed but orders for replicas of these never equaled those for female figures. Two-figured groups were rare.

Of popular interest was the relationship between science and nature. Science implied progress, and nature represented mystery, beauty, and harmony. A union of the two reflected a joining of the intellect and the aesthetic.

The neoclassical style was considered the symbol of an ideal life reborn, and perfection of human form often took precedence over expression and emotion. As general idealism evolved toward more personal expression, it was still represented with nobility, high tragedy, and deep sentiment. Common themes were Morning, Evening, Shipwrecked Boy on a Raft, Pandora, Eve, Spring, Forget Me Not, Penserosa, Psyche, and Sphinxes. The artist expressed his own interpretation of the subject, influenced by previous works of the same title.

Planning

Each division of sculpture has its unique problems of execution, whether it be portraiture, architectural, garden, or monumental; whether large or small, bronze or stone, designed for use indoors or out; or whether installed at eye level or elevated. For example, when a statue was to enhance the beauty of a building, the sculptor needed a knowledge of the purpose and history of the architecture and decorative styles related to the structure.

Many factors in planning and execution had to be taken into consideration. Some of these were pointed out by William Couper in response to a letter from Mrs. Leland Stanford, who had written requesting a set of statues for the Stanford University Art Museum:

> Dear Mrs. Stanford,
>
> I have to acknowledge with kindest thanks the receipt of your highly valued letters.... With regard to giving you a definite answer to the questions asked about the statues for the Art Museum... I cannot draw an exact idea of the necessary height of each statue from simply the measures of the building..., without knowing something of its general form besides its being square. Then again, each figure must be modelled to suit the place upon which it is to stand, and modelled the size the marble is to be.... The time required for the cutting of a figure... will cover at least eight or nine months saying nothing of the six weeks required for the study of each sketch for the statues.... Of course the correct heights of the figures can be gotten from the architect, and a photograph of the plan of the building would be all that is necessary to overcome the first obstacle....
>
> The best marble for the statue is the kind I am using for the Sphinxes from Carrara which is almost as hard as flint and singularly enough, the longer it is exposed to the sun and air the harder and whiter it becomes.
>
> ...Should it ever become necessary for me to make studies of these distinguished men, the greatest pains will be taken to get their likenesses from the most authentic source....
>
> Yours very truly,
> William Couper [2]

Modeling

Modeling, the preliminary stage in sculpture, involves creation of a design in a soft material, for subsequent casting or carving in a more durable material. Formerly sculptors carved their work directly in stone, the *taille direct,* but for evolving a design and changing the form it was essential to make a model of the work, either in plaster or clay.

A small study model (or *maquette*) was a three-dimensional "sketch" of an idea which, when accepted, was later enlarged and completed in stone or bronze. It was presented to the client, and often underwent modifications. Sometimes a number of sketches were made in which different poses of the subject were shown. These were often small (4-6 inches) and rough in design, but gave an idea of the position of the figure. From the preliminary sketches a larger study model was executed, usually one foot in height. Some sculptors used sketch drawings to develop a design, but Couper preferred the method taught by Thomas Ball of using a *maquette.* A photograph of the model was sent to a client overseas, and the overall effect was more realistic than a two-dimensional drawing could provide. Once the design was accepted a full size model was constructed. Artists saved the sketch models for later use. For example, they might incorporate elements from a portrait bust into a statue of the same subject.

Either clay or plaster was used in creating a study model. A good clay needed plasticity, with the ability to hold its form while being worked, and porosity sufficient to allow moisture to escape during drying, without causing shrinkage or cracks. When a statue was particularly large, plaster was used to hold the weight and form, because it did not need constant moisture treatment. But clay was used when detail and expression were important.

Many methods were employed in developing the model. Some sculptors applied the clay in small, round pellets, a process called *modelé à la boulette.* This became very popular in the middle of the nineteenth-century. Other artists applied the clay in large chunks, working it into shape by small removals and additions. Some used the hands and fingers solely, especially the thumb, while others preferred various tools. The choice generally depended upon the type of surface desired.

Thomas Ball had a clear concept on the approach to this process:

I find it a general belief among outsiders that the sculptor takes a big lump of clay and digs the statue out of it. This for the benefit of beginners:—Always remember that every bit of clay added is a step forward, every bit removed is a step backward. Therefore, if there be too much in any part, remove it all at once, and more, with one scoop, and thus save your steps. Pay particular attention to your large forms; shut your eyes to the little ones till the work seems about done, and you will be surprised to find the little ones all there, or as many of them as you want.... Pay particular attention to the parts that the "gods only see," —such as (in a bust) the inside of the nostrils, inside and behind the ears, under the chin, the contour of the top of the head, etc., and you will find it turn to your profitable account. The eyes, nose, and mouth will look out for themselves; there's no dodging them.... We hear a great deal said about leaving certain parts to the imagination.... I hold that in a perfect work of Art the artist's own imagination should be depicted, but in so unobtrusive a manner as to require to be looked for, but when found, not to be mistaken.[3]

Usually a small model was made solid, but larger figures or groups were made hollow. One method of constructing a figure was to build an armature of wood or metal, and then apply the clay or plaster in even layers. The *formatore,* or plaster worker, often assisted in building this internal scaffold. A reporter wrote about model construction in the 1890s:

The clay is molded around a sort of iron skeleton, with lead pipes for the arms and legs, which are bent into the positions required. This model is placed on a revolving stand, so that the sculptor may have the light on any side he wishes. The modeling is done with tools of bone and wood of various sizes. Some are about the length and thickness of a carpenter's pencil, and flattened out at one end or at both ends; others have a triangular wire loop projecting from one end. The finer touches are often put in with the fingers alone, and it is interesting to watch the artist at work, picking off a small lump of clay at one place and dabbing it on in another, or producing delicate effects by deft digs or sweeps with his thumb. Water is occasionally squirted upon the model to keep it moist, and when the day's work is done the figure, after another sprinkling from the hose, is covered with damp cloths.[4]

The summers in Florence were so warm that during July and August clay models were covered and stored until cooler weather returned. Thomas Ball described the large task of constructing the interior of his equestrian statue, *George Washington*:

> Screwed firmly to my platform was an iron post, about ten feet high and four or five inches square; a horizontal timber, about the length of the body of the horse, rested upon the top of the iron post, which entered and passed through the middle of it, the two forming a T,—the timber intended to lie along just under the lowest part of the back, and together with the iron post, support the entire weight. I then formed of plaster a series of rough slabs, ten inches wide, three inches thick, and in the form of a half-circle of the diameter of the body of the horse. As soon as they were hard, I simply hung them up—a dozen on each side—to the timber, their lower ends coming together under the belly, supporting each other till I could join them with plaster. Thus I had a hollow cylinder, the ends of which I closed in the same manner, forming a foundation upon which to build the "barrel" of my horse. I next drew on the floor the outlines of the legs in their right proportions and positions; bending a strong iron to lay in the middle of each leg, I raised them about an inch from the floor, with a bit of plaster under each end, then filled in the outlines with plaster, covering the irons over and under; these irons should be long enough to project six or eight inches under the hoof and over the top, to enter the plinth below and the barrel above. In this way I had the legs solidly roughed out, with an iron exactly in the middle of each, and ready to be placed under the horse. Of course, my small model told me where to place the hoofs. After this the building up of the neck and head of the horse was a simple matter.[5]

Hiram Powers preferred to use lead or tin to support the arms of a clay model, rather than iron, because they could be bent without difficulty.[6] French commented on the materials of modeling in a letter to Mrs. Ball:

> You ask me why I do not model my statues in plaster. I thought Mr. Ball did not approve of that method. Is he trying it with his Sumner? I should think it would take much longer. I find also that I want to

vary from the original model in enlarging, & that would be difficult in plaster.[7]

Thomas Ball responded:

> I am modelling the figure of my Sumner in plaster, as I wish to make an exact copy of the small model, but the head, I have modelled in clay and shall also the hands, there are some advantages in working in plaster but I think there are more in the clay if you set it up with irons four times as large as you know is necessary.[8]

Each clay statue was first cast in plaster before being transferred to marble or bronze. This process took about twenty days, and provided the sculptor with a permanent model for safekeeping. Finishing touches were made in the plaster. Hiram Powers kept a working notebook on the process of forming the plaster mold:

> In future remember to make the first coat of plaster thick about the sharp corners as otherwise they are liable to break in taking off.
> ...Convex parts of the first inner coats are liable to be forced from the mould by the expansion of the plaster. Had to cut away a part at the small of the back (of Eve) on this account. I replaced it with a new coat.
> ...In moulding statues and busts the plaster should not be suffered to harden about the borders of each coat but while a fresh coat is preparing small quantities should be added to the edges in order to avoid irregularities on the surface of the cast. Spots of plaster should be instantly wiped away from the clay.
> ...In applying the first coat to the mould previous to putting the parts together *lay the plaster very thin* on convex surfaces else when it sits it will spring from the mould and render removal of such portions necessary and thereby occasion a difference in the color of such parts of the cast.[9]

Modern sculptors use a modeling material called plasticine, a claylike substance of an oily composition, which dries much more slowly than clay and does not crack as readily.

The design details for the study models in Florence were obtained from many sources: live sittings, photographs, drawings, and characteristics taken from previous sculpture or paintings of the same subject. In this way portrait busts could be done posthumously, depicting persons who lived before photography was in use. When developing an allegorical figure the artist often used a number of live models, taking qualities from each one to express the theme and emotional beauty which gave life to the work.

Modeling freestanding sculpture entailed special considerations, as described by William Couper during development of *Fireman's Memorial*:

> If a fireman is made rushing from a door, it would have to take the
> form of a relief instead of a monumental group—As there would
> then be only one point of view much would depend upon the
> locality in which it is placed—For an open space without a back-
> ground it is best to have the work in full round—More work to be
> sure but it would look better and more imposing.[10]

When a work was to be cast in bronze, the location and type of installation planned caused special problems during modeling. The 14-foot-high *Attending Angel* (fig. 76) required more than two tons of clay, and it was necessary to make a cast of the wall of the granite clock tower where the relief was to be mounted. Then, to ensure a proper fit, an allowance was made for shrinkage of the bronze after casting. This amounted to about one half inch to the foot.

Carving

Although the sculptor must be adept at carving (*sculpere*, to carve) he often entrusted the execution of his work to supporting craftsmen who, though skilled in carving, might not have possessed the skill of artistic creativity. This is the distinction between *sculptor* and *carver*. The carver is a technician who transfers another person's design into stone from a model provided to him (fig. 37). Few sculptors at the end of the nineteenth century had the time, and some lacked the ability, to complete a marble work from

beginning to end. But the artist made any final modifications to carving, detailing, or surface treatment. During the neoclassic period workmen were men of talent, artists were men of genius, and the distinction between them was carefully maintained.[11]

Michelangelo created sculpture from the stone with his own hands. He made a preliminary sketch of his work at one-tenth size, finished in the most minute details. Then he sculpted the marble with the help of scans and measurements. Accurate methods for enlargement of a model gained importance as the need for a sculptor's time became more critical, and also because of the desire that the finished work be an exact replica. In the Pan-American Exposition at Buffalo, 1901, all works were submitted in 2-foot models for judgment and acceptance, and then enlarged to full or heroic size for exhibition. Techniques had been developed through experimentation with tools and pointing machines that assisted in this process. With the help of these devices the mechanical system of carving was easier to learn because it was mathematically exact.

When a statue was ready to be carved, the marble block was brought to the studio and tested for flaws. Rinsing it with clear water showed any specks, veins, or changes of color. Sometimes the stone was tapped with an iron hammer to test for soundness, the ring being less clear if there was a vent or internal flaw. Then, with the use of calipers, the model and marble block were compared to be sure that the final work would fit in the desired proportion.

A pointing machine acted as a three-dimensional guide to aid the carver in transferring the design from plaster to marble. This machine consisted of a vertical bar with a perpendicular bar attached on a movable "armature" (fig. 36). Metal needle points attached to the crossbar were adjusted to touch the model at spots previously marked, to indicate depth. When the machine was moved to an exactly corresponding location beside the marble, a hole was carved or drilled until the needle penetrated to a depth proportional to the depth on the model. This continued until a set of holes covered the marble. The stone was then cut away as far as the bottom of all the holes, producing a rough outline of the figure.

Points were placed on all outermost extremities and innermost depressions. A statue of 6 feet was usually marked every 6 inches. Through a series

of measurements, beginning with the gradual indication of the lines and principal reliefs, the worker transferred a design into the marble. When one level of pointing was achieved, the process was repeated elsewhere until the basic form of the work could be seen in the stone.

For enlarging a model some carvers relied solely upon calipers and a geometric angle drawn upon the workbench. The larger the angle, the greater the enlargement. A measurement on the model was taken with the calipers and laid off on the horizontal of the angle (A, fig. 35). Then a perpendicular line (B) was scanned vertically until it met the angled line to form a triangle. The hypotenuse (C) was the enlargement measurement. This manual process was repeated throughout the carving cycle and is still in use today in the studios of Pietrasanta and Carrara, Italy.

After the basic levels of carving were established, a dented chisel was used to develop the principal form as a whole, avoiding the more fragile details. Greater precision was then added, starting with the head. Files, hammer, and chisels were used cautiously to release the design. During the final stages the artist examined the sculpture in different positions and varied light, checking that the surface was free of undulations. He carefully supervised the work so that it was in keeping with his original conception.

Each assistant carver had a unique task during the execution of a large work. The stone was originally blocked out by the *scalpellino* (stone cutter or chiseler). The *sbozzatóre* (sketcher) gave it a rough shape. The *modellatore* (modeler) gave more detail to the shape. The *scultóre* (sculptor's assistant) refined the simple parts of the work, areas without decoration, such as arms and legs. The *ornatista* (ornamentalist) added details such as hair, pleated clothing, and flowers. The base, pedestal, or column was then formed by the *carpentière* (stone carpenter), who executed all the architectural elements.

Sculptor Joel T. Hart made great strides in the invention of a pointing machine used in directly proportionate transfer of a design, and for this gained a reputation in England. There was strong interest in creation of a device which could also do enlarging. The sculptors in Florence experimented with their own versions of pointing machines. A lighthearted contest started between Daniel French, Thomas Ball, and Preston Powers as to who could invent the best design. French wrote to Mrs. Ball:

Thank you & Mr. Ball for the drawing of his pointing machine. I am very stupid that I cannot understand it. I see that the two circles & the perpendiculars are proportional, but how are the measures applied.... I see that the perpendicular gives one proportional distance; what other points do you measure from? My machine will be in running order this week... and when I have proved its usefulness, I shall send Mr. Ball a careful drawing and explanation of it.[12]

Thomas Ball responded to French:

I think your arrangement very ingenious, especially the plumb, and scale on the floor, but it does not seem to me that it can be very accurate, and I don't see any advantage over my first idea which you remember I discarded because I had my doubts about the possibility of turning the figure or traveling round it with the machine with perfect accuracy....

I think your machine will work beautifully when you arrange the models to turn *exactly* true in level and plumb together. I have not yet seen or had described Preston's idea, but a new one has occurred to me which I intend to put in trial at once. If it should happen to be the same as Preston's it would be a good joke on him for being so secret about it.... If my turntables work perfectly, my new instrument will be the ne plus ultra of simplicity and accuracy. It is so simple that it seems to me it must be the same as his because whenever he has spoken of his he has harped upon its simplicity.[13]

A description of the resulting effects from use of a pointing machine on the model is provided by French: "I was going to have the bust of the little Hayden photographed, as mother desired, but the marble-cutter seized on it, and put in his points, disfiguring it so that I shall now wait for the marble."[14]

Casting

The art of metal casting advanced to a high degree of excellence in Germany during the middle of the nineteenth century. Ferdinand von Müller (1813–87), of the Royal Foundry in Munich, made such remarkable progress in the casting of colossal monuments that the resulting statues often required no finishing work. This was the leading center in Europe for bronze casting, and was the foundry used by Thomas Ball for casting the *Washington Monument* in 1892. Bronze works completed in Florence were cast at the local Galli or Papi foundries.

Sand casting of bronze involved three basic steps: preparing a negative mold from the plaster cast, casting the metal, and cleaning and coloring the final figure. Large or irregularly shaped models were cast in separate pieces and then joined together. A New York newspaper reported on the casting process in France in 1891:

> The first step in the operation is to make a sand mold from the plaster cast, the sand for which is brought from Fontenay-aux-Roses, a place about sixteen miles from Paris. The plaster is first coated with shellac, over which "talk [sic]," the dust of potatoes, finely ground, is applied, before the sand is put on. There are really two molds, the inside one, or "core," and the outside one, or mold proper, which is lined with plumbago [graphite]. Into the space between the two the molten metal is poured. Here it remains for from two to four days until the metal is completely cooled. The latter is then taken out of the mold and cleaned of sand by means of brushes and tools of hard wood. It is then dipped into acid, which takes off all impurities and gives it the gold-like color of bronze.... If the casting is found to be all right, it is then turned over to the chaser, who takes off the seams.... It then goes to the mounter, who joins the pieces together. Across the water this joint is made within one-eighth of an inch, but here, the parts of the statue are joined to within one-sixty-fourth of an inch. When the statute [sic] is thus mounted, the chaser goes over it again; it is then examined by the sculptor, and if any slight changes are found to be necessary, the chaser makes them under the sculptor's eyes.[15]

Polishing

When a sculpture was finished it was usually polished so that the beauty and color of the material could be brought to light. This added depth to the work, especially where translucence of the stone was an integral part of the desired effect. But this technique could be misapplied. Highly polished marble sometimes acquired the look of majolica. And some Renaissance bronzes lost the effectiveness of their modeling because of confusing reflections caused by overpolishing.

In Florence, during Couper's time, a moderate degree of polishing was preferred to high gloss. Chemicals were not used. Hiram Powers preferred to use a very fine pumice stone imported from Vienna in applying a finish to his marble works. He often left the surface in a smooth but porous state, to more closely resemble the natural texture of skin. William Couper wrote home about his procedures for polishing stone:

> The straw you wet and rub the surface of the marble after it has been honed, until it becomes very smooth, but in the mean time don't let the hard black knots in the straw bear hard on the surface as they will scratch the soft ones worst. The white powder is then used quite in the same way as you always do, either with a block or a clothe in the hand. The powder is composed of lamb bones calcined, and then beaten very fine in a mortar. You use nothing but pure water on either mixing the bone into a paste or producing a polish. To polish soft dark marble lamp-black is used in the same way.[16]

Modern polishing procedures call for marble or alabaster to be washed with sand and rubbed with a rough cloth. If a higher polish is desired the stone is rubbed with real or artificial pumice mixed with clean water. It is then treated with oxalic acid applied with a damp cloth. At the finish all traces of acid must be removed because it can be corrosive to the stone.

Materials

During the period of Willam Couper's career the three major raw materials used for sculpture were marble, alabaster, and bronze. Each is described below, with emphasis on the origins, and methods of excavation and implementation in the latter nineteenth century.

A knowledge of marble was essential to the neoclassic sculptor. Because of its texture, consistency, and workable qualities, marble was considered the best stone for expression of an ideal. Alabaster was sometimes used, but this stone was softer, not as durable, and often contained blemishes or natural cracks, which made it difficult to carve. Bronze became a popular medium at the end of the century, influenced by the French school.

A number of factors had to be considered in the process of selecting the final medium. Some sculpture attractive in bronze would lose aesthetic qualities if transferred to stone because of the nature of the material. Bronze, with high tensile strength, supported intricate designs which contained holes, open areas, or fine detail; while stone, with lower tensile strength, was executed in more solid mass. The composition of stone could add interest to a work, whether it was granular, stratified, or crystalline. Not only were texture and grain important, but in the modeling of a head the features of the nose and ears could not be made too thin if the figure was to be put into marble because they would appear too translucent. Marble, alabaster, granite, and the harder stones basalt and diomite change color when polished, while bronze has its own special qualities of hardness, color, and reflecting powers.

A million years ago when the Apuane region was covered by water, dead organisms were deposited layer after layer on the sea floor, creating a deep limestone bed. When the mountains were formed by an enormous stress of heat and pressure, the limestone condensed into hard crystalline rock. White marble is the purest of these metamorphic stones, and can endure the worst of weather conditions. Hiram Powers reintroduced the pure white Seravezza marble from the quarries which Michelangelo had opened for the Medici family in the sixteenth century. A Florence newspaper reported on the methods of excavating marble in Carrara in the 1890's:

Whoever has stood on the beach near Viareggio, at the spot where the body of Shelley was cremated, will remember the wondrous beauty of the scene, fit setting for a poet's pyre. The blue waves of the sea, and the long line of the green Pineta, form the fore-ground, while behind rise the great mountains, purple-tinted, many peaked, with snow-like streaks falling down their sides. These are the Carrara mountains, but it is not snow that streaks their flanks, it is marble dust, the debris of the quarries which have furnished the sculptors of the world with their most precious material, ever since the days of ancient Rome.

The Romans called this marble Lunensis, after the Old Etruscan port of Luna, long since silted up by the encroaching sand, and its very site forgotten. The Roman poet Lucan, in his Pharsalia, alludes to it as the abode of Aruns, the most venerable of the Etruscan haruspices;... and Dante, taking up the Allusion, makes Aruns live in a cave of the Carrara mountains, in the... Inferno.... With the decay of the Roman Empire the quarries ceased to be worked, and... it was not until the Pisans, in the eleventh century, began construction of their Duomo and other buildings, that the marble works of Carrara received the impulse which has lasted until the present day....

The marble quarries, which are 400 or 500 in number, are situated far above the town, in the midst of the grandest and most savage scenery.... The six thousand quarrymen who are busy here appear as ants crawling on the vast hill-side.... The marble is quarried by dynamite. Every moment explosions rend the air and hugh fragments fly up, as if expelled from a volcano. Often the mine has to be placed in the perpendicular face of a precipice. Then the workman is lowered by a rope and hangs suspended 'Like the Samphire-gatherer, 'twixt earth and heaven.'... The rough fragments are squared on the spot into blocks, which are drawn out of the quarries by oxen, the smaller blocks in cars, which take them to a railway, constructed as far as the lower quarries for the transport of the marble to Carrara, a town of workshops and sculptor's studios, where 3000 more workmen are employed in sawing and working it up. But the larger blocks have to be removed on the *lizza,* a rough sledge, made of two parallel beams of wood, braced together by iron bolts, and lying upon short moveable rollers. Twenty or more oxen are attached, and when the impetus is given to the mass it slides like a ship launched from the dock, and woe betide who gets in its path.

> Or else the block is lowered by ropes, held by the lizzatori, as the workmen are called, who are employed in this special task. Sometimes the ropes break and the huge block thunders into the ravine below, and is broken into pieces. Then the workmen lose their days wage, for they are paid by the piece. They are divided into groups under master workmen, who settle the terms of the employers. These master workmen, who are about 400 in number, earn as much as five or six francs a day. The ordinary workmen earn from two and a half to three francs a day. The boys, of whom there are about 600, under fifteen years of age, get 50 centimes a day....
>
> About 160,000 tons of marble are annually exported, of which much goes to America. The quantity is inexhaustible. The entire mass of the Monte Sagro, 5,600 feet high, which dominates Carrara, is solid marble, like one great crystal.... Geologically the Carrara marble is described as Jurassic limestone metamorphosed.... One of the most famous [quarries] is in the valley of the Polvaccio. From this were extracted in Roman times the 1700 tons of marble that served for the construction of Trajan's Column at Rome.[17]

Dynamite is no longer the sole means used to blast the marble free, because of the great breakage and loss. The quarrymen (*cavatóri*) have returned to earlier, more controlled methods. Holes are drilled along the line of excavation. Wooden plugs are inserted and then soaked with water. As they expand, a crack forms. Metal wedges are used to help pry the block loose. Then a very small amount of dynamite is ignited behind the block to move it forward. The marble is sliced into desired sizes (fig. 34) using a special wire consisting of three woven stands (*filo elicoidale*), to which sand has been added from the local lakebeds of Massaciucoli. The sand acts in much the same way as diamond dust, enabling the wire to penetrate the stone slowly and evenly. Because marble has a grain similar to meat, it must be "carved" accordingly (*con pelle, contro pelle*).

Today the marble is transported by truck to the marina of Carrara. But in the past it was carried by workers (*lizzatori*) on wooden sleds (*lizzature*) and oxen drawn carts (*carri romani*) (fig. 32) to the beaches of Massa Carrara or Forte dei Marmi, for loading onto ships (fig. 33) As a result, remnants of marble dust and stone fragments (*ravanéto*) covered the hillsides like snow and caused the rivers to resemble milk. The workers walked the streets like apparitions, painted white by the dust.

Today, the high quality marble used for sculpture accounts for only 10 percent of the stone excavated from Carrara. The remaining marble is veined and less compact and is used for tombstones, building faces, pavement tiles, and other industrial purposes. In 1985, 1,200,000 tons of white marble was excavated, and another 550,000 tons was brought in from Portugal to be milled and then exported again. Carrara is the largest center for marble processing, and 70 percent of the world's marble passes through this port. Supplies are almost endless, with 6 cubic kilometers of white marble in Carrara alone. Stone can be reordered from the same quarry fifty years later and processed to match existing tiles.[18]

The alabaster industry is centered near Carrara in the Etruscan city of Volterra. A correspondent described this area in 1895:

> The country about Volterra is bleak and desolate, but has a certain savage grandeur that is not unimpressive. Low bare hills and hillocks of clay, deeply fissured by the strong rains... lie around for considerable distance.... It is in the midst of such a country as this that Volterra alabaster abounds. This industry would seem to be as old as the town itself, which was in existence already 4000 years ago....At the outset it is needful to lay stress on the fact that the modern alabaster of commerce is a totally different substance from that employed in Roman decoration.
>
> True alabaster is a fine massive or crystalline variety of gypsum, and is found in its greatest purity in the neighborhood of Volterra.... The substance is found in caves.... The men only work six hours a day, and never for more than two hours at a time. The bad air of the caves renders this regulation imperative.... The men have a belief that the fine white alabaster powder which they inhale in the process of picking, .. has strong hygienic properties.... The debris of the limestone matrix is removed from the caves in baskets by boys (locally known as "ciuchetti," ie. small donkeys). Both their hands are occupied in carrying the basket and they are thus unable to light their way with one of the unprotected lamps, but the little fellows, with something of the instinct of bats, have learnt to come up securely in the dark; the greater moisture of the centre of the path is a sure guide to their bare feet. Their wage is sixpence a day. The men work mostly with small T-shaped picks by the dim light of unprotected flaming oil lamps of Etruscan pattern....

72

The worked alabaster industry is divided into two strongly differentiated branches; first, sculpture;...; secondly, the miscellaneous industry,... such as vases, ewers, pillars, and stands, etc.... The alabaster used in... sculpture comes exclusively from the Castellina district, while the alabaster used in the miscellaneous industry... comes chiefly from the second and larger district.... Nearly all the best sculpture of alabaster is now carried on in Florence, whereas the miscellaneous industry is almost wholly confined to Volterra city....

The railway from Volterra station is still only partially used for the transport of alabaster. Both the rough and the worked material is often sent to Leghorn or Pisa in the picturesque one-horse carts of the country (baroccini [*sic*]).... Unlike the alabaster articles of Volterra, the sculpture is not subjected to a polish, but to a whitening process which is as follows. The figure is immersed in water which is gradually raised to boiling point and then allowed to become quite cold again before it is taken out. Great care has to be exercised, as too much heat would reduce the alabaster to plaster, and a too sudden exposure to air would cause it to crack. This process deadens the too great transparency of the alabaster and gives it the appearance of fine white marble. The alabaster of Castellina is alone susceptible of this treatment, if tried upon white Volterra alabaster the result would be to give it the semblance of a plaster cast.[19]

Tuscan alabaster is formed from calcium sulphate hydrate ($CaSO^4 2H_2O$), and was used from the eighth century B.C. (Villanoviana civilization). Carved alabaster is still one of the most traditional products exported from Italy.

From around 1800 B.C. bronze has been one of man's most useful materials. It is an alloy of copper and tin, with small amounts of lead or zinc added to alter the color and consistency. The name was probably derived from the Italian *bruno,* or brown. The Egyptians, Greeks, and Persians used bronze in early civilizations. Copper was obtained in Cyprus, and tin was brought from Spain and Britain. Although metals had been used primarily for utensils and weapons, in the Italian Renaissance bronze came into its own for sculpture. Florence became a flourishing center of bronze casting under patronage of the Medici family.

The methods of working in bronze have not changed greatly, except for refinement of techniques. The earliest form of a casting mold was an *intaglio*, or inverse design cut into stone. Later, sand molds were used for simple objects, and greater detail was obtained through the use of *cire perdue*, or the lost wax process. The Greeks developed a piece mold technique for casting large works, in which the original model was not destroyed. After casting, blemishes were cleared by metal artisans using a chisel and file.

During the nineteenth century a process of bronze electrotyping was devised. This established a mechanical method of sculpture reproduction in metal. A piece mold was formed from an existing sculpture. Then an electric current was used to take atomic metal particles dissolved in an electrolytic solution and deposit them on the surface of the mold in a uniform metallic coating until the desired thickness had been built up. Very accurate copies of antique sculpture could be made by this method. In Naples bronze foundries were set up to specialize in making reproductions of statuary excavated at Pompeii, which were popular decorations in parlors of the period.

Foundries in Paris specialized in coloring as well as casting. A bronze alloy in common use was composed of 80 percent copper, 17 percent zinc, and 3 percent lead and tin. For a golden tint, additional zinc was used, and more lead gave a grey-blue tint. Mercury was sometimes used to gild the bronze, but this process produced extremely poisonous vapors. A newly cast statue had a golden-brown color, which gradually turned reddish. Then, through aging it became brown, and eventually dark brown. A black patina developed if the bronze alloy had a high content of tin or silver, and often a light green "sulphate" coloration occurred. This gradual process of surface corrosion is called *patination*. If the artist desired to imitate "air patination" it was done through *pickling*, a method that used chemicals such as sal ammoniac, or smoke. Bronzes that have been buried discolor in a variety of ways, depending on the chemical composition of the soil. And bronzes recovered from long periods under water often have a hard smooth olive-green color, similar in appearance to an enamel. This is called water patination.[20]

Marble and bronze were equally popular mediums for sculpture during the 1800s, but as the century came to a close bronze began to take precedence in popular works because of its ease and speed of execution, durability, and minimum dependence on supporting craftsmen.

7

A Summary of Couper's Works

Many books, manuscripts, newspaper articles, family letters, and business correspondence mention the art of William Couper. Selected works are described here in the categories of allegorical figures, architectural decoration, portraiture, historical monuments, and paintings. Couper's sculptural attitude began with neoclassicism which gently turned toward realism. In the early works there is less modeling, as in neoclassicism, yet there is evidence of realism in the dress.

Allegorical Figures

An emotive theme is often inherent within sculpture inspired by a literary source. This cross-pollinization of the arts and literature was prominent during the romantic movement of the nineteenth century. Couper executed ideal subjects drawn from his own imagination, from ancient fables, and from writings by such authors as Cervantes, Tennyson, and Longfellow. Many of his works were executed in low bas-relief. The full effect of the design was obtained by using the translucency of the marble and subtle gas lighting, which gave an ethereal air to the art.

One of William Couper's first works was a marble relief, *Evening* (fig. 58), which depicts a young figure standing over clouds, clasping a new moon. A drapery covers the child's head. Couper later executed a companion relief called *Morning* (fig. 57) showing the drapery being lifted away to the rays of sunshine. The statue *Psyche* (fig. 60) represents a beautiful maiden just as she is about to open the vase in which she bears the gift of beauty from

Persephone to Venus. She is resting on one knee, and her face shows the doubt and curiosity with which she invades the secret of the goddess. The bust *Laura* (fig. 53) departs from the neoclassic style and shows greater naturalism, brought about by more modeling.[1]

The marble bust *Lily of Florence* was named by Mr. Marcus, an art collector from Tiffany & Co., New York. He had ordered an ideal bust without seeing the model, basing this decision on Couper's previous works. He wrote back upon its arrival:

> I write to let you know what a rare treat I have enjoyed on opening the marble bust, "The Ideal."... The quality of the marble... is exceedingly perfect and pure and in harmony with the subject.... I thought it appropriate to name it "The Lily of Florence," and hope you will permit us to call it by that name. I trust you will continue to execute your beautiful Evangeline as we now have an order for three more, and I would advise you also to commence immediately one more "Lily of Florence."[2]

Mr. Marcus also named another work, the *Vision* (fig. 59). This is a low relief which depicts a profile head of an angel looking toward a star. "I sent a photo to Mr. Marcus of the intaglio of it, calling it an angel head, and he wrote back it looked like a Vision. So thinking it a much better name [I] adopted it at once."[3] A number of copies of this work were sold, in both marble and bronze. A copper plug inset on the back of one marble relief has the following inscription: "Bellman and Ivey, 37 Piccadilly London. By Appointment to the Queen." This firm specialized in plasters, scagliola, and modeling, and represented a number of artists in their London gallery.

The *Boston Transcript* published an article from a Florence correspondent who described the *Coming of Spring* (fig. 64): "[It] is a beautiful floating or flying figure, bearing a wreath of flowers. It has just been cast in plaster, and is for Tiffany of New York. The cutting in marble will take about two years. The exquisite nymph... is so delicate that one wonders if she touches the flowers and leaves over which she is being borne by a light zephyr."[4] This figure, in rippling drapery, measures 8 feet high. It has a lightness and delicacy which defies the marble in which it was executed. The work sold for $18,000.

A Crown for the Victor (fig. 72) was thought by William Couper to be his finest work. He kept the sculpture, eventually donating it to the local art museum in Montclair, New Jersey, near his home. It depicts a girl in classic clothing weaving a garland of wild olive leaves while sitting on a leopard skin that has been draped over the capital of an ancient column. It combines the past, present, and future. The capital worn by time represents the past; the crown in the making, the present; and the victor who has yet to win, the future. Olive leaves were used, leaves from a fruit-bearing tree, to represent victory in the general sense, instead of laurel leaves, which might signify a warlike victory. This subject was suggested by some lines in one of the Nemean Odes of Pindar, in which the most beautiful Greek maiden presented a wreath to the victor of the Olympic Games. The task of transferring this statue to marble was fraught with challenges:

> I started the figure called "Beauty's Wreath for Valor's Brow" in marble about the middle of July. The block chosen cost me $300 where it lay at the quarries and to all appearances was sound and clear of marks. A beautiful color and just large enough to get the statue out. When it was gotten to the studio I found there was not an 1/8 of an inch to lose, so the work was started. The head was cleared and found to be perfect; then the workmen went on clearing the front of the figure. After passing below the projecting knee a seam appeared in the marble. That shot down through the part that had to be cut away and stopped just before it reached the foot and base of the figure. I then breathed freely—finally the statue was turned and work was commenced on the right side when another seam was struck shooting in which had every appearance of running through the arm crosswise between the wrist and elbow. This dry seam, like the other, stopped short of the arm, leaving it perfectly solid. Finally we got around to the back of the figure and in cutting off the rough another seam was struck that I would have sworn would take away a part of the base and a corner of one of the blocks of stone upon which the figure sits; but this too vanished before the vase was reached.
>
> Now if the figure had been placed in any position other than the one it had in the block it would have proved a total loss of marble and time, which would have squelched me. As it is, it stands perfect without a flaw or mark. Now what do you think of that for luck or whatever you may call it? [5]

The weather-beaten capital upon which the figure sits was first carved in exact detail. Then it was chipped and marred to represent the destructive effects caused by time and the elements.

Te Deum Laudamus (fig. 87), a marble profile relief of the sculptor's son Richard Hamilton Couper (fig. 86), shows a youth with sensitive face and bowed head, his fingers pressing the strings of a cello. Taft states that the modeling of the hair and the drapery over the shoulder is a lesson in what sculpture ought to be. The relief could hardly be altered.[6] Copies of this work were sold in order to finance Richard's cello lessons.

Shortly before his return to America in 1897 Couper completed a life-size statue of a girl running with a falcon in her hand. He stored this work inside a 10-foot wooden crate that was lined in metal to maintain the moisture of the clay. The *Falconer* was left in Florence to be cast in bronze.

Architectural Decoration

The bronze and granite *Drinking Fountain for Horses* (fig. 81), made for the Willet Farm, is an example of the patronage of sculpture by successful American businessmen who wished to decorate their estates and country places.

A dolphin fountain (fig. 46) was designed for the city of Norfolk. At the back stands the figure of a young woman. In front, idealized dolphins are represented with legs to make them appear amphibious. This design was inspired by Norfolk's motto, The City by the Sea, and was intended for a park under consideration by the town council, but was never completed.

Couper specialized in the execution of winged figures. Payne states: "The art of William Couper has displayed itself to a greater degree in angel portrayal than in any other field of sculptural art."[7] And from Taft—his angels are radiant creations that are gracefully conceived, carefully drawn, and exquisitely carved. Billows of realistic drapery provide an image that is even more winning on this account.[8] Because the sex of an angel is not defined, both male and female characteristics were used in their features. One of the most beautiful of these works was commissioned by Edward F. Searles for his

estate at Methuen, Massachusetts. This is the *Attending Angel* (fig. 76), a 14-foot-high bronze relief which decorates the clock tower. The detailed treatment of the wings offsets the floridity of the robe. It was Searles who ordered the colossal bronze statues and busts in the *Washington Monument* from Thomas Ball, for the city of Methuen, Massachusetts, for which Couper executed the eagles and flags (fig. 66). These flags were initially not the well-known American standards that they became in the final group. A newsman visiting the studio in Florence reported

> The group of flags about the base are finely designed with some symbolic intention by Mr. Couper and include some standards less known to the average European than the famous star spangled banner. One is adorned with a new moon and was designed by the young Republic to typify the dawn of a new era. Another has a rattlesnake, symbol of the New Continent.... Mr. Couper has draped them with a quite original grace, making the union flag embrace and include the others without hiding them.[9]

The *Washington Monument* was cast at the Müller Foundry in Munich, not at the local Galli Foundry of Florence, by special request of Edward Searles.

Angel of the Resurrection (fig. 80) was executed for Mrs. Albert Cones, wife of the treasurer of the Kimball Piano Company. In the same year Couper completed the model for *Recording Angel* (fig. 110), a statue that was to be placed at his mother's gravesite. He wrote a note to his father regarding the inscription: "The model for the Angel is off to the Buffalo Exposition, and when she is through showing herself to the people she can be sent direct to the founders. In the meantime it would be well to formulate the inscription that will go on the scroll for that should be attended to before it goes to the founders."[10] The inscription reads: In Thy presence is fullness of joy. At Thy right hand there are pleasures for evermore.

The *Recording Angel* was cast in 1903 at the Bureau Brothers Foundry in Philadelphia. The method of placing the 2,600-pound statue on a granite base was carefully prescribed by the artist in a letter to his father:

There are four bolts or rods with a split end into which is placed a wedge. Four holes have to be drilled into the granite just a little larger than the rods directly under the holes in the bronze plinth.... Have the statue carried out, take it out of the box, draw a contour of the base on a piece of cardboard and find the exact position of the holes upon it. Then place it upon the pedestal just as the statue is to go, and drill the holes not less than 2½" deep. The bolts I think would measure ⁴/₈ or ⁵/₈ of an inch in diameter.

...After the holes have been made in the granite the wedges must be driven into the end of the rods until it is spread so it will just go in—Then the wedge must be cut off so when pounding upon the top of the rod the wedge will strike upon the bottom of the hole and force the rod open so it won't come out and at the same time not spread so much as to break the corner of the granite base off when the necessary amount of pounding is applied to rivet the top of the bar into the plinth.... I could be with you and we could go out and land the lady in her place."[11]

In 1899 Couper was selected to execute a statue of Moses to be placed on the Appellate Court House, New York City. This public structure was designed to serve as a pedestal for sculpture, and as a frame for paintings. Couper was extremely critical of his own work, and after working on the *Moses* for a year he was unsatisfied with the results. He smashed it and started over again. The influence of Michelangelo can be seen in Couper's *Moses* (fig. 75), which is similar in countenance, folds of the robe, and bend of the wrist to the Moses in the church of Santo Pietro in Vincoli, Rome. Taft commented that the statue has that rare thing in art—a soul, with the intellectual fire of the old-time prophets. It is not "the meekest man", but the Moses who broke the tablets of stone in indignation.[12]

Portraiture

Couper's medallions and portrait busts were handled with dignity and restraint. Between 1904 and 1906 he was commissioned to do twelve heroic portrait busts of internationally famous scientists for the American Museum of

Natural History, New York. All of the works were executed after the scientists' deaths, and it required careful research to discover and reveal the character of each man. The unveiling ceremony was a gala event attended by many notable persons in the arts and sciences, including Franklin W. Hooper of the Brooklyn Institute, who wrote to Couper:

> The occasion was one of the most notable in the history of scientific meetings in this country, and it was a pleasure to me, not only to listen to the admirable addresses upon the men of science whose busts have been carved by you, but also to realize that your work as an artist was being presented under such fitting conditions. I had time to examine each of the sculptures, but was naturally more interested in the portrait of Agassiz than in the others. The sculpture of... this naturalist and teacher of natural history, and its appearance in the niche which has been reserved for it was all that could be desired from an artistic point of view.[13]

Mr. Wetherill ordered a plaster copy of the *John James Audubon* bust (fig. 101) for his country home in Mill Grove, Pennsylvania, which had been the first home in America for the famed ornithologist. The portrait of Charles Darwin (fig. 120) was well received and a replica was ordered for Christ Church, Cambridge, England.

While Couper was modelling the bust of Admiral Robert E. Peary (fig. 133) he asked that the admiral be present for live sittings so that the most realistic image could be achieved. Henry Osborn commented, "It is a highly characteristic likeness, full of spirit and determination, and... I believe it will be the most enduring likeness of the great explorer."[14] The donor of the bust was Mrs. Morris Jesup. Admiral Peary had reached 90 degrees north latitude on the sea ice and planted an unfurled American Flag on the North Pole on April 9, 1909, just two years before the bust was executed. A copy was presented to him as a gift.

In 1960 the busts of the twelve scientists were distributed to other institutions when the foyer of the American Museum of Natural History was converted for an American Indian display.

(

Prof. Thomas Egleston was the founder of the school of mines at Columbia University. His bronze bust (fig. 85) was cast at the Bureau Brothers Foundry in Philadelphia.

In 1885 Couper sent home pictures of two portrait statues, *Miss Lila Routt* and *Mr. Bartlett's Son* (figs. 62, 63). "The one standing is of the same little figure I sent a long time ago of Gov. Routt's little daughter, as they wished a little more movement to it, I have made this change. The other little statue is of Mr. Bartlett's little son." [15]

Among the heroic bronze statues and life-size portrait busts are subjects whose names are associated with the wealth, construction, and philanthropies of this nation. These include *Joseph P. Branch* and *Joseph Bryan* (fig. 127) Branch was important in the development of the railroads within Virginia. He was present on September 21, 1880, when the first train on the new road out of Richmond left the depot opposite Gamble's Hill and went to Maiden's Adventure. [16]

The heroic bronze portrait statue of Joseph Bryan was placed on an eight-foot granite pedestal in Monroe Park, Richmond, on June 10, 1911, and contains the inscription, The Character of the Citizen is the Strength of the State. On May 21, 1912, the executive committee of the Joseph Bryan Memorial Association drafted the following statement regarding the statue: "The artist has expressed the characteristic features and attitude of the man—as his friends love to remember him—laying before his fellow citizens some great measure of public interest to which he was giving himself, heart and soul." [17]

Other prominent persons modelled were financier John D. Rockefeller, Sr. (fig. 130) and engineer John A. Roebling. Five life-size busts of Rockefeller were commissioned to be placed in his estate at Pocantico Hills, in his New York offices, and at various colleges.

The *John A. Roebling* (fig. 103) monument graces the Public Park at Trenton, New Jersey. It depicts him seated with architectural blue prints on his lap, and is mounted on a base of highly polished red granite imported from Sweden. Roebling is known as the engineer for the Brooklyn Bridge, the Cincinnati Bridge, and the span across Niagara. He died from an accident suffered while supervising the construction of the Brooklyn Bridge in 1869, and it was completed by his son Washington and wife Emily, in the year 1883. Washington Roebling wrote to Couper about the monument:

With much pleasure I take this occasion to express my grateful appreciation of the artistic and masterful work you have accomplished in creating the life-like statue of my father.... When we consider that Mr. Roebling has been dead for forty years, that one or two photographs were all you had to work from, and that the personal recollections of those that knew him in life, had slowly faded away, and were of but feeble assistance; all these negative circumstances only serve to enhance the skill you have shown in your art—and also show that the sculptor's aim must be something higher than a mere painful adherence to exact reproduction of facial peculiarities.[18]

The heroic statue of Henry Wadsworth Longfellow (fig. 128), in Washington, D.C., was started by Thomas Ball and completed by William Couper. The 6-foot high seated figure of white marble was placed on a base of polished pink granite, and faces east. The granite for the pedestal was imported from Scottish quarries. Longfellow's intense gaze reflects a gentle nature. He is dressed in an academic robe, his right hand supporting his chin, and his left holding a book. He was affectionately called the Children's Poet, having written "Hiawatha," "The Courtship of Miles Standish," and "Evangeline," among other poems. The statue was unveiled in May, 1909, by a granddaughter of the poet. The *Boston Herald* reported:

The nation paid tribute this afternoon to the memory of Henry Wadsworth Longfellow when Atty.-Gen. Wickersham, on behalf of the President, formally accepted a statue of the poet, the gift of thousands of American citizens. A notable gathering, including descendants of the bard, participated in the exercises....

A splendid piece of work from the chisel of William Couper, the Virginia sculptor, the statue stands in a triangular plot at the intersection of Connecticut avenue, 18th and M streets, on a thoroughfare which will enable it to be viewed by all the visitors in Washington....

Longfellow admirers who gathered tonight at the Masonic Temple easily could have imagined themselves in the historic old New England hostlery where the poet laid the scene of his beautiful "Tales of a Wayside Inn."

Illustrated by beautifully colored stereopticon views, J. Townsend Russell told over in the poet's language the landlord's story of

> "Paul Revere's Ride", the Sicilian's tragic narrative of Robert of Sicily, the Scandinavian's recital of King Olaf and all the other stories which have added so much to the popular love for the poet.[19]

The statue of John Witherspoon stands 10 feet high. Witherspoon is depicted in colonial dress with a Bible in his hand (fig. 105). On the west of the pedestal is the inscription Signer of the Declaration of Independence, on the east Presbyterian Minister, and on the south 1722—Scotland—John Witherspoon—Princeton—1794. On the north side is a plaque which bears the quotation:

> For my own part, of property I have some, of reputation more. That reputation is staked, that property is pledged on the issue of this contest; and although these gray hairs must soon descend into the sepulchre, I would infinitely rather that they descend thither by the hand of the executioner than desert at this crisis the sacred cause of my country.

The bronze bust of Isaac Wallach (fig. 118) was sculpted for the Mount Sinai Hospital, New York City. It was produced in the absence of suitable photographs, but was considered a very close likeness by those who knew him.

Historic Monuments

Parks and promenades have long been pleasant outdoor galleries for the display of sculpture. Couper was commissioned to do six works for the National Military Park in Vicksburg, Mississippi. These included full sized portraits of naval Flag Officer Andrew Foote (fig. 122), and army Captain Andrew Hickenlooper (fig. 123). The statues were placed in similar settings, therefore a different treatment was needed. A breeze appears to be blowing back sailor Foote's coat; he stands as though on a sea-tossed ship, with arms in a slightly counterbalanced position. Army officer Hickenlooper, by contrast, stands as though on a more stationary surface, with arms closer in

toward the body.[20]

The heroic bronze statue *Peace* (fig. 114) was placed at the Minnesota monument. It depicts a female symbolic seated figure holding a sheathed sword at her right side, and an American shield garlanded with a victory wreath at her left. These signify that both armies of the Civil War have placed their weapons in her keeping, and the Union is now at peace. The work sits before a 90-foot white granite obelisk erected by the Van Amringe Granite Company, of Boston, Massachusetts. The granite was taken from a quarry at Mount Airy, North Carolina, which contains stone known for its strength and uniformity. The bronze was cast by the Gorham Manufacturing Company, and was dedicated on May 24, 1907. The Minnesota Committee for the memorial reported:

> The thought that dominated the commission in selecting a design
> for the State memorial was that it should in some striking manner
> suggest the idea of peace, hence the principal difficulty encoun-
> tered was to secure an original work of art that would properly
> symbolize this idea, and give to the structure a character that would
> at once appeal to the beholder along that line.[21]

Two angel figures were modeled at the same time the Peace was executed and may have been alternate designs for the monument. Each stands before a stone obelisk: *Angel of Victory* (fig. 113) and *Angel with Wreath* (fig. 112). The former holds a wreath and sheathed sword. But records at the Minnesota Historical Society do not indicate that an angel design was considered.

The *Confederate Soldier* (fig. 109) was executed on a commission from the Pickett-Buchanan Camp of the Confederate Veterans. It was unveiled on May 16, 1907, in Norfolk, Virginia, during the festivities of the Jamestown Exposition, and was dedicated to those who lost their lives fighting for the liberties of Virginia and the South (figs. 38, 39). It stands atop a 50-foot white granite column. Vermont granite was used because it is extremely durable and well suited for outdoor carved decoration. A Providence, Rhode Island, newspaper reported on the work just after it was cast in bronze:

· William Couper's heroic statue "The Color Bearer" has just been completed at the Gorham works in Elmwood and will be started this week on its trip to Norfolk, Va., where it is to crown a soldier's monument....

"The Color Bearer" is of heroic proportions, the figure proper standing nine feet in height, while from the base of the plinth to the top of the banner the work is 16 feet, 2 inches high. Cast of United States statuary bronze, it weighs 2,100 pounds.

Mr. Couper has created a battle piece of great and peculiar strength. "Great" as an expression of the universal quality of heroism, "peculiar" as a remarkable expression of the Southerner, whose defiant courage rose to sublimity in the course of the defeat.

The military element has been simply treated, the colors showing plainly in their folds the cross of the Confederate arms, conveying emphatically the motif of defence.

The figure is one of superb physical grace and elasticity, and is greatly lacking in the appalling sense of stolidity, which statuary in bronze is so liable to convey. It is in the countenance, however, that the artist has reflected the whole spirit of the composition. Even while the face is contracted with a keen and forbidding look, its expression enhances the beauty of a noble and virile countenance glorified by one consuming passion—the defence of the colors....

A statue of such conspicuous merit will be duly treasured by Americans, irrespective of section traditions, and will be a proud gift from the Buchanan Camp to the Confederate Camp of those who are so perpetuating the memory of the greatness and nobility of the fighting Southerner.[22]

While designing the monument Couper used as reference a photograph of Walter A. Edwards in military dress. Edwards was a Confederate soldier who later became owner and editor of the Virginia newspaper *Evening Ledger.* A number of models were executed. The *Man of War* or Confederate Soldier with Gun (fig. 108) is a less formal pose, and depicts the flag bearer wearing an ammunition belt. The second model is almost identical to the completed design, but the military jacket is longer, and the flag drapes behind, ungathered. (See figs. 107, 109)

In 1907 William provided a model to the city of Plattsburg, New York, for a memorial to honor Champlain (fig. 115). Business correspondence about the monument mentioned the design.

46
Dolphin Fountain, 1877

47 *Forget Me Not*, 1878
Photo: Courtesy of the Valentine
Museum, Richmond, Virginia

48 *Thomas Ball*, 1878

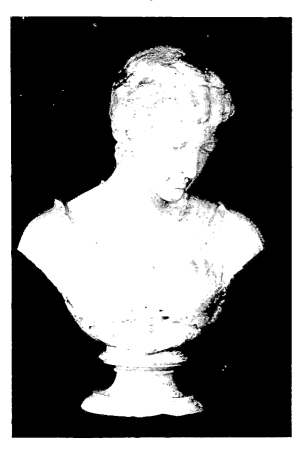

49 *Evangeline*, 1880
The Chrysler Museum, Norfolk, VA.
Gift of Herbert Nash Lee and Mrs. Rives C.W. Hitch.
Also, Collection of the Newark Museum.
Gift of Mrs. and Mrs. William A. Couper, 1943.

50 *Head of Bacchante,* 1872
Courtesy of Rusby Couper

51 *Princess* (Tennyson's), 1882
National Museum of American Art,
Smithsonian Institution (1918.5.26)
A.R. and M.H. Eddy donation.

52 *below* Portrait of a woman, *c.*1877
(possibly of Eliza Ball Couper)

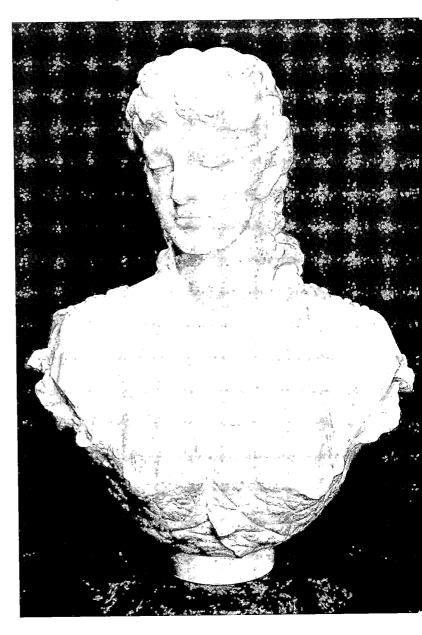

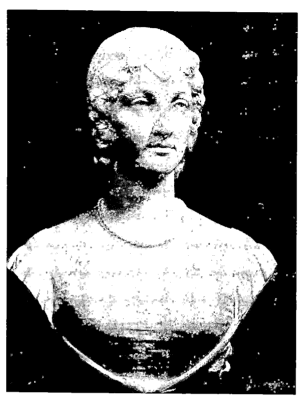

53 *Laura* (Petrarch's), 1884

54 *Fair Enid*, 1879
Courtesy of Joseph M. Napoli

55 *Flora*, 1883
The Lightner Museum, St. Augustine, Florida.
Photographer: Irene Lewis Lawrie

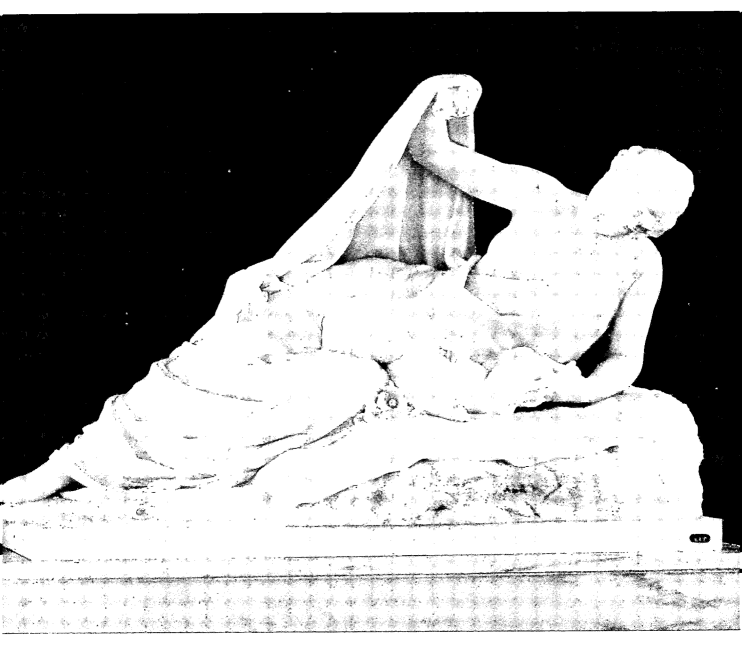

56 *Mother's Lullaby*, 1879. Also called *Mother's Love*. Forest Lawn Memorial-Parks, Glendale, California

57 *Morning*, 1882
Photograph: Christie's New York. Courtesy of Joseph M. Napoli

58 *Evening*, 1878
Photo: Chesterwood Museum Archives, Chesterwood, Stockbridge, Massachusetts,
a Property of the National Trust for Historic Preservation (NT69.38.3829)

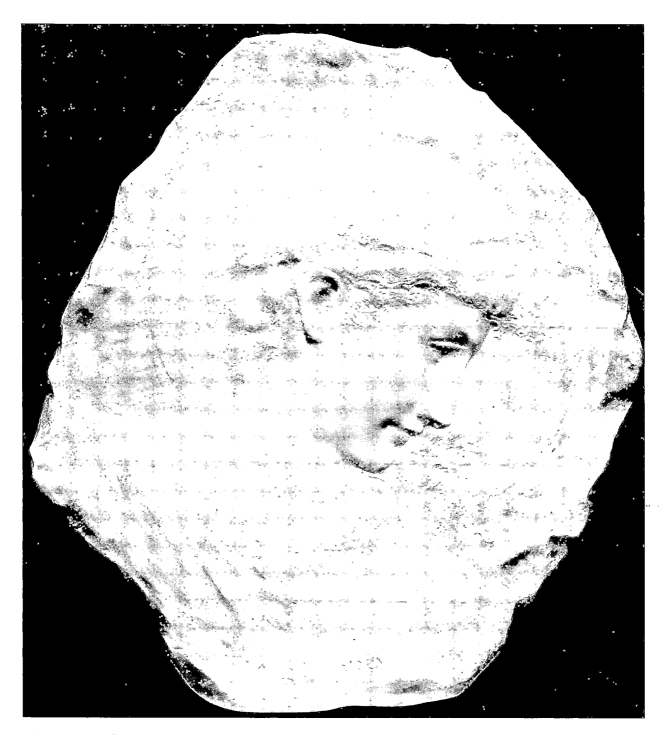

59 *Vision*, 1884
National Museum of American Art, Smithsonian
Institution, Washington, D.C. Museum purchase (1983.1)

60 *opposite*
Psyche, 1882

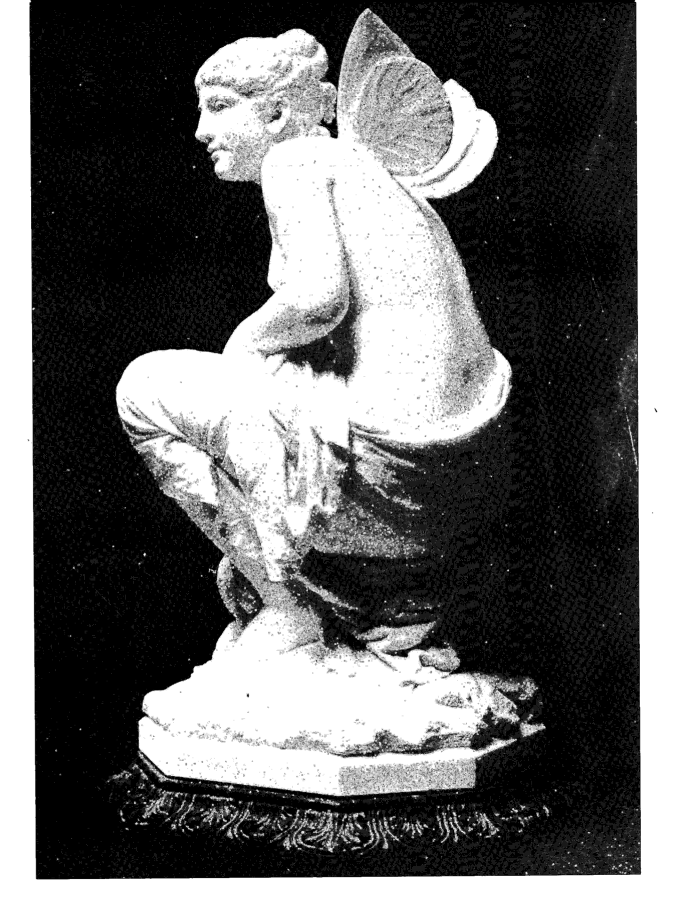

61 *Hand*, 1884. Standord University Archives (AM00-23)

62 *Miss Lila Routt*, 1884-1885

63 *Mr. Bartlett's Son*, 1885

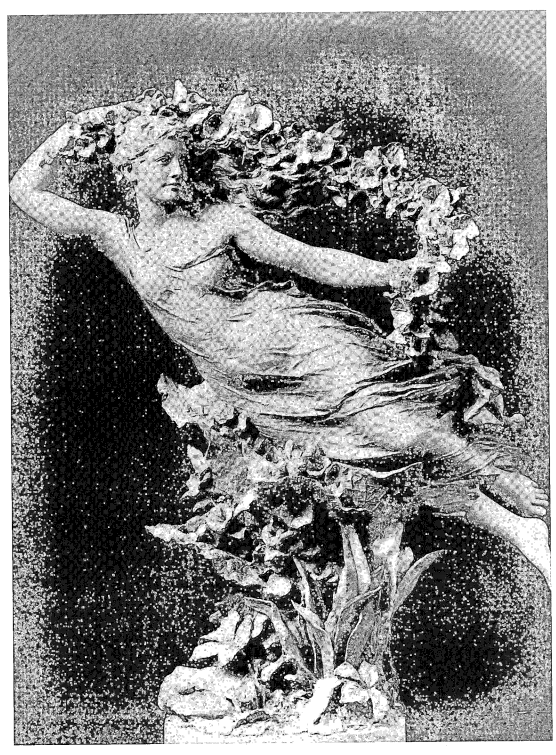

64 *Coming of Spring,* 1883-86
National Memorial Park, Falls Church, Virginia

65 *Egyptian Sphinxes,* 1891
Photo: Stanford University Archives (5521)

66 *Eagles and Flags*, 1893
Forest Lawn Memorial-Parks,
Glendale, California

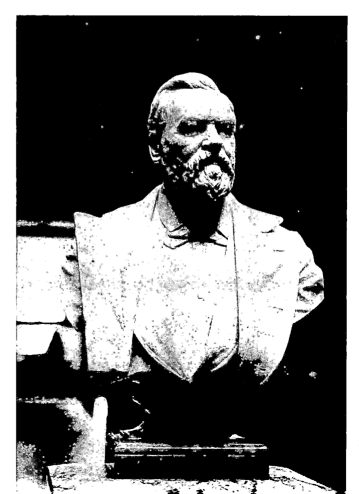

67 *Gov. Leland Stanford*, c.1892
Photo: Stanford University Archives (6320)

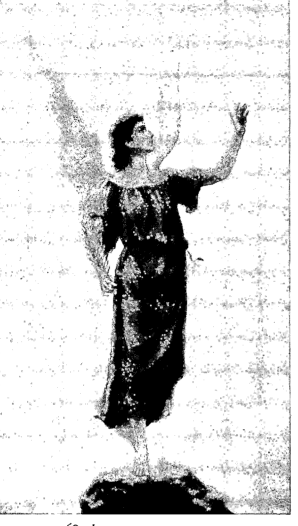

69 *Greek Maiden*, bust *c.* 1892

68 *above*
Angel Standing on a Rock, 1891

70 *left*
A Labour of Love, 1892
Courtesy of Rusby Couper

71 *above*
Cupid in a Tulip, c. 1894
Courtesy of Monroe Couper

72 *A Crown for the Victor*, 1896. Collection of The Montclair Art Museum

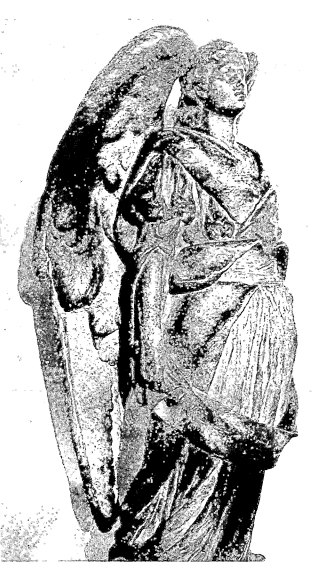

74 *above*
Eliza In Theatre Box, 1896

73 *Angel with Scroll, c.*1899
Courtesy of Monroe Couper

75 *right*
Moses, 1899

76 *opposite page*
Attending Angel, 1900
Congregation of the Presentation of Mary, Inc.
Methuen, Massachusetts

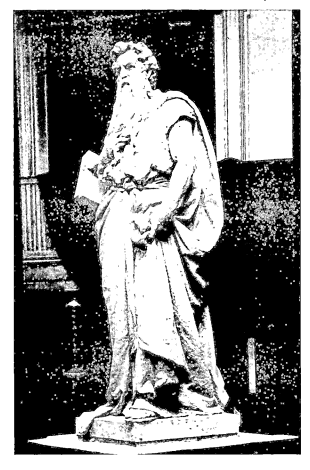

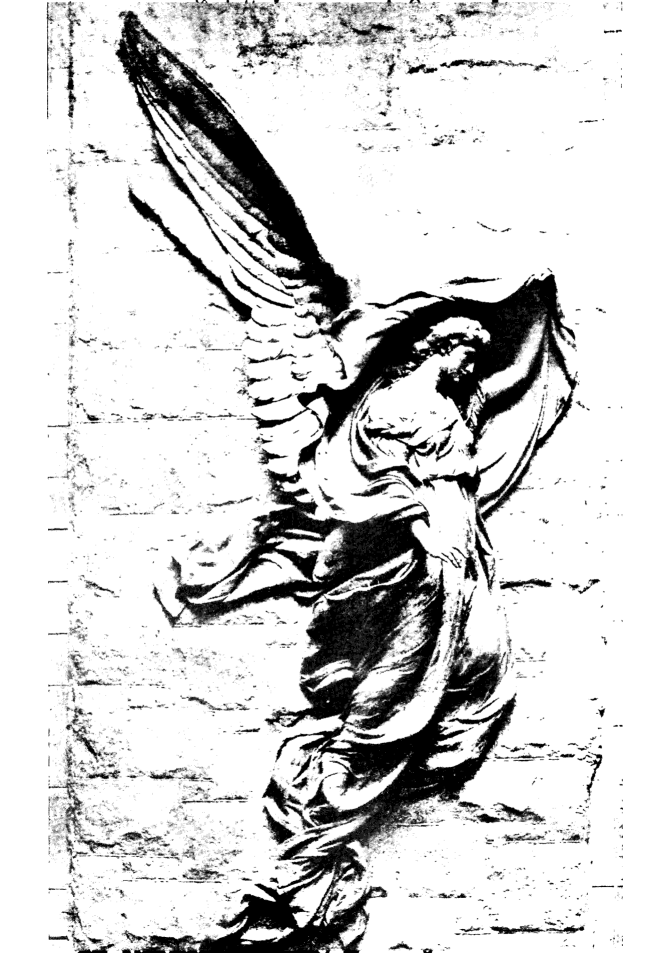

77 *Protection of our Country,* 1899

78 Decoration for Sarcophagus, 1901

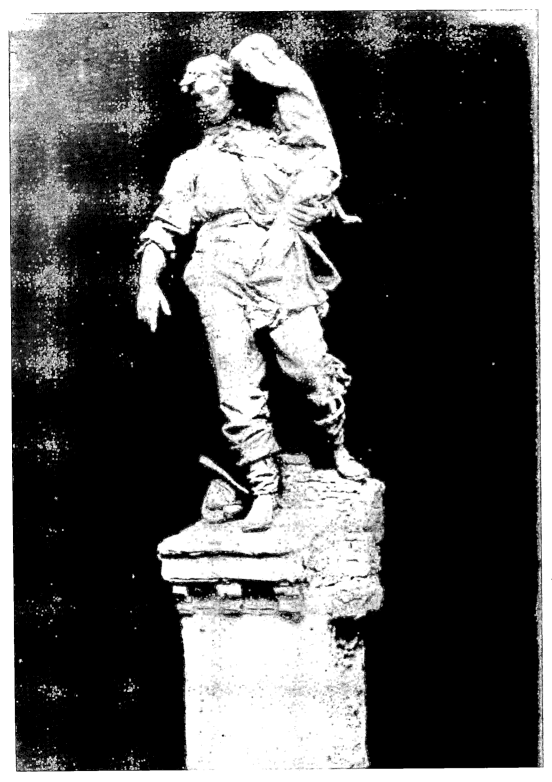

79 *Fireman's Memorial,* 1900

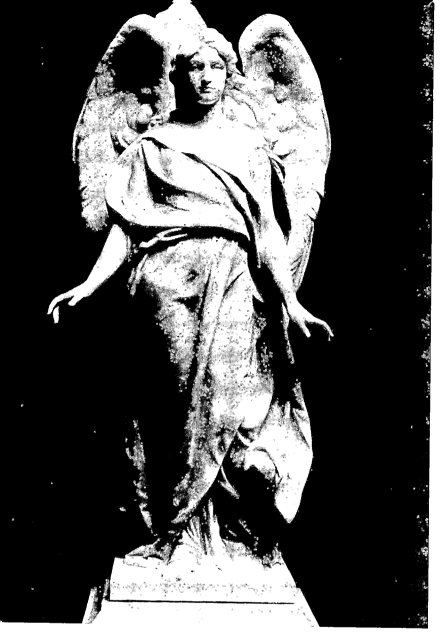

80 *Angel of the Resurrection,* 1901

81 *Drinking Fountain for Horses,* 1901

82 *Timothy B. Blackstone*, 1903

83 *right*
Pres. William McKinley, 1903

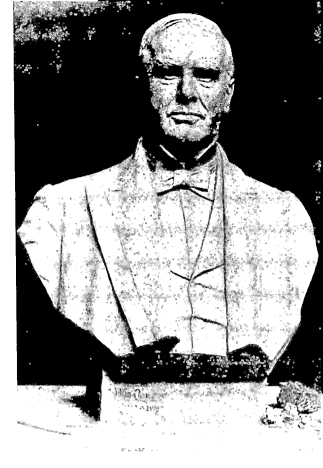

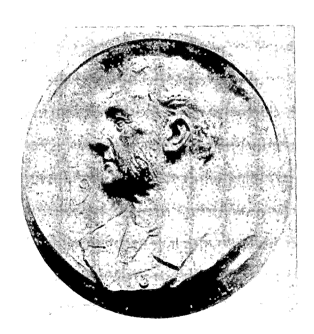

84 *Rev. Dr. William Stone Hubbel*, 1901

85 *right* *Prof. Thomas Egleston*, 1901
Columbia University, Gift of the Students, 1901

86 Photo Model for *Te Deum Laudamus*, 1900
Courtesy of Rosalind Nordli

87 *Te Deum Laudamus* (R.H. Couper), 1901

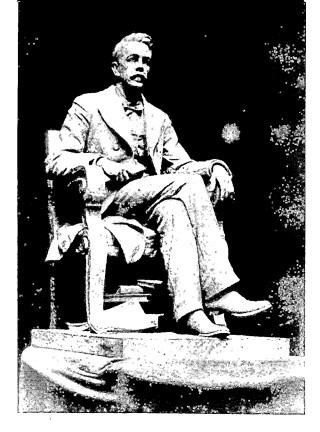

88 *Dr. Hunter McGuire*, 1903

89 *Headed for Goal*, 1902
Courtesy of Rusby Couper

90 *A Cornfield Idyl,* 1901
Courtesy of Rusby Couper

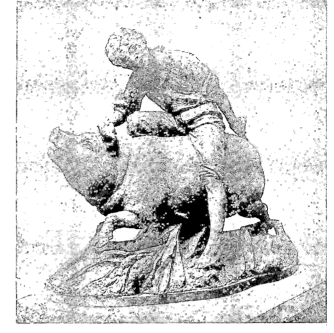

91 *Rural Industry,* c.1905
Photo: Peter A. Juley and Son Collection,
National Museum of American Art,
Smithsonian Institution (J0113889)

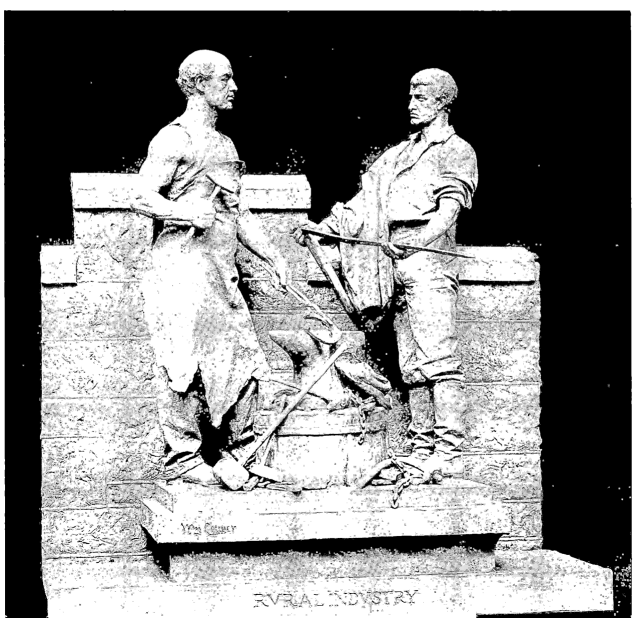

92 *Col. Alexander L. Hawkins*, c.1903

93 *Abram S. Hewitt*, 1905
New York Chamber of Commerce & Industry, Inc.

94 *Col. Alexander L. Hawkins Memorial*, 1904

95 *John Torrey*, 1906

96 *Joseph Leidy*, 1906 Neg./Trans no. N/A
(Photo by N/A). Courtesy Department of
Library Services, American Museum of
Natural History, New York

97 *Benjamin Franklin*, 1906
National Museum of American Art,
Smithsonian Institution, Gift of the American
Museum of Natural History (1960.10.2)

98 *James Dwight Dana*, 1906
The Earth and Mineral Sciences
Museum, The Pennsylvania State
University

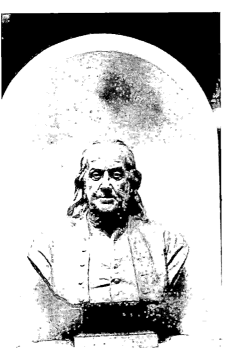

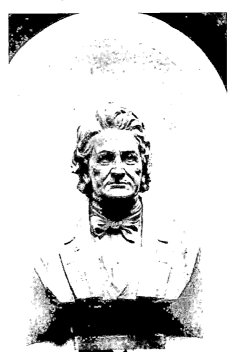

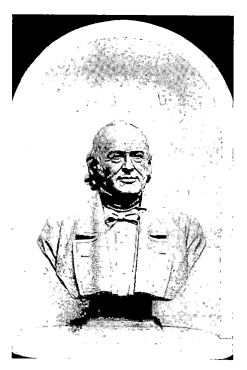

99 *Spencer Fullerton Baird*, 1906
National Museum of American Art,
Smithsonian Institution, Gift of the
American Museum of Natural History
(1960.10.3)

100 *Jean Louis Rodolphe Agassiz*, 1906
National Museum of American Art, Smithsonian
Institution, Gift of the American Museum of
Natural History (1960.10.5)

101 *John James Audubon*, 1906
Neg./Trans. no. N/A (Photo by N/A)
Courtesy Department of Library Services,
American Museum of Natural History,
New York

102 *Alexander von Humboldt*, 1906

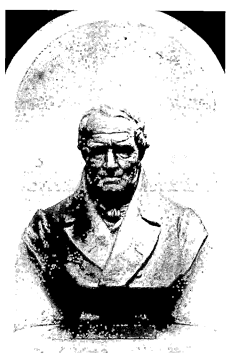

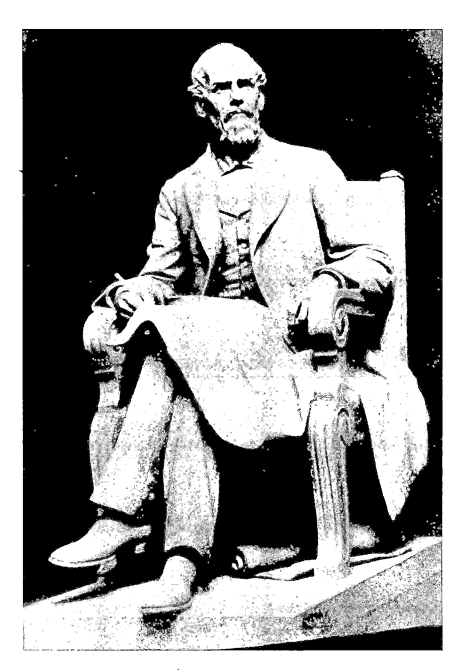

103 *John A. Roebling, 1906*

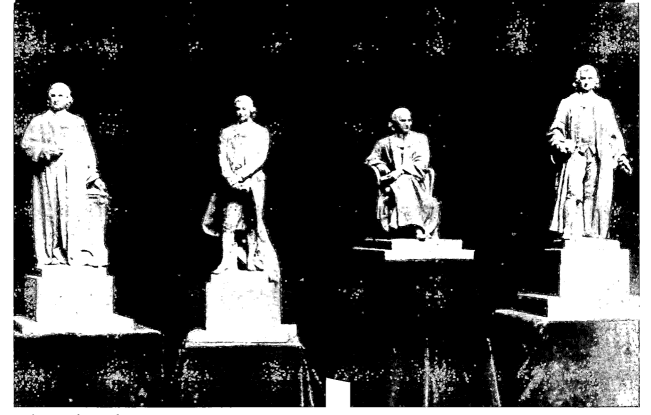

104 *Dr. John Witherspoon*, studies, 1907

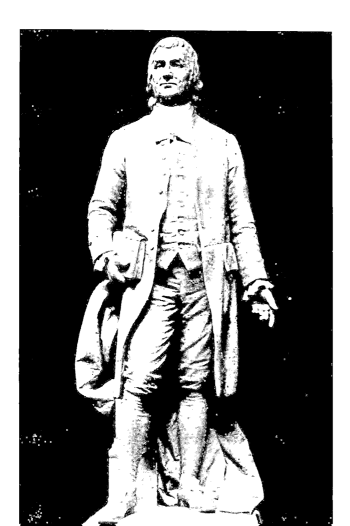

105
Dr. John Witherspoon, 1908

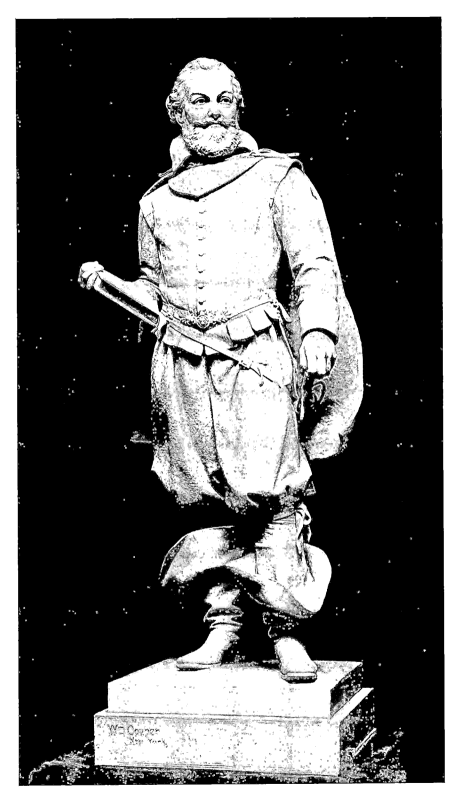

106
Captain John Smith, 1907
Photo: Peter A. Juley and Son
Collection, National Museum
of American Art, Smithsonian
Institution (J0113904)

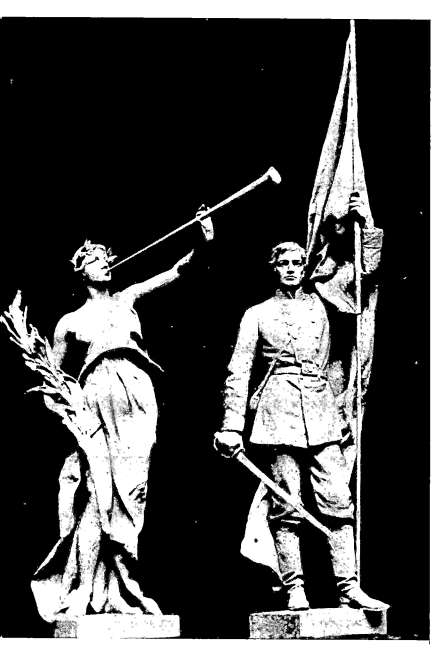

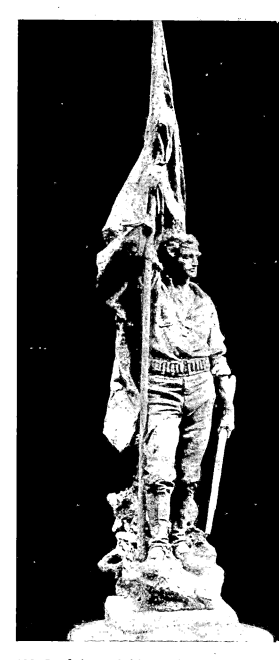

107 *Confederate Soldier* and *Peace*, studies, *c.*1903

108 Confederate Soldier with Gun,
study *c.*1903
Study for a monument, The Chrysler
Museum, Norfolk, Virginia.
Gift of Foy C. Casper, Jr.

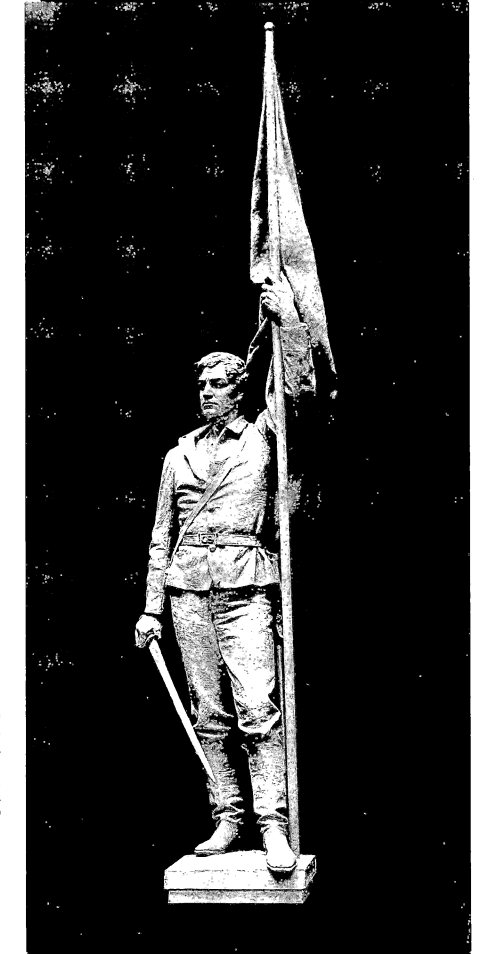

109
Confederate Soldier, 1906
Photo: Peter A. Juley and
Son Collection, National
Museum of American Art,
Smithsonian Institution
(J0113921)

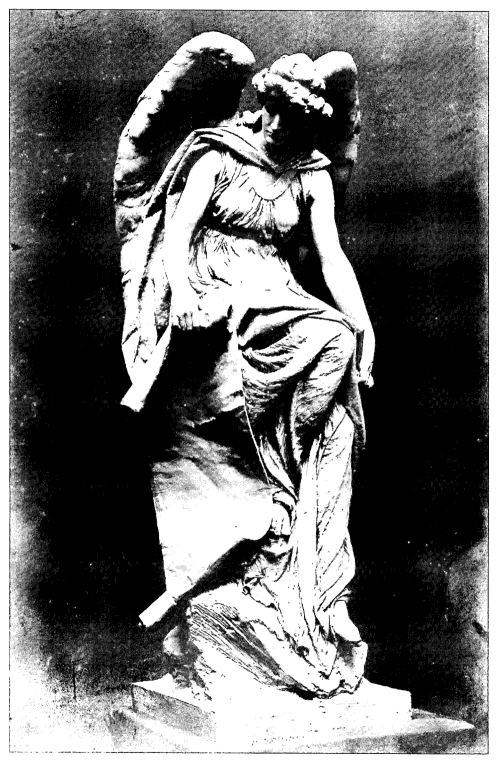

110 *Recording Angel,* model, *c.*1901

111 *opposite
Recording Angel,* 1906

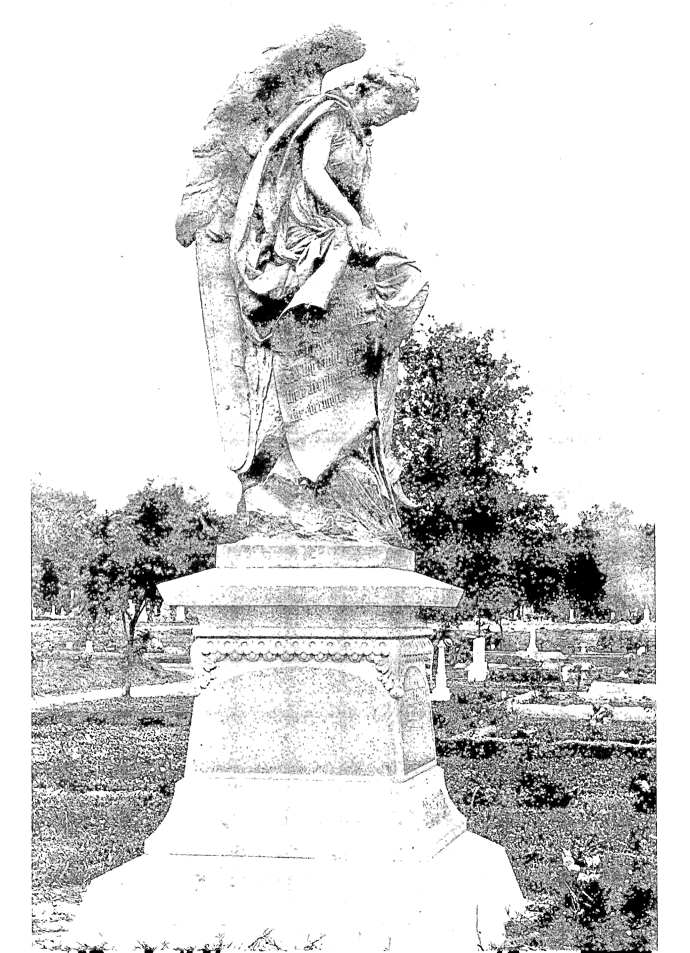

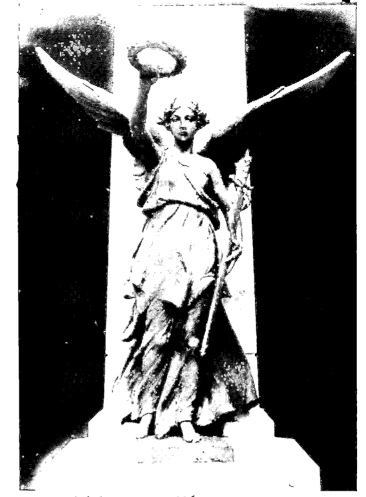

113 *Angel of Victory*, 1906

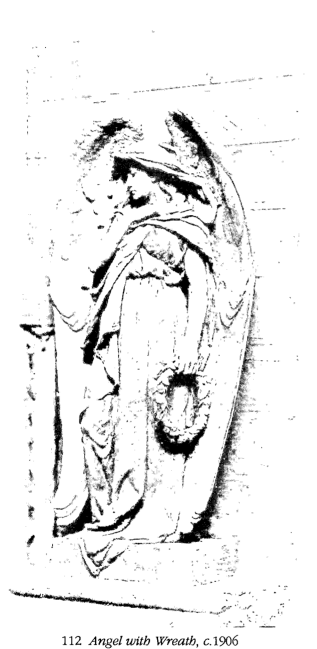

112 *Angel with Wreath*, c.1906

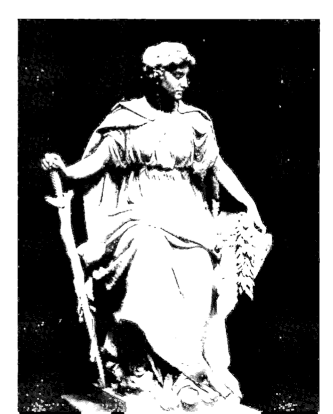

114 *below* *Peace*, 1906
Minnesota Monument. Courtesy: Superintendent,
Vicksburg National Military Park, Mississippi

115
Champlain Monument,
study, 1911

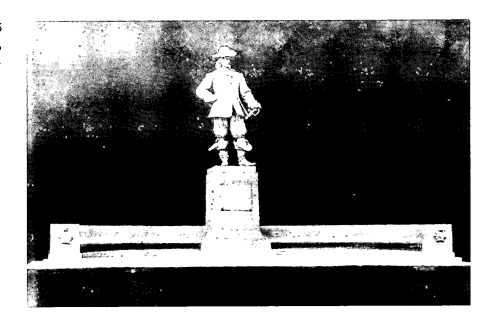

117
Woman on a Sarcophagus, *c.*1908

116
Mourning Figure with Urn, 1908

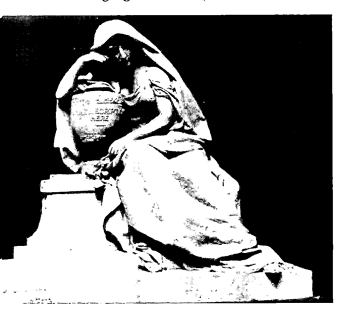

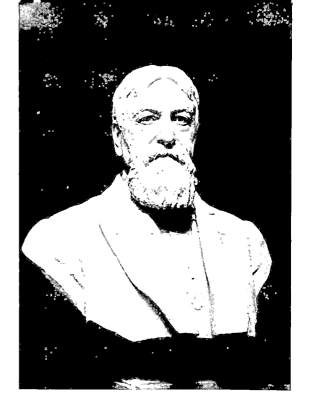

118 *Isaac Wallach*, 1908
The Mount Sinai Medical Center, New York

119 *Crosby Stuart Noyes*, 1908
District Building, Washington, D.C.

121 *Gen. Isham Warren Garrott*, 1908
Courtesy: Superintendent, Vicksburg National
Military Park, Mississippi

120 *Charles Darwin*, 1908
The New York Academy of Sciences

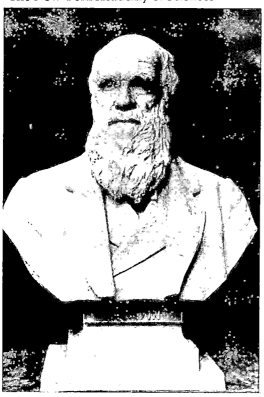

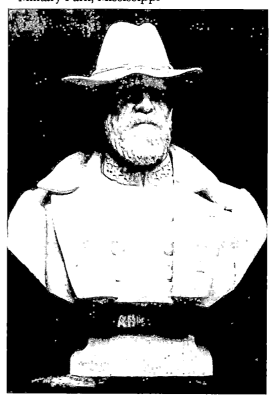

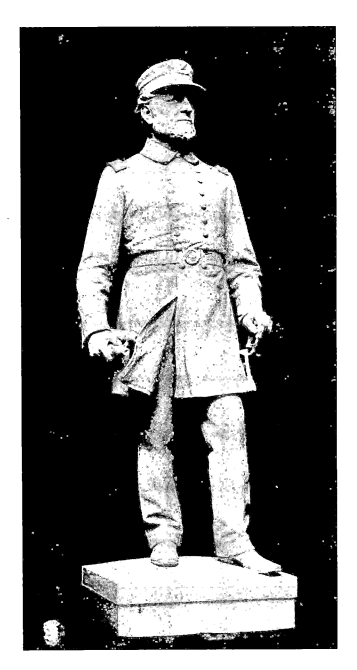

123
Capt. Andrew Hickenlooper, 1911
Courtesy: Superintendent, Vicksburg
National Military Park, Mississippi

122 *Officer Andrew Hull Foote,* 1911
Courtesy: Superintendent, Vicksburg National
Military Park, Mississippi

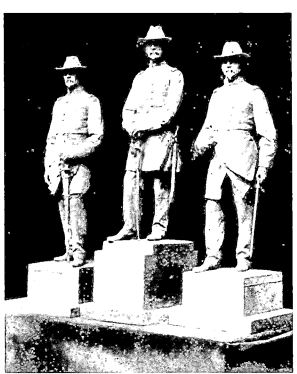

124
Capt. Andrew Hickenlooper, studies, *c.* 1909

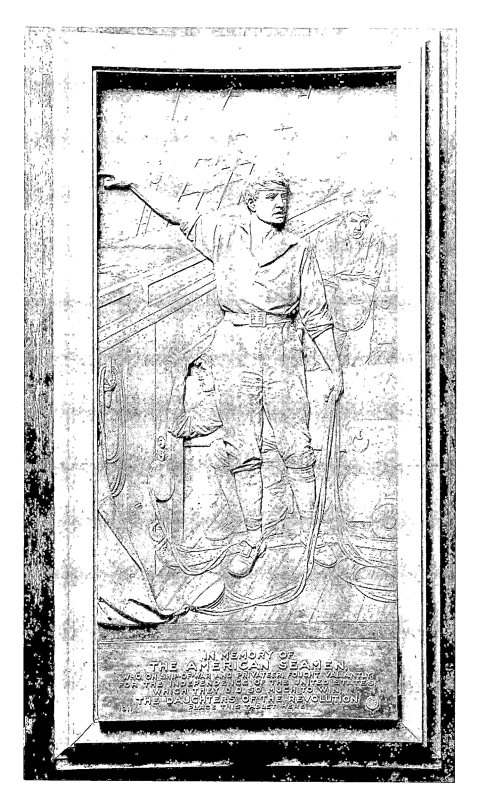

125
Sailors' Memorial, 1911
United States Naval
Academy, Annapolis,
Maryland. Gift of the
Daughters of the American
Revolution
Photo: Peter A. Juley and Son
Collection, National Museum
of American Art, Smithsonian
Institution (J0113919)

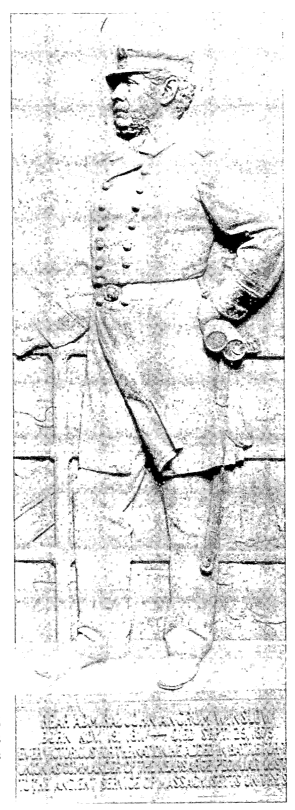

126
Admiral John A. Winslow, 1908
State House, Boston, Massachusetts

127
Joseph Bryan, 1910
Monroe Park, Richmond, Virginia

128
Henry W. Longfellow, seated, 1909
Connecticut and M Streets, Washington D.C.

129 *right*
Frederick T. Gates, 1910

130 *far right*
John Davison Rockefeller, Sr., 1910

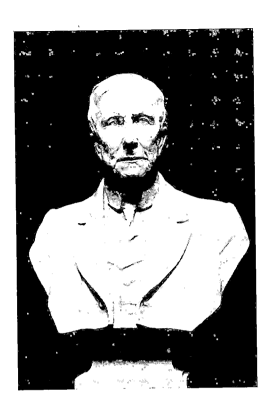

131 *Brig. Gen. Isaac F. Quinby*, 1911
Courtesy: Superintendent, Vicksburg National Military Park, Mississippi

132 *Gen. Francis Preston Blair*, 1911.
Courtesy: Superintendent, Vicksburg National Military Park, Mississippi

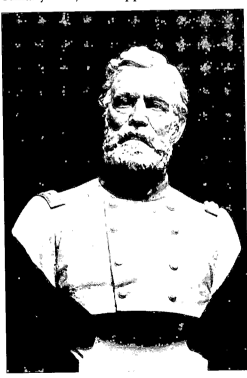

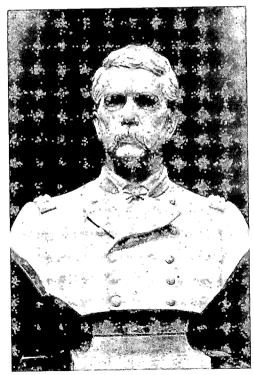

133
Rear Adm. Robert Edwin Peary, 1911
The Chrysler Museum, Norfolk, Virginia. Gift
of the American Museum of Natural History,
New York

135
William Watts Sherman, 1912

134
Henry W. Longfellow, bust, 1912
Fulton St. Park, Grand Rapids, Michigan

136
Rev. Dr. Augustus H. Strong, 1912
Colgate Rochester Divinity School/Bexley Hall/Crozer
Theological Seminary, Rochester, New York

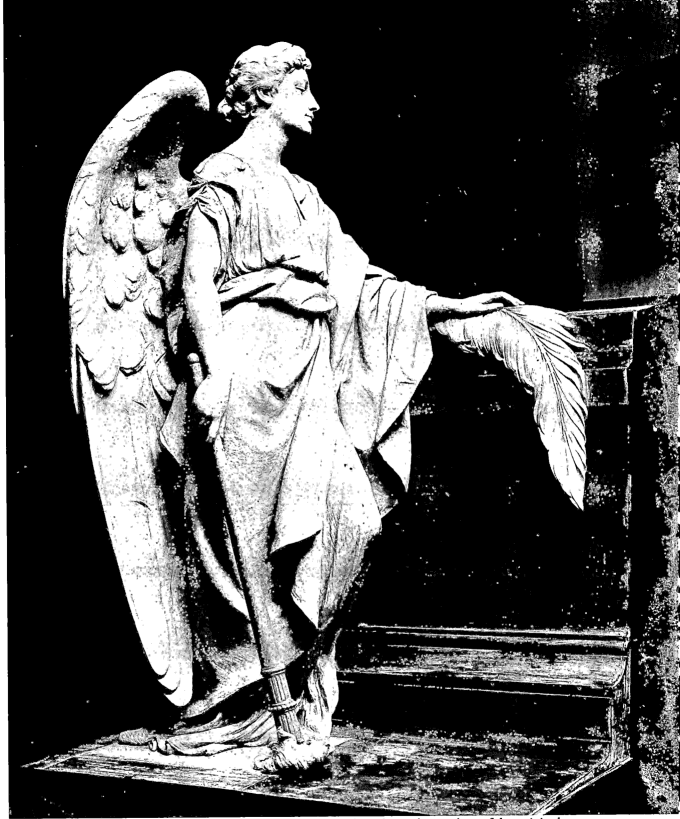

137 *Snowden Memorial*, 1911. Courtesy of Robert S. Snowden, direct descendent of the original owner. Photo: Peter A. Juley and Son Collection, National Museum of American Art, Smithsonian Institution (J0113920)

138
Seascape, 1918

139
Seascape, 1921

140
Seascape, 1922

141
Seascape, 1921

We took the matter up with Mr. William Couper, Sculptor,... and he has prepared a sketch model of a monument consisting of an exedra with seats and a massive column on the top of which is placed an allegorical figure, and at the foot of the column the statue of Champlain which it seems is very appropriate for the location.[23]

For the *Colonel Hawkins Monument* (fig. 92), in Pittsburg, Pennsylvania, Couper won the commission over a field of twenty-two other sculptors. The 8-foot bronze statue portrays the soldier in field uniform, including an overcoat, with a hat pulled down over his brow. He stands at ease with his hands resting on a sword in front of him, the point touching the ground. The statue was placed in the center of a Greek exedra, with low walls extending around from the pedestal to half-enclose an open court. Eight bronze tablets representing the companies of his regiment are set into the walls (fig. 94). The bronze was cast by the Gorham Company. The architect was Albert Randolph Ross, and total cost for the memorial was $20,000.

The statue of Captain John Smith was erected on Jamestown Island to honor Smith's courage in leading the first permanent settlement of English-speaking people in America. It was a gift of Mr. and Mrs. Joseph Bryan. The captain holds a book in his right hand, a symbol of the fact he was both an author and an explorer (fig. 106). The statue was cast by the Gorham Company, and was installed on a green granite pedestal by the Couper Marble Works. A life size companion statue of the Indian maiden Pocahontas was executed by sculptor William O. Partridge for Jamestown. She was the daughter of Powhatan, and became famous as the savior of Captain Smith.

The high relief monument of Admiral John Winslow, of Kearsarge fame, stands in the Massachusetts State House, Boston, opposite sculptor Pratt's relief of General Stevenson. These bronze portraits are in the Great Stairway Hall and are surrounded by murals of colored, polished marble. Winslow stands on the deck of his sloop of war as he might have during the historic battle with the *Alabama.* In his left hand he holds marine glasses against his hip, and with the other grasps the rail of the bridge. Smoke and spray appear in the background (fig. 126).

The *Fireman's Memorial* (fig. 79) was modeled after Couper met the widow of Syracuse firefighter Hamilton Salisbury White. He corresponded with Mrs. White about the design:

I had thought of putting an overcoat on the fireman which could be blowing in the wind for the sake of getting a better outline, but after reading your letter I have decided to use a blanket which will be only partly around the little girl in a night-dress, and blowing about in order to get a good effect of light and shade and make the composition full—this subject somehow has seemed to haunt me ever since you spoke of it.[24]

...The fireman who has rescued the child is supposed to have made his way to the roof, all other ways having been cut off by flames— He has just appeared on the eaves with the terror stricken little girl and is holowing [sic] down orders to the other firemen below—This gives one an opportunity of making a monumental group with the faces visible from below.[25]

The *Sailor's Memorial* (fig. 125) was commissioned by the General Society of the Daughters of the Revolution, to be dedicated to the seamen fighting in the war. The bas relief is 5 feet wide by 10 feet high and was placed in a slightly curved inner wall of Memorial Hall at the United States Naval Academy. The relief depicts a gun crew on a frigate, in the act of firing. The bronze was cast at the Gorham Manufacturing Company, Providence, Rhode Island, and was dedicated May 11, 1911. The tablet for the memorial is worded as follows:

> In memory to the American Seamen who in ship of war and priva-
> teer fought so valiantly for the independence of the United States
> which they did so much to win, the Daughters of the American
> Revolution place this tablet here 1911

The relief *Protection of Our Country* (fig. 77) was erected in Portsmouth, Virginia, to honor Commodore Richard Dale, who served aboard the *Bon Homme Richard* in her victorious engagement with the HMS *Serapis* during the American Revolution. It is a small copy of the large relief erected for the temporary arch in New York City during the festivities honoring Admiral Dewey.

Paintings

Because of his special interest in angels, Couper made his parents a pastel drawing of an angel standing on a rock (fig. 68). He wrote

> I am so thankful to learn through your letter... that the picture which I took the greatest pleasure in making... for you and father, meets your approval. Our minister here was so much pleased with it he brought several friends at different times to see it, and as my artist friends judged favorably of it from an artistic point of view I felt when I sent it, it would "pass muster."[26]

After his retirement from sculpture in 1913, Couper dedicated his talents to painting seascapes in oil and water colors (figs. 138–141). He did these from memory, having observed the sea during many transatlantic voyages.

Summary

One of Virginia's distinguished native-born sculptors, William Couper established a wide reputation for the scope and refinement of his portrait and allegorical works. His subjects are more than just accurate depictions, they evoke a living personality. A Norfolk newspaper described Couper's style:

> Perhaps... the highest praise we can give him is to say that to forms of great beauty, the beauty of health, and faultless anatomy, he adds lovely faces which are not Greek. They are outside the conventional type of sculpturesque beauty and are within our recognition as reasonable probabilities of our own day and generation. Finally, and best of all, every conception he has embodied is... pure and tender.[27]

Appendices

Appendix A

Checklist of Couper's Works and Dates

The date, title, and place of execution of each work are listed below. Locations are the last known address. An asterisk indicates that an illustration is included. A (P) indicates that the work is in a private collection.

DATE	TITLE OF WORK; LOCATION	DESCRIPTION
	Norfolk, Virginia	
*1872	*Head of Bacchante* (P) Orinda, California	cameo shell carving
	New York City (Cooper Institute)	
1873	Shell Shaped Fountain 1873 Norfolk Agricultural Fair	miniature model
1873	Study of Foot	clay
1873	Study of Hand 1873 Norfolk Agricultural Fair	clay
1873	Female Head	ideal model
1873	*Don Quixote* 1873 Norfolk Agricultural Fair	ideal bust, clay
1874	Landscapes (P) Lexington, Virginia	water colors
	Villa and Studio: via Dante da Castiglione, Florence, Italy	
c.1876	*Mrs. Preston Powers*	model portrait bust
c.1876	Small Figure	2 feet, marble

DATE	TITLE OF WORK; LOCATION	DESCRIPTION
*1877	*Dolphin Fountain* (dolphin with legs, submitted to City of Norfolk)	small model for a fountain
1877	*Chief Engineer Brooks (USN)* Portsmouth, Virginia	portrait bust, bronze
1877	*Chief Engineer King (USN)*	portrait bust
1877	*Mrs. Brooks*	portrait bust
1877	*Eliza Chickering Ball*	portrait bust
*c.1877	Portrait of a Woman (possibly of Eliza Ball)	relief, plaster
*1878	*Forget Me Not*	bust, marble
*1878	*Evening* (companion to *Morning*) (Sold through Tiffany & Co., New York City) (P) Montecito, California	medallion, 19 inches, marble
1878	*Col. J. Schuyler Crosby* American Consul to Italy	portrait relief
*1878	*Thomas Ball*	portrait relief, marble
1878	*Miss Grace Tilton* (P) Boston, Massachusetts	bas relief
*1879	*Fair Enid* (P) Brooklyn, New York	medallion relief, marble 19 x 16 feet
*1879	*Mothers Lullaby* (Also called *Mother's Love*) Forest Lawn Memorial-Parks, Glendale, California	mother and child, 28 inches, marble
c.1880	*Feeding the Swan*	statue
*1880	*Evangeline* (Sold through Tiffany & Co., New York City) (Sold through W. K. Vanderblice Jewelers, San Francisco) Chrysler Art Museum, Norfolk, Virginia	ideal bust, marble

DATE	TITLE OF WORK; LOCATION	DESCRIPTION
	The Newark Museum, New Jersey H. V. Allison Gallery, New York (P) Norfolk, Virginia	
1881	*Miss Ives* (Probably of sculptor Charles B. Ives' family)	portrait bust
*1882	*Psyche* (Sold through Tiffany & Co., New York City)	kneeling statue, life size, marble
*1882	*Morning* (companion to *Evening*) (Sold through Tiffany & Co., New York City) (P) Brooklyn, New York	medallion, 19 inches, marble
1882	*Iphigenia* (Sold through Tiffany & Co., New York City)	bust, marble
*1882	*Princess* (Tennyson's) (Sold through Tiffany & Co., New York City) National Museum of American Art, Smithsonian Institution, Washington, D.C.	bust, 28 inches, marble
*1883	*Flora* (model for *Coming of Spring*) Lightner Museum, St. Augustine, Florida (P) Blacksburg, Virginia (plaster)	bust of woman, marble
1883	*Lily of Florence* (Sold through Tiffany & Co., New York City)	ideal bust, marble
1883	*Antigone* (P) Wilmington, Delaware	medallion
1883	*Mrs. J. J. Hagerman* (P) Colorado Springs, Colorado	portrait bust, marble

DATE	TITLE OF WORK; LOCATION	DESCRIPTION
*1884	*Vision* (also called *Head of an Angel*) (Sold through Tiffany & Co., New York City) (Sold through Bellman & Ivey, London, England) National Museum of American Art, Smithsonian Institution, Washington, D.C. Allentown Art Museum, Pennsylvania (P) West Orange, New Jersey (bronze) (P) New York City (bronze)	medallion, marble
1884	*Mrs. D. L. Bartlett* (P) Baltimore, Maryland	portrait bust, marble
*1884	Hand for the Stanford family Stanford Mausoleum, Stanford, California	hand, marble
1884	*Leland Stanford, Jr.* (Possibly in outer quad, Stanford University, California)	portrait bust, marble
*1884	*Laura* (Petrarch's) (P) Ithaca, New York	bust, marble
1884	*Miss Shreve* (P) Louisville, Kentucky	portrait medallion, marble
1884	*Before the Scenes* (Sold through Tiffany & Co., New York City)	low relief, marble
1884-85	*Miss King* (P) Chicago, Illinois	portrait medallion, marble
*1884-85	*Miss Lila Routt* Governor's daughter (standing young girl) (P) Denver, Colorado	portrait statue, 35 inches, marble
*c.*1885	*Governor Routt* (P) Denver, Colorado	portrait statue, marble

DATE	TITLE OF WORK; LOCATION	DESCRIPTION
1885	*Alfred Smith Barnes* (publisher) (P) Brooklyn, New York	portrait medallion
1885	*Mrs. A. S. Barnes* (P) Brooklyn, New York	portrait medallion
1885	*Mrs. Gordon McKay*	portrait medallion, marble
1885	*Coming Spring* Paris, France	small statue
*1885	*Mr. Bartlett's Son*	small statue, seated, marble
*1883-86	*Coming of Spring* (also called *Flora*) Statue is inscribed "C. Francini Galleries, NY" (Sold through W. Frederic Gallantine, New York City) (Sold through Tiffany & Co., New York City) (was in Mayflower Hotel, Washington, D.C.) National Memorial Park, Falls Church, Virginia, overlooking pond (P) Norfolk, Virginia (small copy)	life size statue, marble
c.1886	*Spring* (P) Norfolk, Virginia	profile head medallion, bronze
1888	*Miss Benedict* (P) London, England	medallion, marble
1888	*Prince* (Tennyson's) (P) Great Barrington, Massachusetts	bust, 28 inches, red Levanto marble
1888	*Mrs. T. H. Newberry* (P) Detroit, Michigan	portrait medallion, mable
1888	*Miss Newberry* (P) Detroit, Michigan	portrait medallion, marble

DATE	TITLE OF WORK; LOCATION	DESCRIPTION
1889-90	*Charles Fiske Bound* (P) New York City	portrait medallion, marble
*1890-91	*Egyptian Sphinxes* Stanford Mausoleum, Palo Alto, California	two heroic statues, marble
*1891	Angel Standing on a Rock (P) Los Angeles, California	pastel drawing, 16 x 25 inches
*1891-92	*A Labour of Love* (also called *Load of Joy*) (mother carrying child on her back) (William Alan Couper and Eliza were models) (sold through Bellman & Ivey, London) (P) New York City (P) Orinda, California	low relief, 3 x 18 inches, marble
*c.1892	*Gov. Leland Stanford* Stanford University, Palo Alto, California	portrait bust
1891-92	*Wirt Dexter* (P) Boston, Massachusetts	portrait medallion, marble
*c. 1892	*Greek Maiden* (P) Lexington, Virginia	study, portrait bust
*1893	Eagles and Flags (part of *Washington Monument*) Forest Lawn, Hollywood Hills, California	group, bronze
*c.1894	*Cupid in a Tulip* (P) Washington, D.C.	medallion, 10 inches, bronze
1894	*Mrs. David Goodwin* (P) Chicago, Illinois	portrait medallion, marble
1894	Bronze Vases Lekies Mausoleum, Elmwood Cemetery, Norfolk, Virginia	bronze
1894	*Lion's Head* Presentation of Mary Academy, Methuen, Massachusetts	relief on fountain, marble

DATE	TITLE OF WORK; LOCATION	DESCRIPTION
1894	*Bishop John P. Newman* Methodist Church, Washington, D.C.	portrait bust, marble
1894	*John Reynolds* (P) Montclair, New Jersey	portrait bust, marble
1894	*W. W. Baldwin* (P) Florence, Italy	portrait bust, bronze
1895	*Mrs. Henry Villard* (P) New York City	portrait medallion, marble
*1896	*A Crown for the Victor* (also called *Beauty's Wreath for Valor's Brow*) (won bronze medal at 1901 Pan. Am. Expo., Buffalo, New York) Montclair Art Museum, New Jersey	seated figure, 5 feet 10 inches, marble
*1896	*Eliza In Theatre Box* (Eliza Ball was model) (P) Waynesboro, Virginia (P) Brooklyn, New York (P) New York City	copper medallion, 15 x 21 inches
1897	*Falconer* Left in Florence, Italy	running girl and falcon, life size

Studio: East 17th Street, New York City
Home: Upper Mountain Avenue, Montclair, New Jersey

DATE	TITLE OF WORK; LOCATION	DESCRIPTION
1898	*Repose* (P) Norfolk, Virginia	allegorical relief, bronze
1899	*Henry Maurer* (P) New York City	portrait bust, bronze
*1899	*Moses* Atop Appelate Courthouse, New York City	heroic statue, marble
*1899	*Protection of our Country* Dewey Arch, New York City Com. Richard Dale Monument,	large panel, seamen and woman, 11 x 12 feet

DATE	TITLE OF WORK; LOCATION	DESCRIPTION
	Portsmouth, Virginia, half size (P) Norfolk, Virginia, reduced copy	
*c.1899	*Angel with Scroll* (P) Waynesboro, Virginia	model, 26 inches, bronzed plaster
1900	*Rev. George D. Armstrong Tablet* First Presbyterian Church, Norfolk, Virginia	bronze
*1900	*Attending Angel* On clock tower, Presentation of Mary, Methuen, Massachusetts	heroic relief, 14 feet, bronze
1900	Design for Tablet Searles Art Gallery entrance, San Francisco, California	
1900	Design for Fountain Government Building, Pan. Am. Expo., Buffalo, New York	
*1900	*Fireman's Memorial* (submitted to Syracuse, New York, for H. S. White Memorial)	fireman carrying child, clay
*1900-01	Decoration for Sarcophagus Two Cherubs, for McKim, Mead, and White, New York City	marble
*1901	*Prof. Thomas Egleston* Columbia University, New York City	heroic portrait bust, bronze
*1901	*Angel of the Resurrection* (P) Chicago, Illinois	life size statue, marble
1901	*Rev. James Mulcahey Tablet* St. Pauls Church, New York City	bronze
*1901	*Rev. Dr. William Stone Hubbell* New York City	portrait relief, bronze
*1901	*Drinking Fountain for Horses* (rear has inscription: "CF to HW, 1901") (P) White Plains, New York	bronze and granite

DATE	TITLE OF WORK; LOCATION	DESCRIPTION
1901	*Miss Elisha Turner* Public Library, Connecticut	portrait tablet, bronze
*1901	*Te Deum Laudamus* (of the sculptor's son Richard Hamilton Couper) Chrysler Museum, Norfolk, Virginia (P) Fullerton, California (P) Norfolk, Virginia (plaster) (P) Fort Lauderdale, Florida (P) Waynesboro, Virginia (bronze)	portrait relief, marble
*1901	*A Cornfield Idyl* (P) Blacksburg, Virginia (P) Lexington, Virginia (plaster) (P) Orinda, California	boy riding hog, 11 inches, bronze
*c. 1901	*Recording Angel* Exhibited at the 1901 Pan. Am. Expo., Buffalo, New York	plaster model
1902	*Jefferson-Davis Arch* Richmond, Virginia	model
*1902	*Headed for Goal* (P) Fort Lauderdale, Florida (P) Lexington, Virginia (P) Orinda, California	football group, bronze
1902-03	*John P. Branch* Richmond, Virginia	portrait bust, bronze
*c.1903	*Confederate Soldier* and *Peace*	study models
*c.1903	Confederate Soldier with Gun (also called *Man of War*) Chrysler Museum, Norfolk, Virginia	study, plaster, 39 inches
*1903	*Dr. Hunter McGuire* Capitol Square, Richmond, Virginia	heroic seated statue, bronze
*1903	*Timothy B. Blackstone* (P) Chicago, Illinois	portrait medallion, bronze

DATE	TITLE OF WORK; LOCATION	DESCRIPTION
*1903	*President William McKinley* Albright Library, Scranton, New Jersey Public Park, Redlands, California	heroic portrait bust, bronze
*c.1903	*Col. Alexander L. Hawkins*	3 plaster models
*1903-04	*Col. Alexander L. Hawkins* *Memorial* (Colonel and eight tablets for Tenth Pennsylvania Regiment) Schenley Park, Pittsburgh, Pennsylvania	heroic statue, bronze
1904	*George J. Magee* (P) Corning, New York	portrait bust, marble
1904	*Richard H. Deming* Public Park, Providence, Rhode Island (being restored)	heroic portrait bust, bronze
1904	*Mrs. C. S. Crane* (consigned to Gorham Company, New York City)	portrait tablet
*c.1905	*Rural Industry*	group model, clay
1905	*Abraham Lincoln* (equestrian) (worked with Thomas Ball)	clay and plaster model, life size
*1903-05	*Abram S. Hewitt* Chamber of Commerce and Industry, Inc., New York City	life size statue, marble
*1904-06	*Jean Louis Rodolphe Agassiz* National Museum of American Art, Smithsonian Institution, Washington, D.C.	portrait bust, 38 inches, marble
*1904-06	*John James Audubon* American Museum of Natural History, New York City (P) Mill Grove, Pennsylvania	portrait bust, marble
*1904-06	*Alexander von Humboldt* Harcum College (unable to locate)	portrait bust, marble

DATE	TITLE OF WORK; LOCATION	DESCRIPTION
*1904-06	*Benjamin Franklin* National Museum of American Art, Smithsonian Institution, Washington, D.C.	portrait bust, 35 inches, marble
*1904-06	*Joseph Leidy* American Museum of Natural History, New York City	portrait bust, marble
1904-06	*Edward Drinker Cope* American Museum of Natural History, New York City	portrait bust, marble
*1904-06	*James Dwight Dana* Mineral Industries Museum, Pennsylvania State University	portrait bust, marble
1904-06	*Joseph Henry* National Museum of American Art, Smithsonian Institution, Washington, D.C.	portrait bust, 37 inches, marble
*1904-06	*Spencer Fullerton Baird* National Museum of American Art, Smithsonian Institution, Washington, D.C.	portrait bust, 30 inches, marble
*1904-06	*John Torrey* Harcum College (unable to locate)	portrait bust, marble
*1906	*Recording Angel* Elmwood Cemetery, Couper plot, Norfolk, Virginia (model exhibited at Pan. Am. Expo., Buffalo, New York, 1901)	life size statue, bronze
*1906	*Angel of Victory*	holding wreath and sword
*c.1906	*Angel with Wreath*	standing before obelisk
*1906	*Peace* (seated woman in front of 90-foot obelisk, holding wreath and sword)	heroic statue, bronze

DATE	TITLE OF WORK; LOCATION	DESCRIPTION
	Minnesota Monument in National Military Park, Vicksburg, Mississippi	
*1906	*Confederate Soldier* (white granite shaft by Couper Marble Works) Atop Confederate Monument, Norfolk, Virginia	heroic statue, 9 feet, bronze
*1906	*John A. Roebling* Public Park, Trenton, New Jersey	heroic seated statue, bronze
1905-07	*Morris K. Jesup* Public Library, Westport, Connecticut	heroic portrait bust, marble
*1906-07	*Captain John Smith* Jamestown, Virginia	heroic statue. bronze
*1907	*Dr. John Witherspoon*	four standing models, clay
*1907-08	*Isaac Wallach* Mount Sinai Hospital, New York City	heroic portrait bust, bronze
1907-08	*Mrs. A. R. Gazzam* Cornwall-on-Hudson, New York	life size portrait bust, marble
*c.1908	Woman on a Sarcophagus	seated figure, marble
*1908	*Dr. John Witherspoon* Connecticut Ave and N Street, Washington, D.C.	heroic statue, bronze
*1908	*Charles Darwin* New York Academy of Sciences (replica, 1909, Christ College, Cambridge, England)	heroic portrait bust, bronze
*1908	*Gen. Isham Warren Garrott* (granite base by Couper Marble Works) National Military Park, Vicksburg, Mississippi	heroic bust, bronze
*1908	*Admiral John A. Winslow* State House, Boston, Massachusetts	life size relief, bronze

DATE	TITLE OF WORK; LOCATION	DESCRIPTION
*1908	*Crosby Stuart Noyes* District Building, Washington, D.C.	heroic portrait bust, bronze
1908	Two Figures on a Sarcophagus For McKim, Mead, & White, New York City	marble
1908	Mourning Figure with Urn	study model
*1909	*Prof. Albert F. Bickmore* American Museum of Natural History, New York City	heroic portrait bust, bronze
*1909	*Henry W. Longfellow* (shared work with Thomas Ball) Connecticut and M Street, Washington, D.C.	life size seated figure, bronze
*c.1909	*Capt. Andrew Hickenlooper*	three statue models
1908-10	*Morris K. Jesup* American Museum of Natural History, New York City (in 1948 it was remodeled to bust size and placed in the 77th Street entrance)	heroic statue, marble
*1909-10	*Joseph Bryan* Monroe Park, Richmond, Virginia	heroic statue, bronze
*1910	*Frederick T. Gates* (P) Montclair, New Jersey	life size bust, bronze
*1910	*John Davison Rockefeller, Sr.* Pocantico Hills, Tarrytown, New York (plaster) Rockefeller University, New York City (bronze)	five life size busts, marble, bronze
*1910-11	*Sailors' Memorial* United States Naval Academy, Annapolis, Maryland	large relief, bronze
*1910-11	*Officer Andrew Hull Foote* National Military Park, Vicksburg, Mississippi National Museum of American Art,	heroic statue, 104 inches, bronze

DATE	TITLE OF WORK; LOCATION	DESCRIPTION
	Smithsonian Institution, Washington, D.C. (plaster model)	
*1911	*Champlain Monument* for Plattsburg, New York	study, statue and benches
*1911	*Snowden Memorial* (for Lt. Col. John B. Snowden, killed in France) Elmwood Cemetery, Memphis, Tennessee	angel for sarcophagus
*1911	*Brig. Gen. Isaac F. Quinby* National Military Park, Vicksburg, Mississippi	heroic bust, bronze
*1911	*Capt. Andrew Hickenlooper* National Military Park, Vicksburg, Mississippi	heroic statue, bronze
*1911	*Gen. Francis Preston Blair* National Military Park, Vicksburg, Mississippi	heroic bust, bronze
*1911	*Rear Adm. Robert E. Peary* Chrysler Art Museum, Norfolk, Virginia Artic Museum, Bowdoin College, Brunswick, Maine (bronze copy to R. E. Peary)	heroic bust, marble
*1912	*Henry W. Longfellow* Fulton St. Park, Grand Rapids, Michigan	heroic bust, bronze
*1912	*William Watts Sherman* (P) New York City	three life size busts, marble
*1912	*Rev. Dr. Augustus H. Strong* Crozer Theological Seminary, Rochester, New York	portrait bust, bronze
*c.*1915	Seascape (P) Blacksburg, Virginia	water color, 8 x 11 inches
*c.*1915	Seascape (P) San Juan Capistrano, California	pastel drawing, 10 x 12 inches

DATE	TITLE OF WORK; LOCATION	DESCRIPTION
c.1916	Seascape (P) Norfolk, Virginia	oil, 10 x 14 inches
c.1916	Seascape (P) Springfield, Virginia	
*1918	Seascape	tempera, 16 x 20 inches
*1921	Seascape (P) Shingle Springs, California	oil painting, 11 x 14 inches
*1921	Seascape (P) Los Angeles, California	oil, 14 x 20 inches
*1922	Seascape (P) Orinda, California	
1924	Seascape (P) Shingle Springs, California	(green tones) oil, 10 x 14 inches
c.1926	Seascape (P) Montclair, New Jersey	

Couper's Works Referenced Name to Date

TITLE OF WORK	DATE
Agassiz, Jean Louis Rodolphe	1904-06
Angel, Attending	1900
Angel, Head of an	(see *Vision*)
Angel, of the Resurrection	1901
Angel, of Victory	1906
Angel, Recording	1906
Angel, Recording, model	1901
Angel, Standing on a Rock	1891
Angel, with Scroll	*c.*1899
Angel, with Wreath	*c.*1906
Antigone	1883
Armstrong, Rev. George D., Tablet	1900
Audubon, John James	1904-06
Bacchante, Head of	1872
Baird, Spencer Fullerton	1904-06
Baldwin, W.W.	1894
Ball, Eliza	1877, 1896
Ball, Thomas	1878
Barnes, Alfred Smith	1885
Barnes, Mrs. A.S.	1885
Bartlett, Mrs. D.L.	1884
Bartlett (son)	1885
Beauty's Wreath for Valor's Brow	(see *Crown for the Victor*)
Before the Scenes	1884
Benedict, Miss	1888
Bickmore, Albert F.	1909
Blackstone, Timothy B.	1903
Blair, Gen. Francis Preston	1911
Bound, Charles Fiske	1889-90
Branch, John P.	1902-03
Brooks, Naval Engineer	1877
Brooks, Mrs.	1877

TITLE OF WORK	DATE
Bryan, Joseph	1909-10
Champlain Monument, study	1911
Cherubs, and Shield	1900-01
Coming Spring	1885
Coming of Spring	1883-86
Confederate Soldier with Gun, study	*c.*1903
Confederate Soldier and Peace, studies	*c.*1903
Confederate Soldier	1906
Cope, Edward Drinker	1904-06
Cornfield Idyl	1901
Couper, Richard Hamilton	(See *Te Deum Laudamus*)
Crane, Mrs. C.S.	1904
Crosby, Col. J. Schuyler	1878
Crown for the Victor, statue	1895, 1896
Cupid in a Tulip	*c.*1894
Dale, Com. Richard	(see *Protection of Our Country*)
Dana, James Dwight	1904-06
Darwin, Charles	1908, 1909
Deming, Richard H.	1904
Dexter, Wirt	1891-92
Don Quixote	1873
Eagles and Flags (on *Washington Monument*)	1893
Egleston, Thomas	1901
Eliza in Theatre Box	1896
Enid	(see *Fair Enid*)
Evangeline	1880
Evening	1878
Fair Enid	1879
Falconer	1897
Feeding the Swan	*c.*1880
Female Head	1873
Figure, small size	*c.*1876
Fireman's Memorial	1900
Flora	1883

TITLE OF WORK	DATE
Foot, study	1873
Foote, Andrew H.	1910-11
Forget Me Not	1878
Fountain, design	1900
Fountain, Dolphin	1877
Fountain, Drinking, for Horses	1901
Fountain, Shell Shaped	1873
Franklin, Benjamin	1904-06
Garrott, Gen. Isham Warren	1908
Gates, Frederick T.	1910
Gazzam, Mrs. A.R.	1907-08
Goodwin, Mrs. David	1894
Greek Maiden	c.1892
Hagerman, Mrs. J.J.	1883
Hand, Study	1873
Hand, for Stanford family	1884
Hawkins, Col. Alexander L.	1903, 1904
Headed for Goal	1902
Head of an Angel	(see *Vision*)
Henry, Joseph	1904-06
Hewitt, Abraham S.	1903-05
Hickenlooper, Capt. Andrew	1909, 1911
Hubbell, William	1901
Iphigenia	1882
Ives, Miss	1881
Jefferson-Davis Arch, model	1902
Jesup, Morris K.	1905-07, 1910
King, Naval Engineer	1877
King, Miss	1884-85
Labour of Love	1891-92
Landscapes	1874
Laura (Petrarch's)	1884
Leidy, Joseph	1904-06
Lily of Florence	1883

TITLE OF WORK	DATE
Lincoln, Abraham (equestrian model)	1905
Lion's Head	1894
Load of Joy	(see *Labor of Love*)
Longfellow, Henry W.	1909, 1912
Magee, George J.	1904
Man of War	(see Confederate Soldier with Gun)
Maurer, Henry	1899
McKay, Mrs. Gordon	1885
McKinley, President William	1903
McGuire, Dr. Hunter	1903
Morning	1882
Moses	1899
Mother's Lullaby	1879
Mourning Figure with Urn	1908
Mulcahey, Rev. James, Tablet	1901
Newberry, Miss	1888
Newberry, Mrs. T.H.	1888
Newman, Bishop John P.	1894
Noyes, Crosby Stuart	1908
Peace, for *Confederate Monument*	c.1903
Peace, for *Minnesota Monument*	1906
Peary, Adm. Robert E.	1911
Powers, Mrs. Preston	1876
Prince (Tennyson's)	1888
Princess (Tennyson's)	1882
Protection of our Country	1899
Psyche	1882
Quinby, Gen. Isaac F.	1911
Repose	1898
Reynolds, John	1894
Rockefeller, John D., Sr.	1910
Roebling, John Augustus	1906
Routt, Gov.	c.1885
Routt, Miss Lila	1884-85

TITLE OF WORK	DATE
Rural Industry	*c.*1905
Sailor's Memorial	1910-11
Sarcophagus, Two Figures on a	1908
Sarcophagus, Woman on a	*c.*1908
Seascapes	1913 to 1926
Sherman, William Watts	1912
Shreve, Miss	1884
Smith, Capt. John	1906-07
Snowden Memorial	1911
Sphinxes, Egyptian	1890-91
Spring	1886
Stanford, Leland Jr.	1884
Stanford, Leland Sr.	1892
Strong, Rev. Augustus H.	1912
Tablet, design for	1900
Te Deum Laudamus	1901
Tilton, Miss Grace	1878
Torrey, John	1904-06
Turner, Miss Elisha	1901
Vases	1894
Villard, Mrs. Henry	1895
Vision	1884-5
von Humboldt, Alexander	1904-06
Wallach, Isaac	1907-08
Washington Monument	1893
White, Hamilton Salisbury	(see *Fireman's Memorial*)
Winslow, Adm. John A.	1908
Witherspoon, Dr. John	1907,1908

Significant Dates in the Life of William Couper

DATE	EVENT
1853 (Sept. 20)	Born in Norfolk, Virginia
1861-65	American Civil War
1872-74	Attended Cooper Institute (Union), New York City
1874 (June 27)	Set sail for Germany
1874 (Oct.)	Started school in Munich, Academy of Fine Arts and Royal Academy of Surgery
1875 (Sept.)	Arrived in Florence, Italy
1876 (Dec. 15)	Began working and studying with Thomas Ball (via Dante da Castiglione, Florence, Italy)
1878 (May 9)	Married Eliza Chickering Ball (daughter of Thomas Ball)
1881 (Jan. 19)	Son born: Thomas Ball Couper, in Florence, Italy
1886 (July 5)	Son born: Richard Hamilton Couper, in Norfolk, Virginia (while family was on vacation in America)
1891 (April 26)	Son born: William Alan Couper, in Florence, Italy
1897 (Sept.)	Returned to America
	Studio in New York City (East 17th Street)
	Home in Montclair, New Jersey
1911 (Dec. 11)	Death of father-in-law, Thomas Ball
1913	Retired from sculpture
1918 (March 18)	Death of son, Richard Hamilton Couper *
1939 (July 20)	Death of wife, Eliza *
1942 (June 22)	Death of William Couper *

Note: Buried in Elmwood Cemetery, Norfolk, Virginia

Appendix B

Biographical Sketches

Thomas Ball (1819-1911)

Thomas Ball, American sculptor, was the father-in-law and lifelong colleague of William Couper. He was born in Charlestown, Massachusetts, June 3, 1819, the son of a sign painter. He originally supported himself through portrait painting, musical oratorio, and giving piano lessons. He then turned to sculpture and went to Florence, Italy, to work with expatriate sculptors Hiram Powers and Joel T. Hart. He was the teacher of sculptors Martin Milmore, Daniel Chester French, and William Couper.

Ball specialized in colossal historical figures, allegorical subjects, and portraiture, and was one of the leading sculptors in America's "Bronze Age." His best known heroic statues are the equestrian *George Washington* in Boston's Public Garden; the *Daniel Webster* in New York's Central Park; the *Emancipation Group* in Washington, D.C. and Boston; and the *Washington Monument* in Hollywood Hills, California. Thomas Ball wrote an autobiography, *My Threescore Years and Ten* (1891). He is buried in Florence's Allori Cemetery near his wife, Ellen Louise.

John Clay McKowen (1842-1901)

John McKowen, author and physician, was a very outspoken as well as cultured man. Couper met McKowen in October 1874, shortly after he arrived in Munich, where both men were students. McKowen was to remain a close friend, and often helped Couper, acting as a kind of mentor. McKowen was from a well-to-do New Orleans family. He became a lieutenant-colonel in the Southern army cavalry division when he was but twenty-one years old. One night he and five scouts captured Yankee General Neal Dow, for which the Southern government presented him with Dow's sword, inscribed with a memorial to the event.

McKowen studied at the École de Médicine in Paris in 1866, and at the Royal College of Surgery in Munich from 1873 to 1875. He was active in many

cultural and social events, including the opera, concerts, and art exhibitions, which he invited Couper to share with him. After completing his studies he began a practice in Rome, Italy, at 54 Piazza di Spagna. He was physican to many Americans in that city and on the island of Capri, from 1876 to 1898.

McKowen bought a house in Anacapri at Damecuta, which he painted red and turreted and battlemented like the blockhouse of a Louisana plantation. He became famous for his authoritarian ways, his arrogant scowl, his boots and his spurs which, to some, made him a perfect stereotype of a Southern slaveowner; but he gave free professional care to the poor, and kept them supplied with medicines. At the same time he gave them the rough edge of his tongue. In Anacapri he became known as "Sciacca e medica" (strike and heal).[1]

McKowen planned to grow cotton and Indian corn at his island estate, but the land cultivation brought to light the remains of one of Caesar Augustus' villas, and the doctor decided to concentrate on archeology instead. In 1884 he published a book entitled *Capri* (published by F. Ricciardi, Napoli, TIP), which describes in detail the archeological and geological features of the island. He also authored a book on the Mafia and the Camorra of Italy.

One day an ancient tomb was excavated between Damecuta and the high ground near Tiberino. McKowen rushed to the spot only to find that Swedish doctor Axel Munthe had arrived first, seeking decorations for his Villa San Michele. Because both men were vying for artifacts they got into a heated argument. This resulted in a challenge to a duel that never materialized, but McKowen thereafter went about with pistols in his pockets while Munthe threateningly brandished a horsewhip.

When McKowen decided to dig a tunnel into the Blue Grotto, which was situated just below property he owned, thereby potentially eliminating the jobs that the local Anacapresi had of boating the tourists inside, he was escorted off the island as a capitalistic upstart.

After returning to Louisiana in 1898, he discovered a chemical method to diagnose yellow fever. He denounced the state board of health for suppressing the truth about the existence of yellow fever in New Orleans from 1898 to 1899, and was expelled from the Orleans Parish Medical Society. He later won a libel suit and was praised by the press in Louisiana, Alabama, and Texas. In 1901 he got into an argument in a bar with state Senator R. E. Thompson. Thompson pulled out a pistol and shot McKowen dead.

Julius Rolshoven (1858-1930)

Julius Rolshoven, painter from Detroit, was a friend of the Couper family and a relative by marriage. (His first wife was Anna Eliza Chickering, cousin of Eliza Ball Couper.) He was often mentioned in correspondence by the name Giulio. He specialized in portraits, landscapes, and still lifes, and had a special interest in various ways of depicting light.

Rolshoven studied art at Cooper Union, New York City, and in the art academies of Düsseldorf and Munich. While in Munich in 1878 he was a student of fellow American artist Frank Duveneck, and later joined him in establishing an art school in Florence, Italy. In 1882 he studied in Paris under Robert-Fleury and Bouguereau, then taught in Italy with Duveneck.

Some of his best paintings were done in northern Africa where he depicted the strong sunlight upon Moslem villages and picturesque natives. He also developed a love of Italy and the Tuscan hills, painting landscapes, churches, and figures.

Between 1890 and 1902 Rolshoven taught in Paris and London. He acted as a mentor for Richard and Mildred Couper when they were studying art and music in Rome. They often visited him in Florence at his restored thirteenth century castle, the Castello del Diavalo. Rolshoven went about dressed in an artist's cape, and his house staff wore colorful Italian peasant costumes, which provided subjects for some of his Florentine landscape paintings.

During the First World War he traveled to the Western United States and became interested in the Indians of New Mexico, where he was active in the artist colony at Taos. He had been inspired by the mysticism of Italian art, and discovered a deep religious feeling and a reverence for ceremonial Indian life. The tragedy of the passing culture impressed him as he studied the rituals of medicine men and chiefs, and attended their festivals. He depicted Indian life and symbolic quests. After the war he returned to Europe, and in his last years Rolshoven divided his time between New York and Italy, painting portraits of prominent citizens and Tuscan landscapes.

Appendix C

Villa Ball: History and Guest Register

When American sculptors Thomas Ball and Hiram Powers realized they would be spending many years in Florence they did not wish to continue renting apartments and studios. They had become good friends, and began looking for adjacent plots of land on the south side of the Arno, outside of the old city walls, which were the boundary between the urban area and the agricultural landscape. Ball wrote:

> About this time my old friend Hiram Powers—whose studio and house were still in the old place in Via dei Serragli, where I first met him—made me a visit one morning, and invited me to walk with him up the Poggio Imperiale, to look at a house then in process of construction, in what is now the most beautiful quarter of Florence, but which... was covered by the vineyard of an old monastery, as far as the eye could reach. This was one of the first houses... erected in the midst of this old vineyard, before the roads were more than lined out on the map. Here we mounted the scaffold to the top of the new walls, and sat down to enjoy the view of the city from this elevated position. "What do you think of this spot," said Powers, "for an old man to end his days in?" I agreed with him that it was a delightful situation.[1]

They decided to buy land on the hill just up from the Porta Romana (fig. 5), along the viale Poggio Imperiale. This was very near the apartments of other artists, sculptors, and writers, who were living just inside the Roman gate. They bought the property from Riccardo Ciampi and registered the sale together at the Conservatoria dei Registri Immobiliari on June 4, 1868. Financing was obtained from the Du Fresne bank. Powers bought enough property to build a number of villas, because his family was large and would need multiple dwellings. He built his villas along the Poggio Imperiale, and Thomas Ball built next door to Powers, using an unimproved access road.

The following year, 1869, the city of Florence officially recognized this thoroughfare and named it via Dante da Castiglione.

Ball decided in favor of one large two-story villa, which included his studio and enough space for a colleague. Behind this was a small two story house with unattached studio which could accommodate his staff (fig. 6). While the villa was under construction he took a trip to America, and Powers asked him to bring back a large number of seeds and plants to place in their gardens. These included sweet corn, hickory, black walnuts, Texas pecans, cinquefoils, cuttings from the Newton pippin and other apples, and sweet potatoes. Powers corresponded with Ball regarding the progress of the construction.

> Mr. Fuller told me this morning that Ciampi says he will not make a thousand lire by his contract with you. He is making the walls 2 feet 3 inches thick and the amount of materials is great. Of one thing you may be quite sure, the masonry is most substantial.
>
> They are now arching over your studio doors and windows and they seem *lofty*. I walked over the staging last evening and took a general view of what is to be your first floor. I could hardly imagine what you, your wife, and little *tow head* are to do with all this room—you will be like mice in the great cave of Kentucky.
>
> Your well still keeps almost full of water and so does mine. I think therefore that we may not trouble ourselves about our water…. Our house is nearly done—the garden is being graded and the studio will be roofed in within a fortnight. The place begins to show what it will be when all is done, and a more lovely position than we have got could hardly be found any where. [2]

> While I think of it Mr. [Henry] Sanford could get an ear or two of the big gourd corn from the west that often grows 10 to 12 feet high. It would astonish the natives here…. Your house grows daily into size and importance. We can now see something of its figure and it will be very handsome, the walls are thicker than mine and the masonry is as good as can be…. I have a dumb waiter made twixt the kitchen below and dining room above in my house…. I mention all this for your guidance, should you think it worthwhile to have it done. The guides, pulleys and shelf case which slides up and down are all on a plan of my own and very simple and not expensive.
>
> …Longworth will have the corner on the Poggio above me, and it will reach to opposite a part of your house. They have com-

menced the foundations of the house on the corner beyond yours, a charming position. Can't you persuade some good American to come out and live in it?[3]

He [Ciampi] is getting in the upper windows (stone casings) and says he will have all under roof in October. An old friend Hart had a look at it last evening. "What are they going to do with all this room?" he said—as standing on the scaffolding he surveyed the general proportions. "Well (he added) Ball has done a wise thing. He has established himself comfortably and splendidly for life."

The trees on the new boulevard in our quarter have grown astonishingly this season.... The talk is pretty general that this drive will in a short time eclipse the Cascene. It is perfectly lovely in the evening about sunset.[4]

I saw last evening a bit of the cornice of your home. It is of carved wood and very simple and handsome. Ciampi told me that he would have no two houses alike. I think that the design of your house now quite apparent, is very handsome and the cornice will be beautiful.[5]

The ground floor of Villa Ball had large arched windows opening into the garden and was used for the studio and offices (figs. 9-12, 17-20), with the second floor used as a private residence. The front entry foyer and many of the interior rooms of the villa were painted with detailed Pompeii-style designs (figs. 15, 16, 18). There were seven rooms to the studio. One of the larger rooms contained heroic portrait busts. Large allegorical statues were displayed in another, and small statuettes and busts in yet another. Two big rooms were used for marble cutting, and a special showroom displayed half a dozen large marbles. A very large lower level (*sottosuolo*) contained the kitchen and storage rooms; this area had windows opening to the back garden but was not visible from the front of the building. The villa was on sloping property, and the back upper-story terrace commanded a sweeping view of the city of Florence (see figs. 7, 8).

A small two-story garden house with attached greenhouse, which could be used for amusement or accommodating guests, was built in the back left corner of the garden. It had arched windows and was designed in the same Italianate style as the large villa. Trompe-l'oeil friezes were painted on the

inside wall to imitate the outer windows. The greenhouse contained tropical plants and exotic birds and canaries.

Mrs. Ball helped to design the garden (fig. 6). Two palm trees were planted in the front, one on each side of the villa. To the left was a large fish pond, which was at first stocked with goldfish. But later, as Ball's grand-daughter-in-law was to comment, "The pond still has Arno fish in it, descendents of the ones that those naughty children threw in & who promptly devoured all the goldfish!"[6] At the right front corner of the garden was a large iron gazebo. Behind the villa, a rose-covered trellis shaded a path leading down to the greenhouse. The entire garden was filled with flowers, to form a tranquil and idyllic setting.

Several artists used the Villa Ball studios, including Daniel Chester French and William Couper. The sculptress Anne Whitney traveled to Florence with her plaster model of the statue of Samuel Adams (Capitol, Washington, D.C.) to have it transferred to marble. Later she sent works to Ball to arrange for the carving. And Frank Duveneck used the studio to complete a model of a memorial sculpture for his wife's gravesite. This was placed in the Allori Cemetery in Florence, but has since been removed.

When the Ball-Couper family left Italy in 1897 they rented out the villa. It remained in the family for another twenty-four years (fifty-one years total), and was eventually sold to Signora Albertina Fenci in July 1919. The sale included the villa, house, studio, glass greenhouse, and terrazza. Signora Fenci converted the villa to a hotel pensione, and renamed it Villa Albertina. A marble plaque with this name is still in place at the entrance today.

The estate remained in the Fenci family, and at the owner's death was transferred to her son, Mario Bartalesi. In 1956 it was sold to a prominent Italian businessman. He leased it to the city of Florence for use as an elementary school, the Scuola Pietro Thouar, which preserved the original structure and saved it from modern remodeling. In 1986 plans were made to close the school after thirty years of service and restore the villa to a private home.

The Porta Romana area, with its many gardens and large spacious villas, is still considered one of the most desirable places to live in Florence. It is close to the center of town but outside the commercial zone, and is within walking distance of the Institute of Art, Pitti Palace, Boboli Gardens, Zoological Museum, and the Ponte Vecchio.

Guest Register of Villa Ball

On Eliza Ball's seventeenth birthday, May 26, 1874, she was presented with an autograph book for Villa Ball, the "Book of Fame." This book contains the names of persons who visited in Florence, Montclair, New York, and Boston. Often the signers added pen-and-ink sketches, poems, or scores of musical notation. At times the book also doubled as an autograph collection. The names are listed here to show the social life at the time. (Some names included, such as Hiram Powers and Jonas Chickering, were inserted by the Ball family from earlier correspondence, and thus the order of names does not imply a chronological sequence. Some signers did not include dates. A few signatures are not clear and are followed by a question mark, but they have been noted as clearly as possible). On the first page Thomas Ball wrote the following ode:

> "To genius! meet it when or where I may
> I dedicate this book." I heard her say.
> "Each leaf shall be devoted to a name
> That is or should be widely known to Fame."
> Then quietly the enterprize [sic] to start:
> She brings the book to me! (Bless her dear heart!)
> Which act would not occasion much surprise
> Could you but see my works with her dear eyes:
> Beaming with love; so ready to create
> Illusions sweet, too sweet to dissipate.
> So, do not, pray, My darling undeceive:
> Whatever you may secretly believe.
> I'd rather know her love enshrined my name
> Than write it foremost in the book of Fame.
>
> Florence, June 1st, 1874
> By Thomas Ball

123

Guests and Signatures

1874	Hans von Bülow [pianist, son-in-law of Franz Liszt]
1874	Giuseppe Buonamici [musician, pianist]
1874	Wilkie Collins [author]
1874	Sir Julius Benedict [musician and conductor]
1874	Jule E. Perkins [musician]
	Jenny L. Goldschmidt [singer Jenny Lind]
1874	Walter A. Gage [artist]
1874	J. R. Lowell [James Russell, author and diplomat]
	Hamilton G. Wild [artist]
1874	[son of the Mikado of Japan]
1869	W.D. Howells [William Dean, author, critic]
1874	W.D. Howells [see 1869]
1874	Camilla Urso [violinist]
1883	W.D. Howells [see 1869]
	L. M. Alcott [Louisa May, author]
1875	Henri Ketten [musician, pianist]
	Francis Alexander [portrait painter]
1875	Edwin White [portrait and historical painter]
1875	Anna Mihlig (?)
1875	C.M. Burns
1875	G.F. Hatton [musician]
	Robert Thallon [musician]
	Nellie E. Powers [daughter of Hiram Powers, Mrs. Lemmi]
1889	James Francis Campbell [musician]
1866	Charlotte Cushman (twice) [actress]
1887	Henry Clements
1862	Robert Franz [composer and song-writer]
c.1870	Hiram Powers [sculptor]
1844	L. Schwanthaler [sculptor]
1876	Daniel C. French [sculptor]
1876	Anne Whitney [sculptor]
1876	Ralph Waldo Emerson [writer]
1876	Bronson Alcott, writer [transcendentalist]
	Edwin Blashfield [painter, muralist, writer]

124

1864	Jean Ingelow (twice) [poet and novelist] William Dannat [artist] Frances Alexander [daughter of Francis, artist, poet]
1872	Richard Wagner [composer] (On a Patronage Certificate for *Ring of the Nibelungen*)
1875	Joel T. Hart [sculptor]
1859	N. P. Willis [Nathaniel Parker, editor, essayist, poet] Alice M. Longfellow [daughter of Henry] Henry W. Longfellow [poet] E.D. Palmer [Erastus Dow, sculptor] B.C. Porter [Benjamin Curtis, artist]
1885	C. Vogel von Vogelstein [painter]
1859	Edward Everett [American statesman]
1876	George C. Munzig [artist]
1863	Edwin Forrest [actor]
1871,1872	W.T. Sherman [U.S. general]
1867	William Cullen Bryant [poet]
1849,1852	Jonas Chickering [pianomaker] Franz Liszt [musician, composer] Hyacinthe Loyson [preacher] Charles G. Dyer [artist]
1878	J.A. Mitchell [John Ames, editor, author]
1881	Christopher P. Cranch [painter, poet] Francis Boott [composer, father-in-law of Frank Duveneck]
1881	Chas Freeman [artist]
1854	James T. Fields [author, publisher] Otto H. Bacher [artist]
1871	Christina Z. Rossetti [poet, sister of Dante Gabriel Rossetti]
1881	Jos. R. DeCamp [artist] William Couper [sculptor]
1879	Helen Reed [artist] calling card for Mrs. William Couper
1887	Virginia W. Johnson [travel author]
1874, 1881	Walter Shirlaw [artist]
1882	Randolph Rogers [sculptor]
1882	C.B. Ives [Chauncy Bradley, sculptor]
1882	E. Keyser [Ephraim, sculptor]
1883	Chas E. Mills [artist]

	Julius Rolshoven [sketch by the artist]
1911	Julius Roshoven [card from Tunisia]
1884	Arthur B. Whiting [musician]
1884	William L. Whitney [musician]
1885	Thos S. Claskins [artist]
1884	Julius Rolshoven [sketch by the artist]
1885	G.W. Cable [George Washington, novelist]
1879	James Barron Hope [writer]
1887	N. Macintosh [artist]
1886	Oliver Bennett Grover [writer]
1890	Ross Turner [artist]
1894	Dudley S. Buck [organist, composer]
	Cornelius Denis O'Sullivan [tenor singer]
1901	Edward C. Caswell (twice) [artist]
1910	J.D. Rockefeller [John Davison, Sr. ,financier]
1908	Thomas Ball [sculptor]
1905	R .E. Peary [Robert Edwin, explorer]
1908	M. Moszkowsky (twice) [composer]
1909	Gedney Bunce [William G., artist]
1886	sketch of Julius Rolshoven
1886	sketch: The Four Seasons—Rolshoven, Couper, Grover, Ives

Notes

(Unless otherwise noted, all letters written by William Couper are from the private collection of Monroe Couper, and news clippings are from the collections of Monroe Couper or Lisa Merryman.)

Chapter 1
Introduction: The Artist in Perspective

1 *Montclair Times,* New Jersey, November 23, 1937, "Desire for Beauty Inspired William Couper's Sculpture."

2 Lorado Taft, *The History of American Sculpture* (New York: Macmillan, 1930), p. 423.

3 William H. Gerdts, *Painting and Sculpture in New Jersey,* vol. 21 of The New Jersey Historical Society Series (Princeton: D. Van Nostrand, 1964), p. 191.

4 Wayne Craven, *Sculpture in America* (New York: Crowell, 1968), p. 144.

5 *Montclair Times,* New Jersey, November 23, 1937, "Desire for Beauty Inspired William Couper's Sculpture."

Chapter 2
Growing Up in Norfolk

1 William A. Couper [sculptor's son] to Lucille Pearce, March 17, 1969.

2 *Virginian,* Norfolk, Virginia, March 20, 1872, "Native Genius."

3 *Norfolk Landmark,* Virginia, October 9, 1873, "Native Genius." Courtesy the *Virginian-Pilot* and the *Ledger-Star*

4 John D. Couper to Edward Valentine, January 22, 1874 (Edward V. Valentine Papers, Valentine Museum, Richmond, Va.)

5 Letter of introduction from Edward Valentine, May 1874 (Edward V. Valentine Papers, Valentine Museum, Richmond, Va.)

Chapter 3
On the Grand Tour

1 William Couper to family, July 7, 1874

2 Ibid., July 13, 1874

3 Ibid., August 30, 1874.

4 William Couper to Edward Valentine, January 27, 1875
(Edward V. Valentine Papers, Valentine Museum, Richmond, Va.)

5 Edward Valentine to William Couper, April 22, 1875
(Edward V. Valentine Papers, Valentine Museum, Richmond, Va.)

6 *Montclair Times,* New Jersey, November 23, 1937, "Desire for Beauty Inspired William Couper's Sculpture."

Chapter 4
The American Colony in Florence

1 William Couper to family, September 14, 1875.

2 Ibid.

3 Ibid., September 27, 1875.

4 Ibid.

5 Ibid., October 7, 1875.

6 Margaret French Cresson, *Journey Into Fame* (Cambridge, Mass.: Harvard University Press, 1947), p. 92.

7 Ibid., p. 87.

8 William Couper to family, 1893.

9 Daniel French to sister Hattie, February 5, 1876 (Daniel Chester French Papers, The American University, Washington, D.C.)

10 Daniel French to his father, March 19, 1876 (Daniel Chester French Papers, The American University, Washington, D.C.)

11 *Boston Transcript,* January 1, 1884, "Fair Florence."

12 William Couper to family, May 5, 1881.

13 Daniel French to his father, March 19, 1876 (Daniel Chester French Papers, The American University, Washington, D.C.)

14 Daniel French to sister Hattie, February 5, 1876 (Daniel Chester French Papers, The American University, Washington, D.C.)

15 Daniel French to Mrs. Ball, February 11, 1877 (Daniel Chester French Papers, The American University, Washington, D.C.)

16 Daniel French to sister Hattie, March 19, 1877 (Daniel Chester French Papers, The American University, Washington, D.C.)

17 Thomas Ball to Daniel French, April 25, 1877 (Daniel Chester French Papers, The American University, Washington, D.C.)

18 Thomas Ball, *My Threescore Years and Ten* (Boston: Roberts, 1892), p. 296.

19 William Couper to family, July 21, 1877.

20 Ibid., August 11, 1877.

21 Ibid., May 31, 1877.

22 Ibid., July 24, 1878.

23 Ibid., August 25, 1878.

24 Donald Martin Reynolds, *The Nineteenth Century* (London: Cambridge University Press, 1985), p. 33.

25 *Virginian,* Norfolk, Virginia, May 1, 1883, "Norfolk Genius."

26 *Norfolk Landmark,* Virginia, June 27, 1878, "Florence the Fairest City on Earth."

27 *Boston Transcript,* January 1, 1884, "Fair Florence."

28 William Couper to family, July 10, 1897.

29 Ibid., 1893.

30 William Couper to Mrs. Stanford, September 9, 1891 (Jane Lathrop Stanford Papers, Stanford University Archives).

31 William Couper to family, October 1, 1885.

32 Adeline Adams, *The Spirit of American Sculpture* (New York: National Sculpture Society, Inc., 1929), viii.

33 Ibid., p. 69.

34 *Florence Gazette,* Italy, (in English) February 2, 1892, "About Town." (Biblioteca Nazionale Centrale, Firenze, Italia).

35 Ibid., January 7, 1893, "Studio Notes."

36 Eliza Couper to Couper family, December 13, 1894.

37 John D. Couper to family in Norfolk, May 14, 1896.

38 *Detroit Free Press,* September 28, 1889, "An American Sculptor."

39 William Couper to family, October 27, 1887.

40 *Italian Gazette,* Florence, Italy, (in English) November 24, 1896, "Round the Cupolone." (Biblioteca Nazionale Centrale, Firenze, Italia).

41 Boston newspaper, November 1896, "Letter from a Florence Correspondent."

42 William Couper to family, January 21, 1897.

43 Ibid., June 20, 1897.

Chapter 5
The Expatriate Returns

1 William Couper to family, July 10, 1897.

2 Ibid.

3 Ibid., December 13, 1897.

4 Ibid., August 22, 1898.

5 Ibid., July 21, 1899.

6 Ibid., September 16, 1899.

7 Ibid., November 20, 1898.

8 Regina Armstrong, "The Story of Sculpture at the Pan-American," *The Bookman,* vol. XIII, March-August (New York: Dodd, Mead, and Company, 1901), p. 349.

9 Morris K. Jesup to William Couper, January 1, 1907. (Collection of Rusby Couper).

10 Edwin H. Blashfield to William Couper, January -, 1907. (Collection of Rusby Couper).

11 J. DeWitt to the Honorable John K. Foster, November 2, 1907. (Collection of Rusby Couper)

12 W. A. Roebling to Judge G. B. Wheeler, August 16, 1907. (Collection of Rusby Couper).

13 Fannie Couper to husband John Couper, December 29, 1899.

14 Julius Rolshoven to Frank Duveneck, May 27, 1898. (The Elizabeth Boott Duveneck Paper [MSS613, Box 3], Cincinnati Historical Society, Ohio).

15 William A. Couper [sculptor's son] to Lucille Pearce, March 17, 1969.

16 Thomas Ball, in Villa Ball Guest Register, May 9, 1905.

17 Henry F. Osborne to William Couper, December 15, 1913. (Collection of Rusby Couper)

18 *Montclair Times,* New Jersey, November 23, 1937, "Desire for Beauty Inspired William Couper's Sculpture."

19 Ibid., article about exhibit at Montclair Art Museum, April 1917.

20 Daniel French to Eliza Couper, September 23, 1928. (Daniel Chester French Papers, The American University, Washington, D.C.)

21 William Couper to family, January 15, 1903.

Chapter 6
Sculptural Techniques and Materials

1 *Florence Gazette,* Italy, (in English) December 3, 1892, "About Town." (Biblioteca Nazionale Centrale, Firenze, Italia).

2 William Couper to Mrs. Stanford, May 25, 1891.
(Jane Lathrop Stanford Papers, Stanford University Archives)

3 Thomas Ball, *My Threescore Years and Ten* (Boston: Roberts, 1892), pp. 179, p. 182.

4 *New York Times,* January 25, 1891, "How Statues are Made—The Sculptor's Art as Practiced Here and Abroad," p. 14.

5 Thomas Ball, *My Threescore Years and Ten* (Boston: Roberts, 1892), p. 225

6 Hiram Powers, *Studio Notebook,* 1842 (Hiram Powers Papers, Archives of American Art, Smithsonian Institution, Roll 688)

7 Daniel French to Mrs. Ball, April 5, 1877 (Daniel Chester French Papers, The American University, Washington, D.C.)

8 Thomas Ball to Daniel French, April 25, 1877 (Daniel Chester French Papers, The American University, Washington, D.C.)

9 Hiram Powers, *Studio Notebook,* 1842 (Hiram Powers Papers, Archives of American Art, Smithsonian Institution, Roll 688)

10 William Couper to Mrs. H. S. White, April 5, 1900, in Calvin McCoy Hennig, "The Outdoor Public Commemorative Monuments of Syracuse, New York: 1885-1950," Ph.D. diss., Syracuse University, 1983. (Courtesy Calvin Hennig).

11 William H. Gerdts, *American Neo-classic Sculpture* (New York: Viking, 1983), p. 18.

12 Daniel French to Mrs. Ball, February 11, 1877 (Daniel Chester French Papers, The American University, Washington, D.C.)

13 Thomas Ball to Daniel French, April 25, 1877 (Daniel Chester French Papers, The American University, Washington, D.C.)

14 Daniel French to his father, March 19, 1876 (Daniel Chester French Papers, The American University, Washington, D.C.)

15 *New York Times,* January 25, 1891, "How Statues are Made—The Sculptor's Art as Practiced Here and Abroad," p. 14.

16 William Couper to family, March 23, 1879.

17 *Florence Gazette,* Italy, February 3, 1894, "The Marble Workers of Carrara." (Biblioteca Nazionale Centrale, Firenze, Italia).

18 *Welcome to Florence,* June 1986 [monthly], "White Marble World."

19 *Italian Gazette,* Florence, Italy, April 6, 1895, "The Alabaster Industry." (Biblioteca Nazionale Centrale, Firenze, Italia).

20 George Savage, *A Concise History of Bronzes* (London: Thames and Hudson, 1968).

Chapter 7
A Summary of Couper's Works

1 Lucille W. Pearce, "Something of Beauty," unpublished term paper, Old Dominion University, Norfolk, Virginia, 1969, p.12

2 *Virginian,* Norfolk, Virginia, May 1, 1883, "Norfolk Genius."

3 William Couper to family, June 29, 1884.

4 *Boston Transcript,* January 1, 1884, "Fair Florence."

5 William Couper to his mother, September 22, 1895.

6 Lorado Taft, *The History of American Sculpture* (New York: Macmillan, 1930), p. 424.

7 F. O. Payne, "The Angel in American Sculpture," *Art and Archeology,* 11, no. 4 (April 1921) (Washington, D.C.: Archeology Institute of America), p. 161.

8 Lorado Taft, *The History of American Sculpture* (New York: Macmillan, 1930), p. 423.

9 *Italian Gazette,* Florence, Italy, April 25, 1896, "Modern Art in Florence." (Biblioteca Nazionale Centrale, Firenze, Italia).

10 William Couper to family, April 25, 1901.

11 Ibid., February 11, 1903.

12 Lorado Taft, *The History of American Sculpture* (New York: Macmillan, 1930), p. 423.

13 Franklin W. Hooper to William Couper, January 2, 1907, (Collection of Rusby Couper).

14 Henry F. Osborn to William Couper, February 6, 1913. (Collection of Rusby Couper).

15 William Couper to family, October 25, 1885.

16 William A. Christian, *Richmond, Her Past and Present,* (Richmond, Va.: L. H. Jenkins, 1912), p. 3.

17 E. G. Leigh, minutes of the Bryan Memorial Committee Association, May 21, 1912. (Collection of Rusby Couper).

18 Washington A. Roebling to William Couper, October 1, 1909. (Collection of Rusby Couper).

19 *Boston Herald,* May 5, 1909, "Unveils Statue to Longfellow."

20 Lucille W. Pearce, "Something of Beauty," unpublished term paper, Old Dominion University, Norfolk, Virginia, 1969.

21 Minnesota Historical Society, *Minnesota in the Campaigns of Vicksburg,* Report of the Minnesota-Vicksburg Monument Commission to the Governor of Minnesota, September 9, 1907, p. 35 and 37.
Civil War Memorial Commissions, Vicksburg Monument Commission; Minnesota State Archives, Minnesota Historical Society.

22 Norfolk newspaper, April 1907, "Color Bearer Highly Praised."
Courtesy the *Virginian-Pilot* and the *Ledger-Star.*

23 Seward W. Jones to the Honorable John B., Riley, May 11, 1911. (Collection of Rusby Couper).

24 William Couper to Mrs. H. S. White, March 29, 1900, in Calvin McCoy Hennig, "The Outdoor Public Commemorative Monuments of Syracuse,

New York: 1885-1950," Ph.D. diss., Syracuse University, 1983. (Courtesy Calvin Hennig).

25 Ibid., letter dated April 5, 1900.

26 William Couper to his mother, June 21, 1891.

27 *Norfolk Landmark,* Virginia, January 31, 1884, "William Couper."

Appendix B
Biographical Sketches

1 Edwin Cerio, *The Masque of Capri* (Edinburgh: Thomas Nelson, 1957), p. 108.

Appendix C
Villa Ball: History and Guest Register

1 Thomas Ball, *My Threescore Years and Ten* (Boston: Roberts, 1892), p. 271.

2 Hiram Powers to Thomas Ball, July 22, 1868 (Hiram Powers Papers, Archives of American Art, Smithsonian Institution, Roll 1144).

3 Ibid., letter dated August 7, 1868.

4 Ibid., letter dated August 19, 1868.

5 Hiram Powers to Mrs. Thomas Ball, September 3, 1868 (Hiram Powers Papers, Archives of American Art, Smithsonian Institution, Roll 1144).

6 Mildred Couper to Thomas Ball, August 18,1911 (Collection of Lisa Merryman).

Illustrations

Index

Italics indicate a work of art or a foreign term.